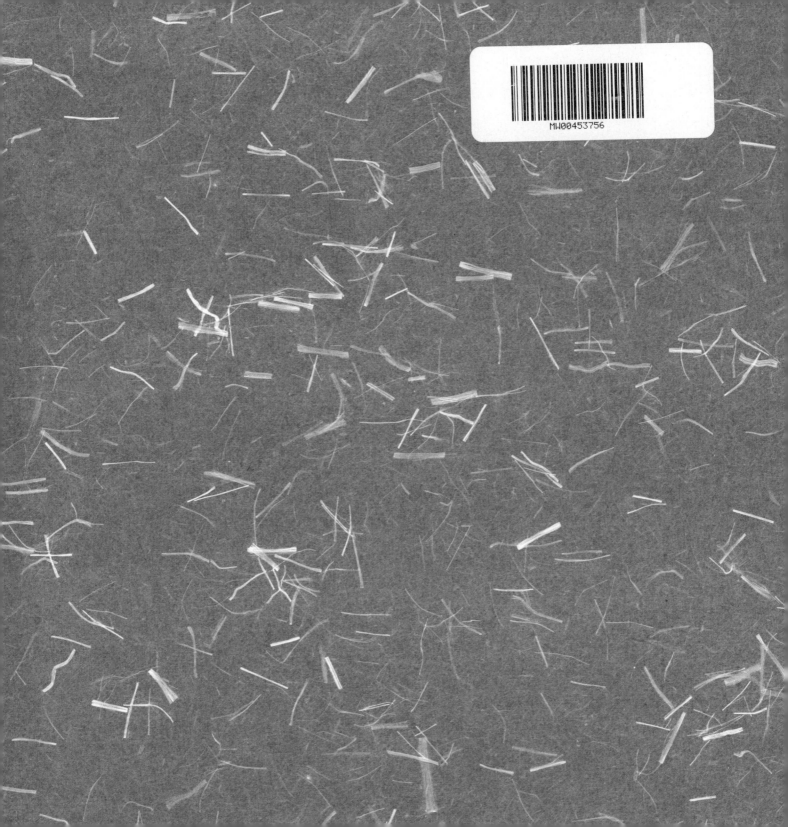

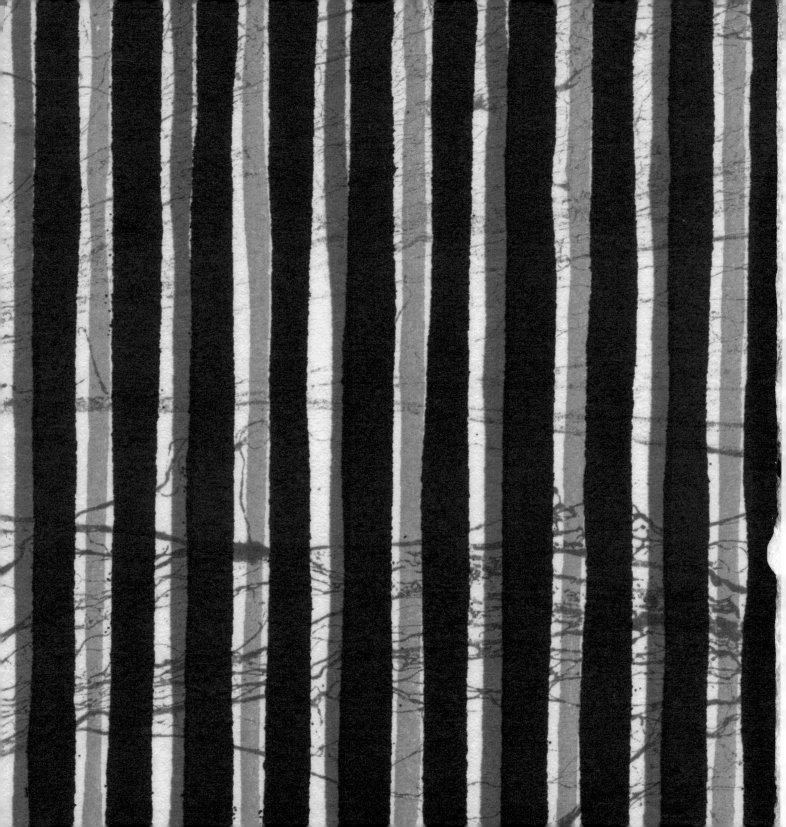

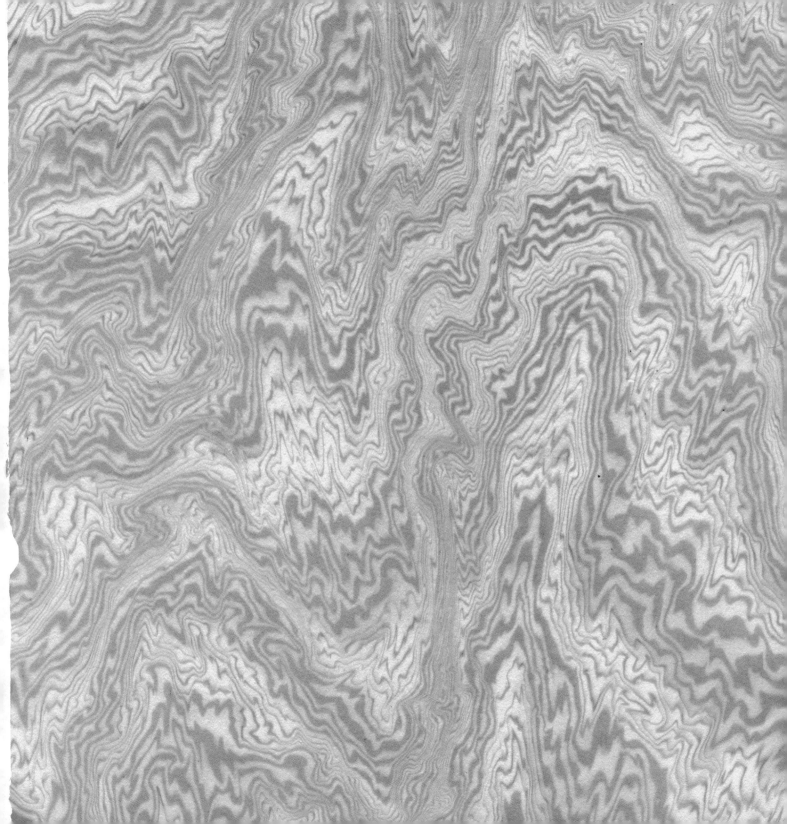

Contents

Free CD-ROM inside the back cover

The Pepin Press publishes a wide range of books and book+CD sets on graphic and web design, typography, fashion, costume, jewellery, architecture, and popular culture.

A small selection:
Japanese Patterns
Chinese Patterns
Islamic Designs
Batik Patterns
Textile Motifs of India
Gothic Patterns
Baroque Patterns
Repeating Patterns 1100-1800
Watercolour Patterns
Tile Designs from Portugal
Barcelona Tile Designs
Havana Tile Designs
Mythology Pictures
Astrology Pictures
World Musical Instruments
Fancy Alphabets
Marbled Paper Design
Structural Package Design
Web Design Index
Free Font Index

Many more titles are available or in preparation. Please visit **www.pepinpress.com** for more information.

Colophon

The Pepin Press | Agile Rabbit Editions
P.O. Box 10349
1001 EH Amsterdam, The Netherlands

Tel +31 20 420 20 21
Fax +31 20 420 11 52
mail@pepinpress.com
www.pepinpress.com

Design & text by Pepin van Roojen

Reproduction & restoration by
Pepin van Roojen & Jakob Hronek

ISBN 978 90 5768 110 3

10 9 8 7 6 5 4 3 2 1
2012 11 10 09 08

Manufactured in Singapore

日本の紙

西暦5年〜6年ごろに製紙技術が中国から日本に伝わって以来、日本の製紙職人によりさまざまな種類の紙が開発されてきました。日本で紙に使用される主な素材は、各種潅木の樹皮ですが、竹や麻などの繊維が用いられることもあります。他の地域と同様、日本でも産業用紙は木材パルプから製造されます。

紙の種類の多さと同様に、紙に施される装飾にもさまざまな技法が用いられます。これらの装飾は、製紙過程で施されるものと、製紙後に印刷されるものがあります。

本書で紹介される紙は、以下のように分類されています。

12〜54ページ：19世紀半ばごろの江戸時代の紙。
糊状の染料を含んだ紙の層に模様をこすり込んだり、ステンシルまたは木版を用いて模様を紙面に印刷する技法が用いられました。このような紙は、壁面や襖などの間仕切りに多く用いられました。

55〜67ページ：1912年から1926年の大正時代に、木版やステンシルを用いて装飾が施された紙です。間仕切り、本の表紙、包装紙、うちわなどに使用されました。

68〜77ページ：20世紀半ばに作られた、白、金、銀などの色彩の繊細な模様を施した紙を紹介しています。

78〜93ページ：防染技術を用いて作られた紙。

94〜97ページ：竹および木を使ったラミネート紙。

98〜110ページ：織り加工された紙には、織り込まれた繊維が表面化しているものや繊維を表面に付着させたものなどがあります。108〜110ページには、製作過程で装飾素材が織り込まれた紙を紹介しています。

111〜125ページ：さまざまなデザインと色彩の薄葉紙やレース紙を紹介しています。

126〜153ページ：型染紙ステンシルを用いて染色しない部分に防染糊を塗布し、その後着色して作られた紙です。防染糊を洗い流すと、模様が現れます。

154〜168ページ：友禅紙複雑なシルクスクリーン処理により装飾が施された紙です。

CD-ROM及びイメージの著作権について

本書に掲載されているデザインは、グラフィック・デザインの参考にしたり、インスピレーションを得るための材料としてご使用ください。本書に掲載されているすべてのイラストは、附録のCD-ROMに収録されています。印刷媒体やウェブデザイン、絵はがき、レター、チラシ、Tシャツなどの作成に利用できます。ほとんどのソフトウエア・プログラムへ、CD-ROMから直接インポートが可能です。直接イメージにアクセスできない場合には、まずファイルを作成することで、ご使用になりたいイメージを簡単にインポートできます。インポートの方法などの詳細については、ソフトウエアのマニュアルをご参照ください。

CD-ROMの各ファイル名は、本書のページ番号に対応しています。このCD-ROMは本書の附録であり、CD-ROMのみの販売はいたしておりません。Pepin Press/Agile RabbitのCD-ROM収録のファイルは、ほとんどのアプリケーションに対応できるサイズですが、より大きなサイズのファイル、あるいはベクトル化されたファイルをご希望の方は、The Pepin Press/Agile Rabbit Editions宛てにご連絡ください。

イメージを非営利目的で一度のみ使用する場合は無料です。印刷媒体、デジタル媒体を含む、業務や営利目的でのご使用の場合は、事前にThe Pepin Press/Agile Rabbit Editionsから許可を得ることが必要です。著作権料が必要となる場合でも最小限の料金でご提供させていただきます。

使用許可と著作権料については下記にお問い合わせください。
mail@pepinpress.com
ファックス：31 20 4201152

日本纸

自从公元五世纪或六世纪造纸术从中国传入日本以来，日本的造纸匠人演绎出了丰富多彩的纸张类型。在日本纸的制造中，最常用的原料是各种灌木的树皮，不过也会使用竹子、大麻和其他纤维来源。日本机制纸则和其他地方一样，采用木浆为原料。

除了丰富的纸张类型以外，在日本纸中还采用了几种装饰纸张的方法，有些运用于制纸工艺的过程当中，有些则在印刷之后运用。

本书包括以下内容：

CD-ROM及图像的版权

Japanese Papers

After the knowledge of papermaking reached Japan from China in the 5th or 6th century AD, Japanese papermakers developed a remarkable variety of paper types. The most common raw material used in making Japanese papers is the bark of various shrubs, but bamboo, hemp and other sources of fibre are also used. Japanese industrial papers, in common with practice elsewhere, are made of wood pulp.

In addition to the array of paper types, several methods are used to decorate paper, some of which are applied during the papermaking process and others printed afterwards.

In this book we include the following:

Pages 12–54: Papers from the Edo period, probably mid-19th century. In some of these, the designs have been scraped into a thick layer of dye (paste paper); others have been printed with the use of stencils or woodblocks. These papers were mostly used for partitions (walls and doors).

Pages 55–67: Woodblock and stencil-decorated papers, from the Taisho period (1912–1926), used for partitions, book covers, wrapping papers and paper fans.

Pages 68–77: Selection of mid-20th century papers delicately decorated with patterns in white, gold and silver.

Pages 78–93: Various resist dye papers.

Pages 94–97: Bamboo and wood veneer papers.

Pages 98–110: Textured papers in which the fibres are clearly visible, or which have fibres added to the top layer. Those on pages 108–110 include decorative elements laid in during production.

Pages 111–125: Tissue/lace papers in various designs and colours.

Pages 126–153: Katazome papers. To produce these papers, a resist paste is applied by means of a stencil, after which the paper is coloured. The design emerges after the resist substance has been washed off.

Pages 154–168: Yuzen papers. These papers have been decorated using an intricate silkscreen process.

CD-ROM and Images Rights

The images in this book can be used as a graphic resource and for inspiration. All the illustrations are stored on the enclosed CD-ROM and are ready to use for printed media and web page design. The pictures can also be used to produce postcards, either on paper or digitally, or to decorate your letters, flyers, T-shirts, etc. They can be imported directly from the CD into most software programs. Some programs will allow you to access the images directly; in others, you will first have to create a document, and then import the images. Please consult your software manual for instructions.

The names of the files on the CD-ROM correspond with the page numbers in this book. The CD-ROM comes free with this book, but is not for sale separately. The files on Pepin Press/Agile Rabbit CD-ROMs are sufficiently large for most applications. However, larger and/or vectorised files are available for most images and can be ordered from The Pepin Press/Agile Rabbit Editions.

For non-professional applications, single images can be used free of charge. The images cannot be used for any type of commercial or otherwise professional application – including all types of printed or digital publications – without prior permission from The Pepin Press/ Agile Rabbit Editions. Our permissions policy is very reasonable and fees charged, if any, tend to be minimal.

For inquiries about permissions and fees, please contact:
mail@pepinpress.com
Fax +31 20 4201152

Японская бумага

После того, как в V-VI веке нашей эры в Японии стал известен способ производства бумаги, изобретенный в Китае, японские бумажники разработали множество самых разнообразных видов бумаги. Наиболее широко в качестве сырья при изготовлении японской бумаги использовалась кора различных кустарников, но применялись также бамбук, конопля и другие источники волокна. Бумага промышленного производства, в Японии, как практиковалось и в других местах, изготавливалась из древесной целлюлозы.

В дополнение к существующим способам производства бумаги, применялись различные методы украшения, некоторые из них впоследствии использовались и в процессе изготовления бумаги, и при печати.

В данную книгу включены образцы бумаги следующих видов:
Страницы 12-54: Бумага периода Эдо, по-видимому, датирующемуся серединой XIX века. При некоторых методах изготовления бумаги рисунки выскабливались на толстом слое красителя (проклеенная бумага). Применялось и нанесение рисунков с помощью трафаретов или гравировкой (ксилография). Такая бумага использовалась, главным образом, для изготовления перегородок (стен и дверей).

Страницы 55-67: Бумага периода Таишо (1912-1926) с нанесенными с помощью трафаретов рисунками и гравировкой использовалась в качестве оберточной, а также для изготовления перегородок, обложек книг и бумажных вееров.

Страницы 68-77: Коллекция образцов бумаги середины XX века, украшенной рисунками светлого, золотистого и серебристого оттенков.

Страницы 78-93: Различные виды бумаги с резервным крашением.

Страницы 94-97: Бумаги из бамбука и деревянного шпона.

Страницы 98-110: Текстурированная бумага с четко заметными волокнами или с добавлением волокон в верхний слой. Образцы бумаги на страницах 108-110 содержат декоративные элементы, закладываемые в бумагу в процессе производства.

Страницы 111-125: Бумага с тканевым/кружевным узором различного строения и расцветок.

Страницы 126-153: Бумага Катазоме. При производстве такой бумаги с помощью шаблона наносится резист (в виде пасты), после чего бумага окрашивается. Рисунок проявляется после того, как резист смывается.

Страницы 154-168: Бумага Юзен. Эта бумага украшается с использованием процесса шелкографии.

Авторские права на компакт-диск и изображения

Изображения, представленные в этой книге, можно использовать в качестве графического ресурса и как источник вдохновения. Все иллюстрации хранятся на прилагаемом компакт-диске. Их можно распечатывать и применять при разработке веб-страниц. Кроме того, иллюстрации можно использовать при изготовлении открыток, как на бумаге, так и цифровых, а также для украшения писем, рекламных материалов, футболок и т.д. Изображения можно непосредственно импортировать в большинство программ. В одних приложениях можно получить прямой доступ к иллюстрациям, в других придется сначала создать документ, а затем уже импортировать изображения. Конкретные рекомендации см. в руководстве по программному обеспечению.

Имена файлов на компакт-диске соответствуют номерам страниц этой книги. Компакт-диск прилагается к книге бесплатно, но отдельно он не продается. Файлы на компакт-дисках Pepin Press/Agile Rabbit достаточно велики для большинства приложений. Однако для многих изображений в The Pepin Press/Agile Rabbit Editions можно заказать и файлы большего объема или файлы векторизованных изображений.

В применениях непрофессионального характера отдельные изображения можно использовать бесплатно. Изображения нельзя использовать в любых видах коммерческих или других профессиональных применений – включая все виды печатной и цифровой публикации – без предварительного разрешения The Pepin Press/Agile Rabbit Editions. Наша политика выдачи разрешений достаточно обоснованна и расценки оплаты, если таковая вообще потребуется, обычно минимальны.

С запросами по поводу разрешений и оплаты обращайтесь:
mail@pepinpress.com
Факс +31 20 4201152

Papiers japonais

Après avoir appris des Chinois à faire du papier au Ve ou VIe siècle, les papetiers japonais ont développé une incroyable variété de papiers. La matière première la plus courante est l'écorce de divers arbrisseaux, mais on utilise aussi le bambou, le chanvre et d'autres matériaux fibreux. Les papiers japonais industriels ont en commun avec les autres productions d'être composés de pulpe de bois.

Outre la diversité des types de papiers, il existe plusieurs méthodes pour les décorer, au cours du processus de production ou bien par impression ultérieure.

Cet ouvrage comprend les chapitres suivants :

Pages 12–54 : papiers de l'époque d'Edo, sans doute du milieu du XIXe siècle. Les motifs de certains de ces papiers ont été gravés dans une couche épaisse de teinture (pâte à papier), tandis que d'autres ont été imprimés à l'aide de pochoirs ou de blocs de bois. Ils étaient surtout utilisés pour les cloisons (murs et portes).

Pages 55–67 : papiers de l'ère Taisho (1912–1926) décorés à l'aide de blocs de bois ou de pochoirs et utilisés pour les cloisons, pour recouvrir les livres, comme papier d'emballage ou pour des éventails.

Pages 68–77 : sélection de papiers du milieu du XXe siècle délicatement ornés de motifs blancs, dorés et argentés.

Pages 78–93 : papiers teints avec réserve.

Pages 94–97 : feuilles de placage de bambou et de bois.

Pages 98–110 : papiers texturés dont les fibres sont clairement visibles ou auxquels des fibres ont été ajoutées dans la couche supérieure. Les exemples des pages 108–110 comprennent également des éléments décoratifs insérés au cours de la production.

Pages 111–125 : papiers de soie/ papier dentelle à couleurs et motifs différents.

Pages 126–153 : katazome. Ces papiers sont réalisés en appliquant une pâte de réserve à l'aide d'un pochoir avant de teindre le papier. Le motif apparaît après retrait de la pâte.

Pages 154–168 : yuzen. Ces motifs sont obtenus par sérigraphie à l'aide d'une trame de soie très fine.

CD-ROM et droits d'auteur

Les images contenues dans ce livre peuvent servir de ressources graphiques ou de source d'inspiration. Toutes les illustrations sont stockées sur le CD-ROM ci-joint et sont prêtes à l'emploi sur tout support imprimé ou pour la conception de site Web. Elles peuvent également être employées pour créer des cartes postales, en format papier ou numérique, ou pour décorer vos lettres, prospectus, T-shirts, etc. Ces images peuvent être importées directement du CD dans la plupart des logiciels. Certaines applications vous permettent d'accéder directement aux images, tandis que d'autres requièrent la création préalable d'un document pour pouvoir les importer. Veuillez vous référer au manuel de votre logiciel pour savoir comment procéder.

Les noms des fichiers du CD-ROM correspondent aux numéros de page de cet ouvrage. Le CD-ROM est fourni gratuitement avec ce livre, mais ne peut être vendu séparément. Les fichiers des CD-ROM de The Pepin Press/Agile Rabbit sont d'une taille suffisamment grande pour la plupart des applications. Cependant, des fichiers plus grands et/ou vectorisés sont disponibles pour la plupart des images et peuvent être commandés auprès des éditions The Pepin Press/Agile Rabbit.

Des images seules peuvent être utilisées gratuitement à des fins non professionnelles. Les images ne peuvent pas être employées à des fins commerciales ou professionnelles (y compris pour tout type de publication sur support numérique ou imprimé) sans l'autorisation préalable expresse des éditions The Pepin Press/Agile Rabbit. Notre politique d'autorisation d'auteur est très raisonnable et le montant des droits, le cas échéant, est généralement minime.

Pour en savoir plus sur les autorisations et les droits d'auteur, veuillez contacter :
mail@pepinpress.com
Fax +31 20 4201152

Carta Giapponese

L'arte della fabbricazione della carta fu introdotta in Giappone dalla Cina verso il quinto o sesto secolo d.C. I giapponesi elaborarono una notevole varietà di tipi di carta, utilizzando principalmente la corteccia di diversi arbusti, ma anche il bambù, la canapa e le fibre di altri materiali. In Giappone, così come nel resto del mondo, la carta industriale deriva dalla pasta di legno.

Oltre alla vasta gamma di tipi di carta, esistono numerosi metodi per decorarla, alcuni dei quali sono applicati durante il processo di fabbricazione, mentre altri prevedono la stampa del prodotto finito.

Il presente volume include:

Pagine 12-54: esemplari dell'epoca Edo, probabilmente della metà del XIX secolo. In alcuni casi i disegni sono incisi su uno spesso strato di materia colorante (carta a colla), in altri sono eseguiti con mascherine o con matrici di legno. Questi fogli di carta erano utilizzati soprattutto come elementi divisori (porte e pareti).

Pagine 55-67: esemplari decorati con matrici di legno o mascherine, dell'epoca Taisho (1912-1926), utilizzati per elementi divisori, copertine di libri, imballaggio e ventagli.

Pagine 68-77: selezione di esemplari della metà del XX secolo delicatamente decorati con motivi in bianco, oro e argento.

Pagine 78-93: diversi esemplari decorati con tecniche di tintura a riserva.

Pagine 94-97: carta di bambù o di legno.

Pagine 98-110: esemplari in cui le fibre sono nettamente visibili o sono aggiunte sullo strato superficiale. I modelli delle pagine 108-110 presentano elementi decorativi eseguiti durante la fabbricazione.

Pagine 111-125: esemplari in tessuto/pizzo in diversi colori e disegni.

Pagine 126-153: Katazome, realizzati applicando, mediante una mascherina, una pasta resistente al colore che viene eliminata dopo la colorazione della carta generando così il disegno.

Pagine 154-168: Yuzen, decorati utilizzando un complicato processo di serigrafia.

CD ROM e diritti d'immagine

Le immagini contenute in questo libro possono essere utilizzate come risorsa grafica e come ispirazione. Tutte le illustrazioni sono salvate sul CD ROM incluso e sono pronte ad essere utilizzate per la stampa su qualsiasi tipo di supporto e per il design di pagine web. Le immagini possono anche essere utilizzate per produrre delle cartoline, in forma stampata o digitale, o per decorare le vostre lettere, volantini, magliette, eccetera. Possono essere direttamente importate dal CD nella maggior parte dei programmi software. Alcuni programmi vi permetteranno l'accesso diretto alle immagini; in altri, dovrete prima creare un documento, e poi importare le immagini. Vi preghiamo di consultare il manuale del vostro software per ulteriori istruzioni.

I nomi dei file sul CD ROM corrispondono ai numeri di pagina indicati nel libro. Il CD ROM viene fornito gratis con il libro, ma non è in vendita separatamente. I file sui CD ROM della Pepin Press/Agile Rabbit sono di dimensione adatta per la maggior parte delle applicazioni. In ogni caso, per la maggior parte delle immagini sono disponibili file più grandi o vettoriali, che possono essere ordinati alla Pepin Press/Agile Rabbit Editions.

Delle singole immagini possono essere utilizzate senza costi aggiuntivi a fini non professionali. Le immagini non possono essere utilizzate per nessun tipo di applicazione commerciale o professionale – compresi tutti i tipi di pubblicazioni stampate e digitali – senza la previa autorizzazione della Pepin Press/Agile Rabbit Editions. La nostra gestione delle autorizzazioni è estremamente ragionevole e le tariffe addizionali applicate, qualora ricorrano, sono minime.

Per ulteriori domande riguardo le autorizzazioni e le tariffe, vi preghiamo di contattarci ai seguenti recapiti:
mail@pepinpress.com
Fax +31 20 4201152

Japanische Papiere

Nachdem das Wissen von der Papierherstellung im fünften oder sechsten Jahrhundert nach Christus von China nach Japan gelangt war, entwickelten die japanischen Papierschöpfer eine bemerkenswerte Vielfalt von eigenen Papiersorten. Dabei fand als Rohmaterial vor allem die Rinde diverser Sträucher Verwendung, aber auch Bambus, Hanf und andere Fasersorten kamen zum Einsatz. Dagegen bestehen japanische Industriepapiere – wie andernorts auch – aus Holzzellstoff.
Neben der großen Auswahl an Papiersorten findet man in Japan auch viele unterschiedliche Methoden zur Dekoration von Papier, die teilweise während der Papierherstellung angewandt oder im Anschluss aufgedruckt werden.

Dieses Buch enthält die folgenden Beispiele:
Seite 12–54: Papiere aus der Edo-Zeit (vermutlich Mitte des 19. Jahrhunderts). Bei manchen Papieren wurde das Design in eine dicke Farbschicht gekratzt, andere wurden mit Hilfe von Schablonen oder der Holzschnitttechnik bedruckt. Diese Papiere dienten hauptsächlich als Raumteiler (für Wände und Türen).

Seite 55–67: Mit Hilfe von Schablonen oder der Holzschnitttechnik dekorierte Papiere aus der Taisho-Zeit (1912–1926), die als Raumteiler, Buchumschläge, Geschenkpapier und Papierfächer Verwendung fanden.

Seite 68–77: Verschiedene Papiere aus der Mitte des 20. Jahrhunderts, dekoriert mit feinen Mustern in Weiß, Gold und Silber.

Seite 78–93: Diverse Papiere, die mit Hilfe eines Reservierungsmittels dekoriert wurden.

Seite 94–97: Bambus- und Holzfurnierpapiere.

Seite 98–110: Strukturpapiere mit deutlich sichtbaren Fasern oder zusätzlichen Fasern, die im Nachhinein auf die Oberfläche aufgebracht wurden. Die dekorativen Elemente der Papiere auf den Seiten 108–110 wurden im Verlauf der Herstellung eingearbeitet.

Seite 111–125: Seiden-/Spitzenpapiere in unterschiedlichen Designs und Farben.

Seite 126–153: Katazome-Papiere. Für die Herstellung dieser Papiere wird eine farbundurchlässige Paste mit Hilfe einer Schablone aufgebracht und das Papier danach eingefärbt. Nach dem Auswaschen der Paste kommt das Design zum Vorschein.

Seite 154–168: Yuzen-Papiere. Diese Papiere wurden mit Hilfe eines komplexen Siebdruckverfahrens dekoriert.

CD-ROM und Bildrechte

Dieses Buch enthält Bilder, die als Ausgangsmaterial für grafische Zwecke oder als Anregung genutzt werden können. Alle Abbildungen sind auf der beiliegenden CD-ROM gespeichert und lassen sich direkt zum Drucken oder zur Gestaltung von Webseiten einsetzen. Sie können die Designs aber auch als Motive für Postkarten (auf Karton bzw. in digitaler Form) oder als Ornament für Ihre Briefe, Broschüren, T-Shirts usw. verwenden. Die Bilder lassen sich direkt von der CD in die meisten Softwareprogramme laden. Bei einigen Programmen lassen sich die Grafiken direkt einladen, bei anderen müssen Sie zuerst ein Dokument anlegen und können dann die jeweilige Abbildung importieren. Genauere Hinweise dazu finden Sie im Handbuch Ihrer Software.

Die Namen der Bilddateien auf der CD-ROM entsprechen den Seitenzahlen dieses Buchs. Die CD-ROM wird kostenlos mit dem Buch geliefert und ist nicht separat verkäuflich. Alle Bilddateien auf den CD-ROMs von The Pepin Press/Agile Rabbit wurden so groß dimensioniert, dass sie für die meisten Applikationen ausreichen; zusätzlich können jedoch größere Dateien und/oder Vektorgrafiken der meisten Bilder bei The Pepin Press/Agile Rabbit Editions bestellt werden.

Einzelbilder dürfen für nicht-professionelle Anwendungen kostenlos genutzt werden; dagegen muss für die Nutzung der Bilder in kommerziellen oder sonstigen professionellen Anwendungen (einschließlich aller Arten von gedruckten oder digitalen Medien) unbedingt die vorherige Genehmigung von The Pepin Press/Agile Rabbit Editions eingeholt werden. Allerdings handhaben wir die Erteilung solcher Genehmigungen meistens recht großzügig und erheben – wenn überhaupt – nur geringe Gebühren.

Für Fragen zu Genehmigungen und Preisen wenden Sie sich bitte an:
mail@pepinpress.com
Fax +31 20 4201152

Papéis do Japão

Depois de o Japão ter aprendido a fazer papel com a China, no séc. V ou VI d.C., os fabricantes nipónicos de papel desenvolveram uma notável diversidade de tipos de papel. No Japão, a matéria-prima mais comummente utilizada para o papel é a casca de diversos arbustos, embora também se recorra ao bambu, ao cânhamo e a outras fontes de fibra. Os papéis industriais nipónicos, tal como sucede noutros sítios, são feitos à base de polpa de madeira.

Para além da panóplia de tipos de papel, aplicam-se diversos métodos de decoração do papel, alguns dos quais durante o próprio processo de fabrico e outros impressos a posteriori.

Neste livro incluem-se:

Páginas 12-54: Papéis do período Edo nipónico, provavelmente de meados do séc. XIX. Em alguns destes papéis, os desenhos foram traçados numa espessa camada de tinta (pasta de papel); outros foram impressos com estênceis ou blocos de madeira. Os papéis aqui apresentados eram utilizados, sobretudo, para divisórias (paredes e portas).

Páginas 55-67: Papéis decorados, com blocos de madeira e estêncil, do período Taisho (1912-1926), utilizados em divisórias, capas de livros, embrulhos e leques.

Páginas 68-77: Selecção de papéis de meados do séc. XX delicadamente decorados com desenhos a prateado, branco e dourado.

Páginas 78-93: Vários papéis com a técnica resist-dye (papel pintado após a criação nele, de diversas formas, de áreas resistentes à tinta).

Páginas 94-97: Papéis em bambu e folheado de madeira.

Páginas 98-110: Papéis com texturas, onde as fibras estão claramente visíveis, ou em cuja última camada foram acrescentadas fibras. Os papéis nas páginas 108-110 incluem elementos decorativos inseridos durante o fabrico.

Páginas 111-125: Papéis de seda/passamanaria, com diversos desenhos e cores.

Páginas 126-153: Papéis Katazome. Para o fabrico destes papéis, aplica-se uma pasta resistente à tinta, com um estêncil, e só depois o papel é pintado. O desenho surge depois de removida, com água, a referida pasta.

Páginas 154-168: Papéis Yuzen. Estes papéis foram decorados com um intrincado processo serigráfico.

CD-ROM e direitos de imagem

As imagens neste livro podem ser usadas como recurso gráfico e fonte de inspiração. Todas as ilustrações estão guardadas no CD-ROM incluído e prontas a serem usadas em suportes de impressão e design de páginas web. As imagens também podem ser usadas para produzir postais, tanto em papel como digitalmente, ou para decorar cartas, brochuras, T-shirts e outros artigos. Podem ser importadas directamente do CD para a maioria dos programas de software. Alguns programas permitem aceder às imagens directamente, enquanto que noutros, terá de primeiro criar um documento para poder importar as imagens. Consulte o manual do software para obter instruções.

Os nomes dos ficheiros no CD-ROM correspondem aos números de páginas no livro. O CD-ROM é oferecido gratuitamente com o livro, mas não pode ser vendido separadamente. A dimensão dos ficheiros nos CD-ROMs da Pepin Press/Agile Rabbit é suficiente para a maioria das aplicações. Contudo, os ficheiros maiores e/ou vectorizados estão disponíveis para a maioria das imagens e podem ser encomendados junto da Pepin Press/Agile Rabbit Editions.

Podem ser usadas imagens individuais gratuitamente no caso de utilizações não profissionais. As imagens não podem ser usadas para qualquer tipo de utilização comercial ou profissional, incluindo todos os tipos de publicações digitais ou impressas, sem autorização prévia da Pepin Press/Agile Rabbit Editions. A nossa política de autorizações é muito razoável e as tarifas cobradas, caso isso se aplique, tendem a ser bastante reduzidas.

Para esclarecimentos sobre autorizações e tarifas, queira contactar:
mail@pepinpress.com
Fax +31 20 4201152

Papeles japoneses

Cuando el conocimiento de la fabricación de papel llegó a Japón procedente de China en el siglo V o VI d.C., los papeleros nipones desarrollaron una extraordinaria variedad de tipos de papel. La materia prima más habitual para elaborar papeles japoneses es la corteza de varios arbustos, aunque también se utiliza bambú, cáñamo y otras plantas fibrosas. Los papeles industriales japoneses, como los del resto del mundo, se elaboran con pulpa de madera. Además de la gran variedad de tipos de papel, existen distintos métodos para decorarlo, algunos de los cuales se aplican durante el proceso de elaboración y otros, con posterioridad.

Este libro incluye lo siguiente:
Páginas 12-54: papeles del periodo Edo, probablemente mediados del siglo XIX. En algunos casos, los diseños se han escariado sobre una capa gruesa de tintura (papel estampado), mientras que en otros se han aplicado con plantillas o bloques de madera. Este tipo de papeles se utilizaba sobre todo a modo de división (paredes y puertas).

Páginas 55-67: papeles decorados con plantillas y bloques de madera del periodo Taisho (1912-1926), utilizado como mamparas, cubiertas de libros, envoltorios y abanicos.

Páginas 68-77: selección de papeles de mediados del siglo XX primorosamente decorados con motivos blancos, dorados y plateados.

Páginas 78-93: varios tipos de papel teñidos por reserva.

Páginas 94-97: papeles de bambú y taraceados de madera.

Páginas 98-110: papeles con textura en los que se aprecian claramente las fibras o las cuales se han añadido sobre la superficie. Los de las páginas 108-110 incluyen elementos ornamentales aplicados durante la producción.

Páginas 111-125: papeles de seda/puntilla de varios diseños y colores.

Páginas 126-153: papeles Katazome. Para obtener este tipo de papel, se tiñe por reserva mediante una plantilla y, después, se colorea. El motivo se aprecia después de lavar la sustancia protectora.

Páginas 154-168: papeles Yuzen. Este tipo de papel se decora mediante complejos procesos serigráficos.

CD-ROM y derechos sobre las imágenes

Este libro contiene imágenes que pueden servir como material gráfico o simplemente como inspiración. Todas las ilustraciones están incluidas en el CD-ROM adjunto y pueden utilizarse en medios impresos y diseño de páginas web. Las imágenes también pueden emplearse para crear postales, ya sea en papel o digitales, o para decorar sus cartas, folletos, camisetas, etc. Pueden importarse directamente desde el CD a diferentes tipos de programas. Algunas aplicaciones informáticas le permitirán acceder a las imágenes directamente, mientras que otras le obligarán a crear primero un documento y luego importarlas. Consulte el manual de software pertinente para obtener instrucciones al respecto.

Los nombres de los archivos contenidos en el CD-ROM se corresponden con los números de página del libro. El CD-ROM se suministra de forma gratuita con el libro. Queda prohibida su venta por separado. Los archivos incluidos en los discos CD-ROM de Pepin Press/Agile Rabbit tienen una resolución suficiente para su uso con la mayoría de aplicaciones. Sin embargo, si lo precisa, puede encargar archivos con mayor definición y/o vectorizados de la mayoría de las imágenes a The Pepin Press/Agile Rabbit Editions.

Para aplicaciones no profesionales, pueden emplearse imágenes sueltas sin coste alguno. Estas imágenes no pueden utilizarse para fines comerciales o profesionales (incluido cualquier tipo de publicación impresa o digital) sin la autorización previa de The Pepin Press/Agile Rabbit Editions. Nuestra política de permisos es razonable y las tarifas impuestas tienden a ser mínimas.

Para solicitar información sobre autorizaciones y tarifas, póngase en contacto con:
mail@pepinpress.com
Fax +31 20 4201152

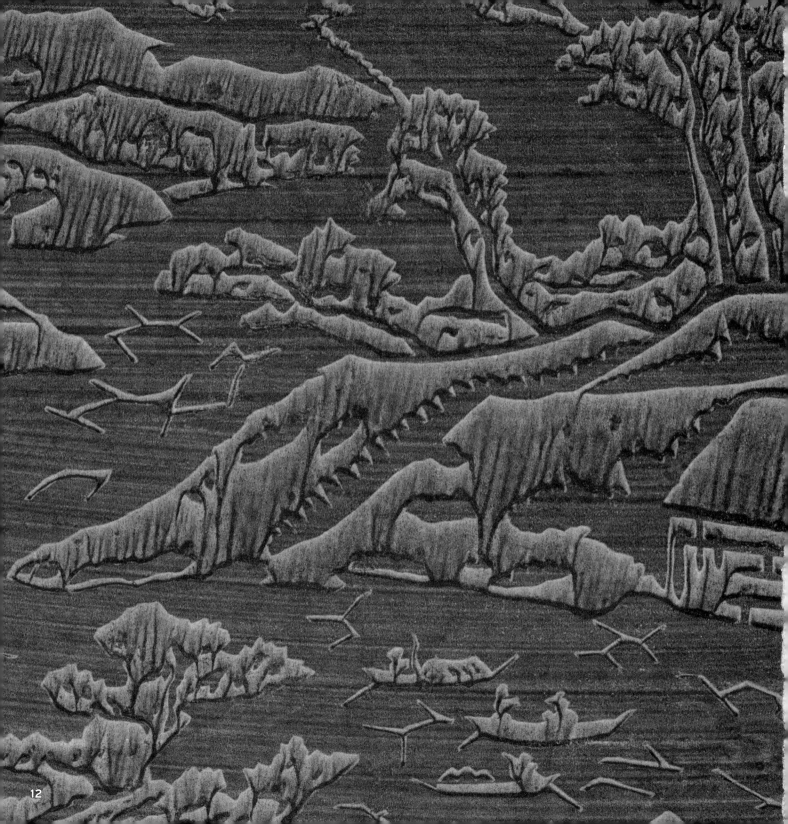

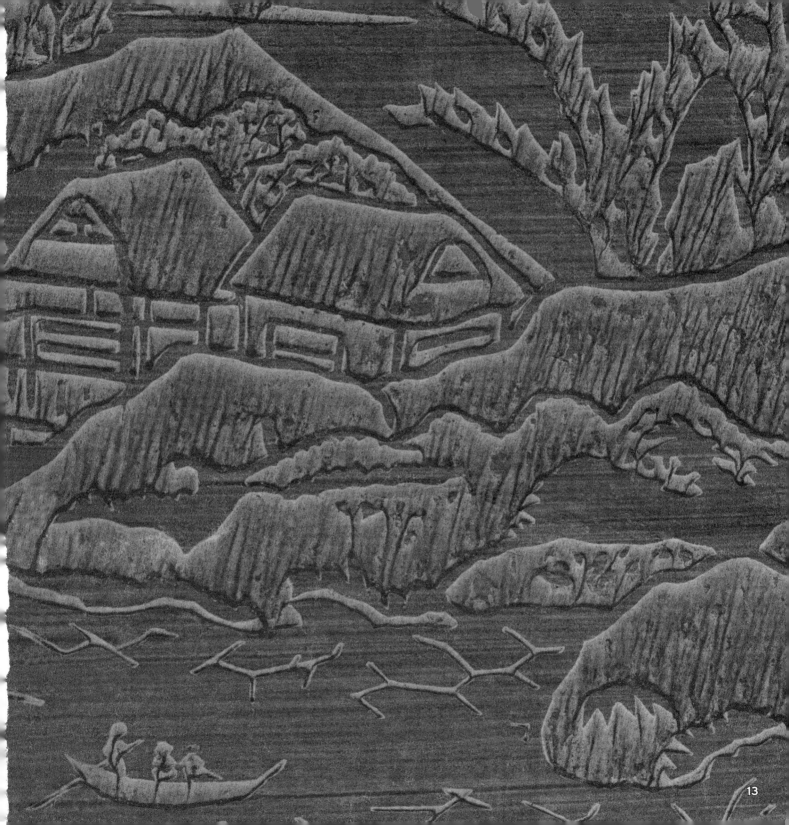

13

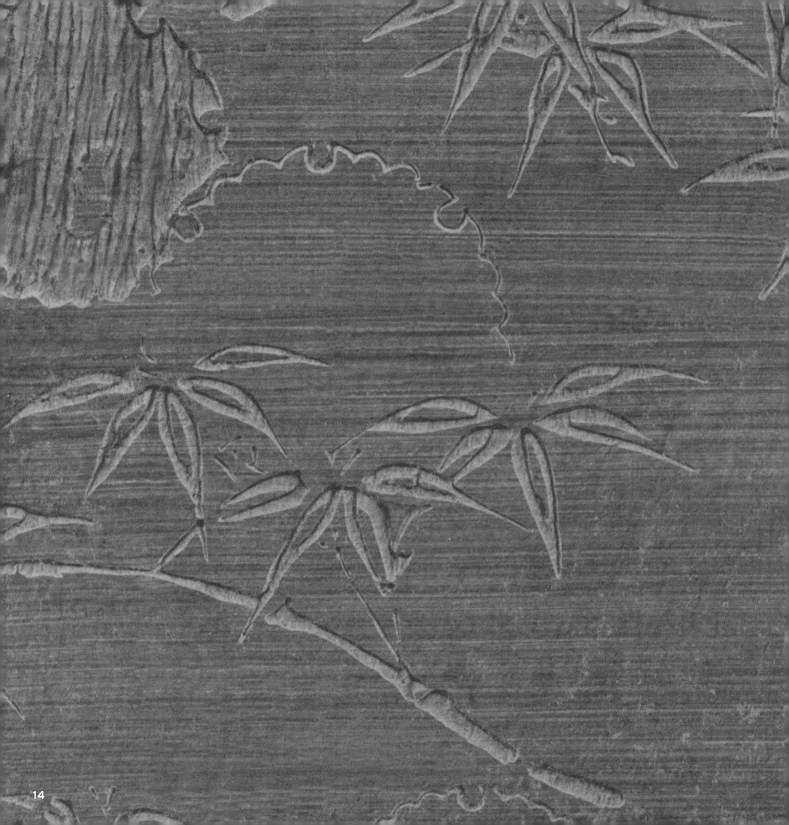

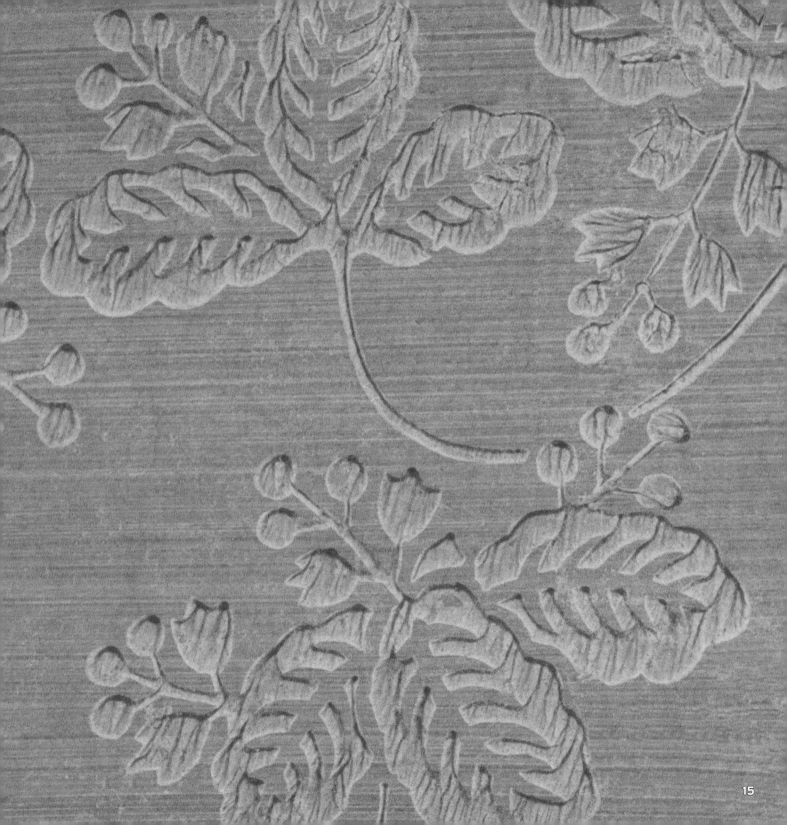

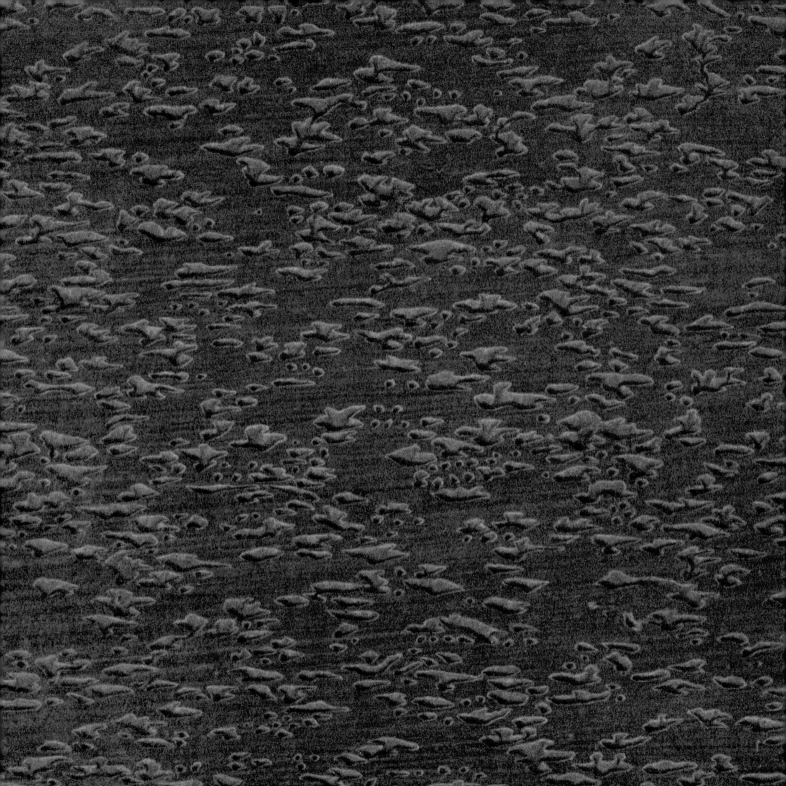

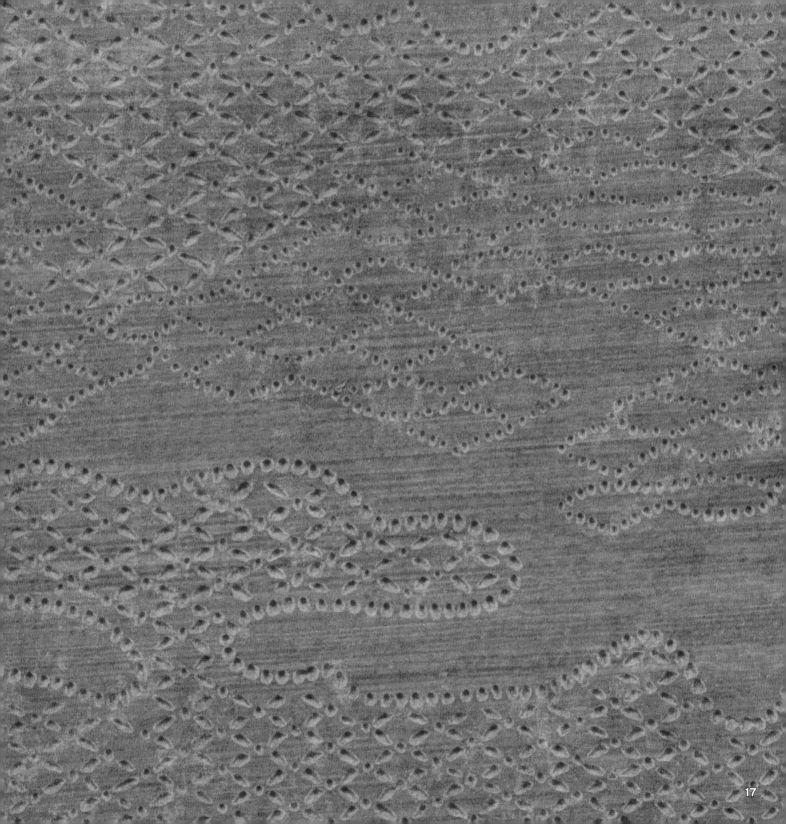

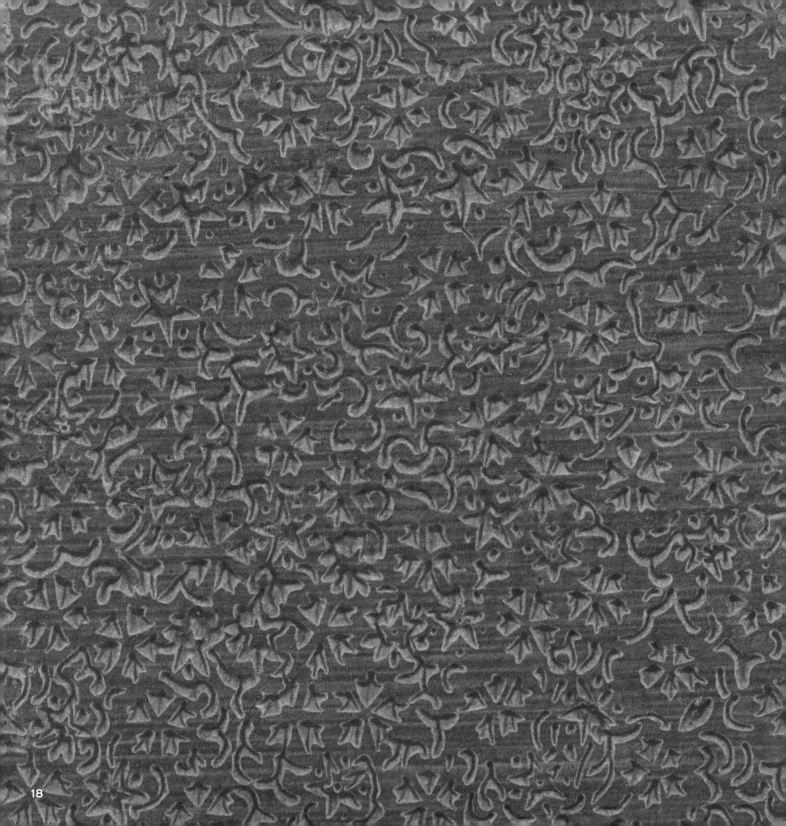

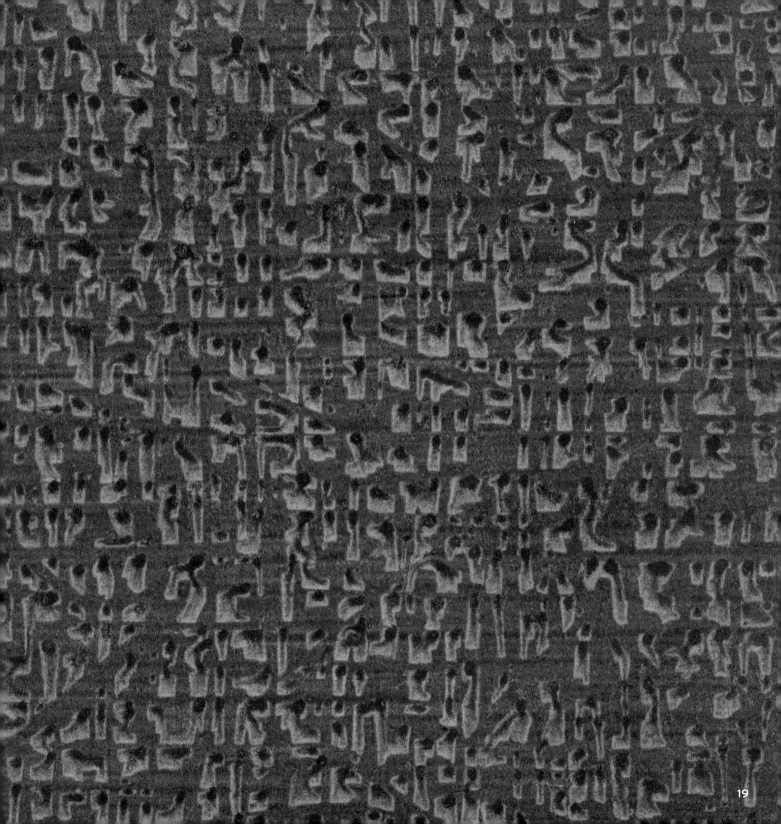

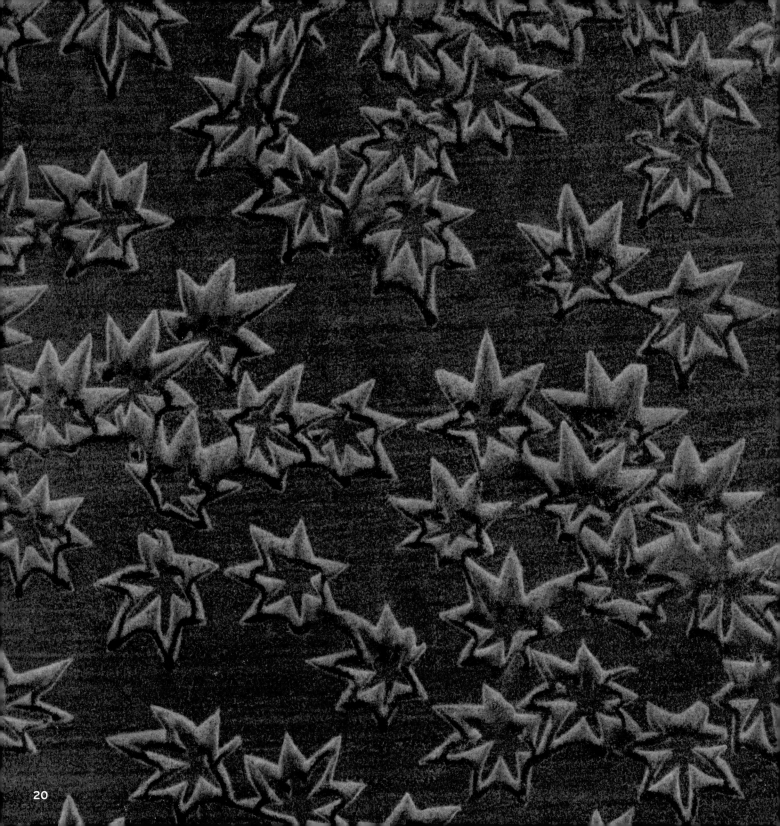

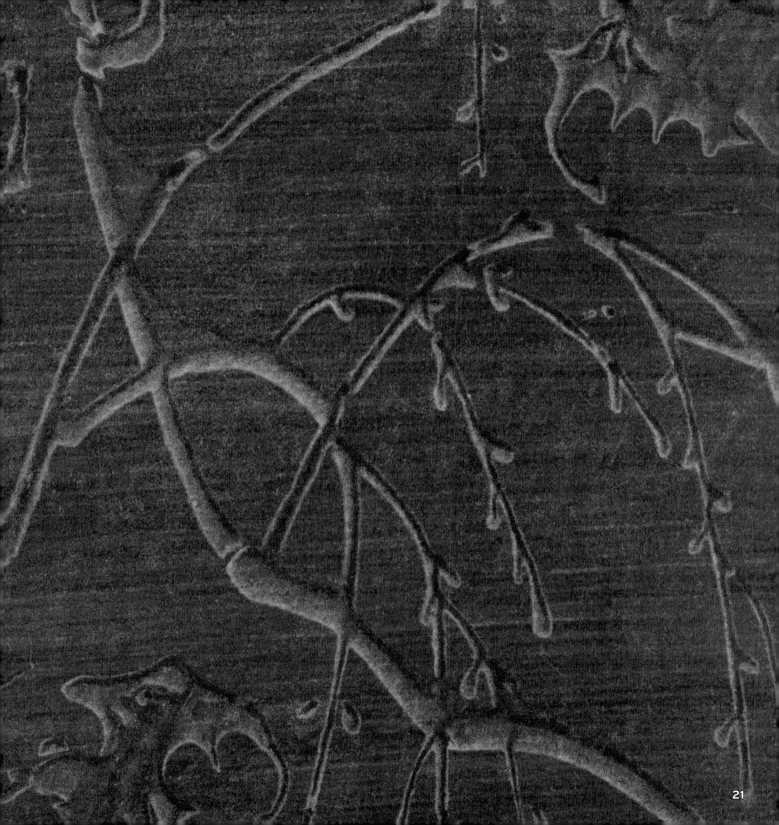

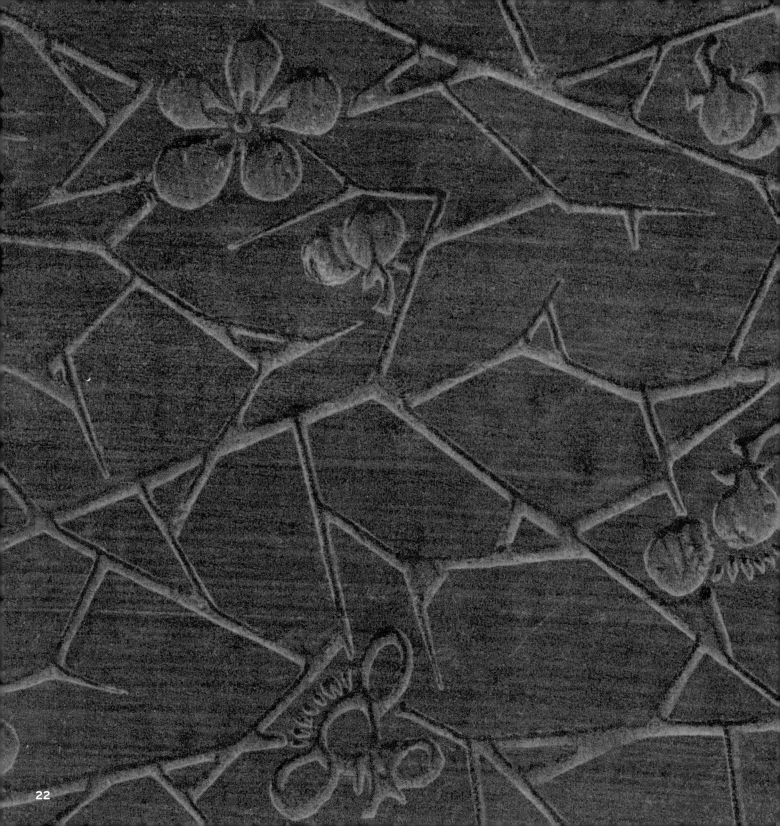

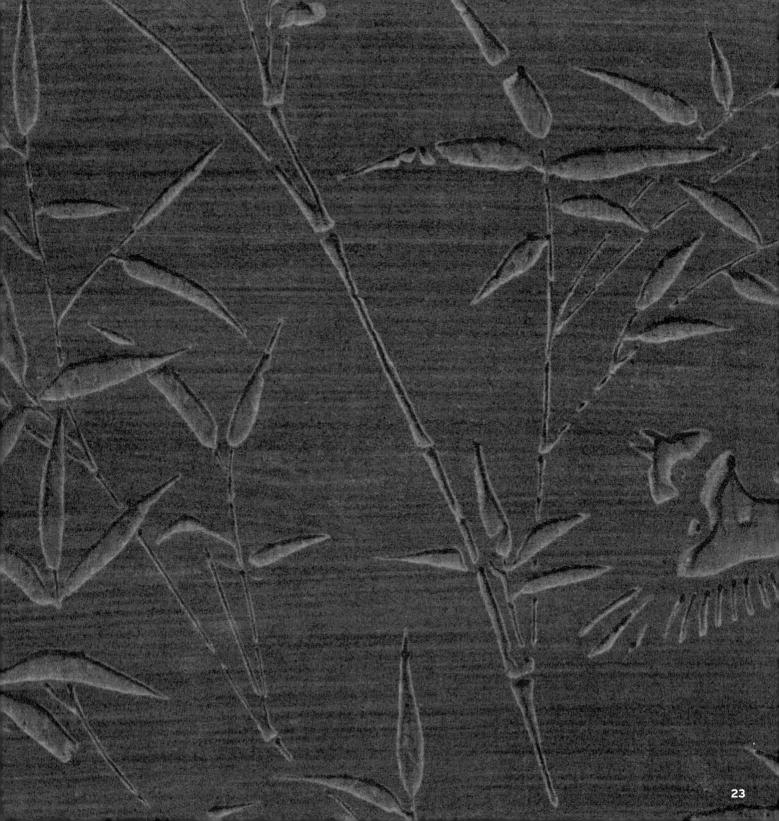

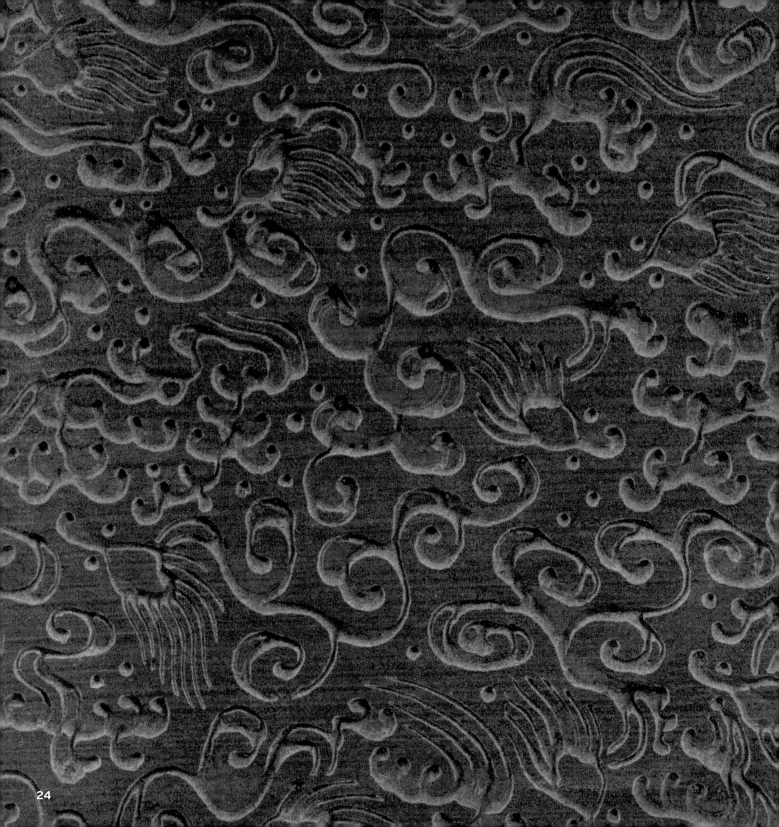

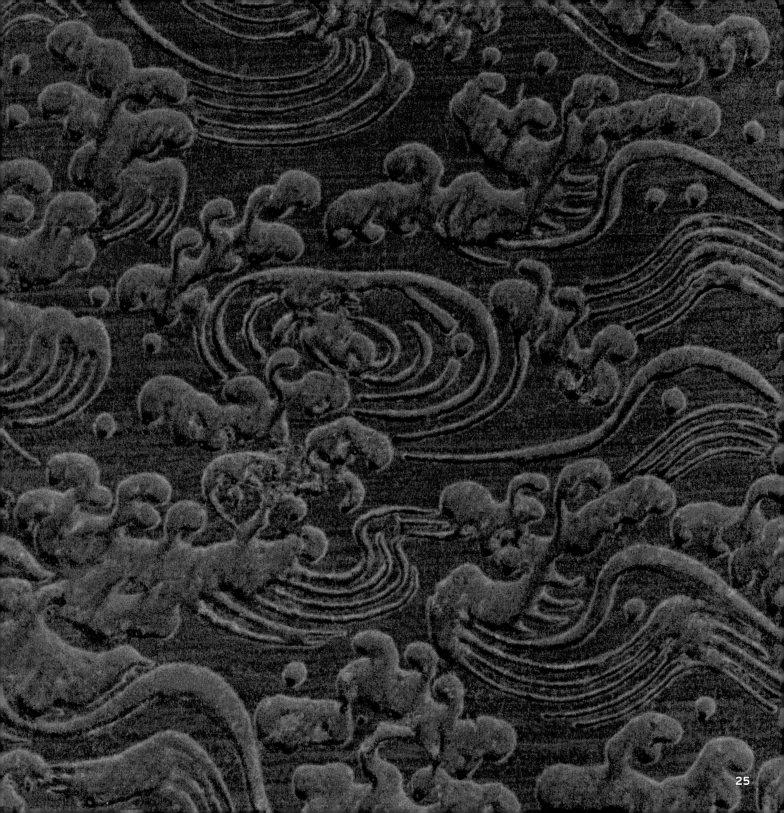

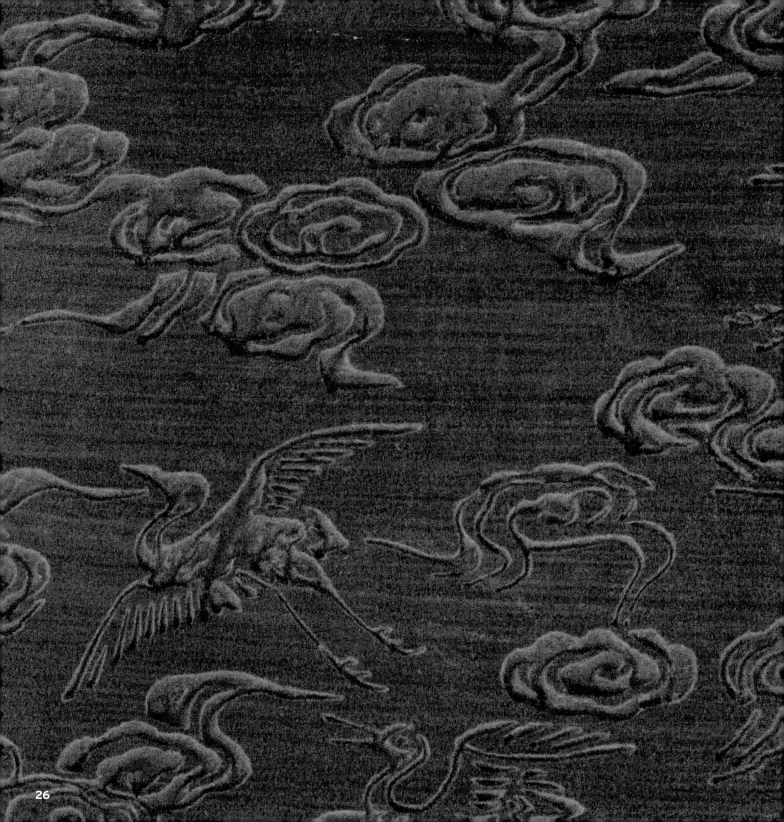

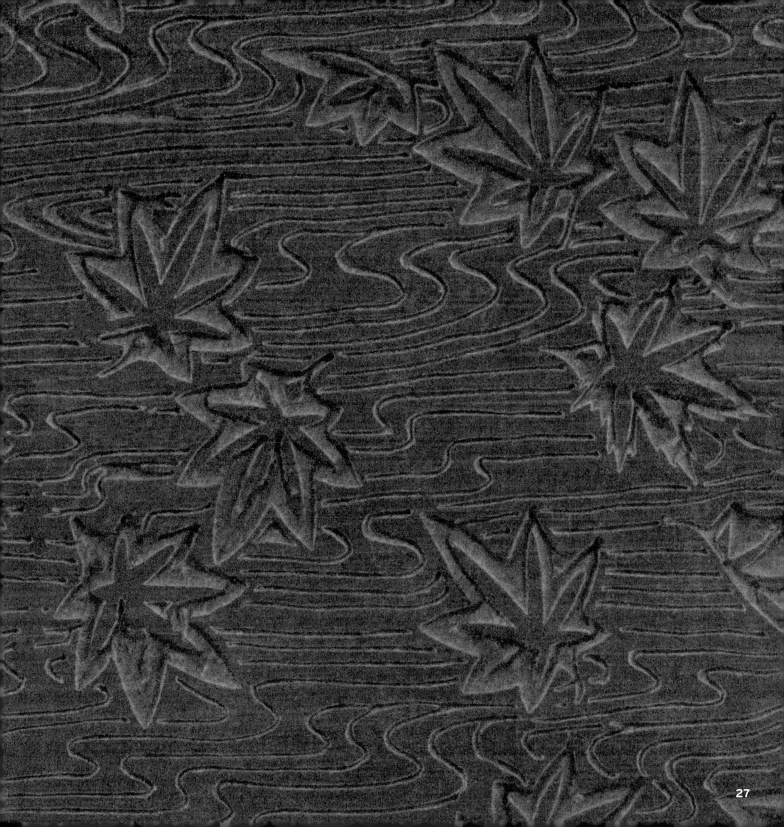

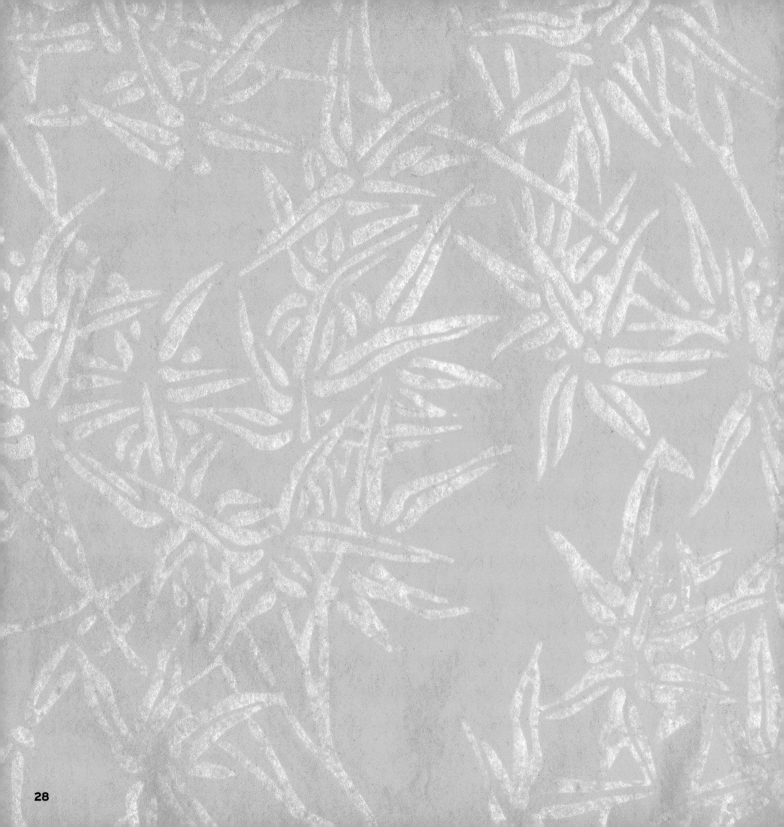

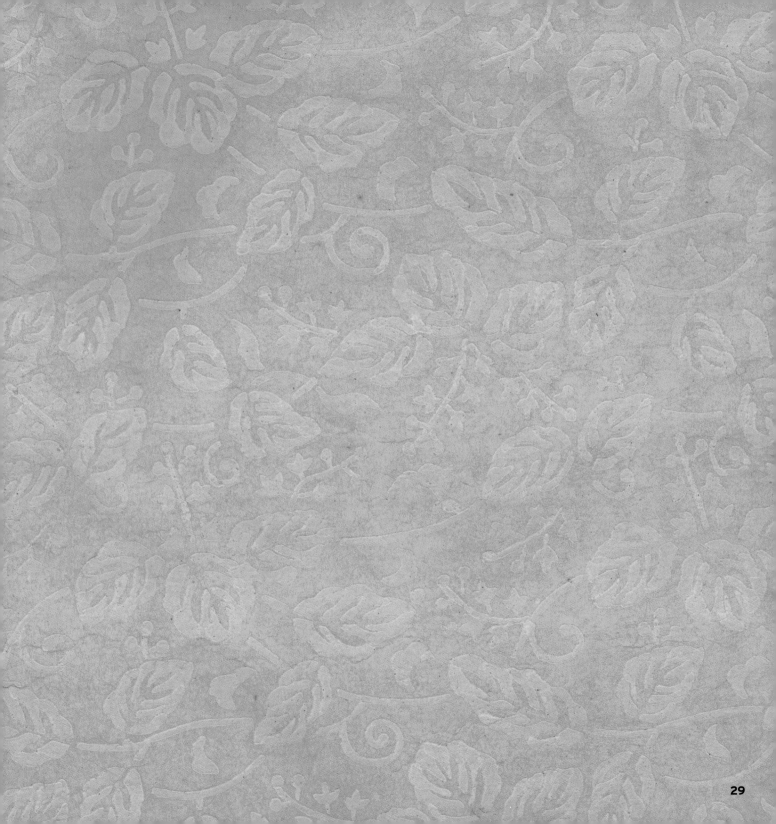

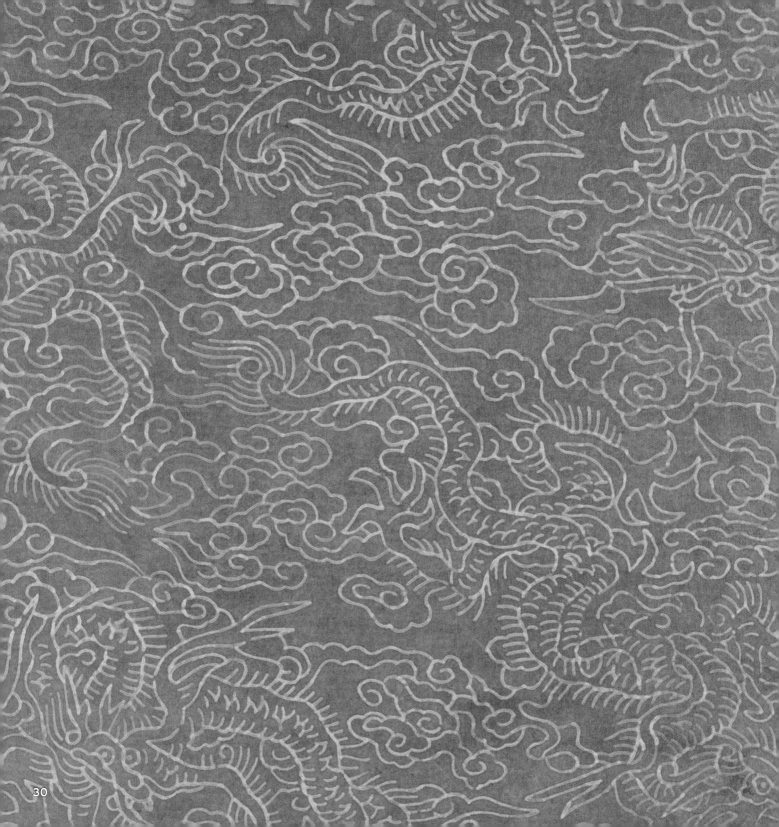

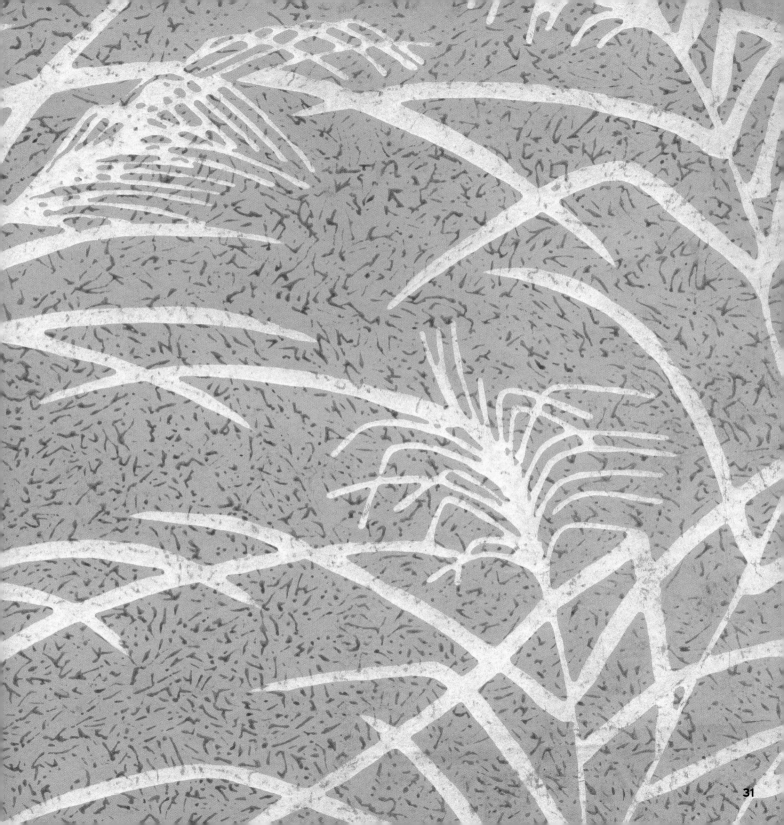

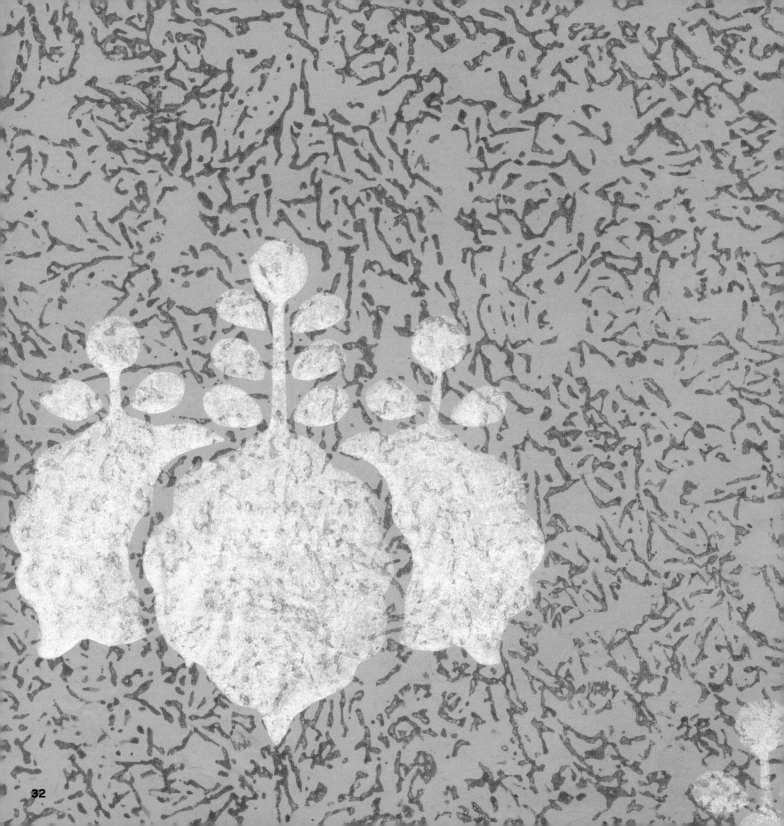

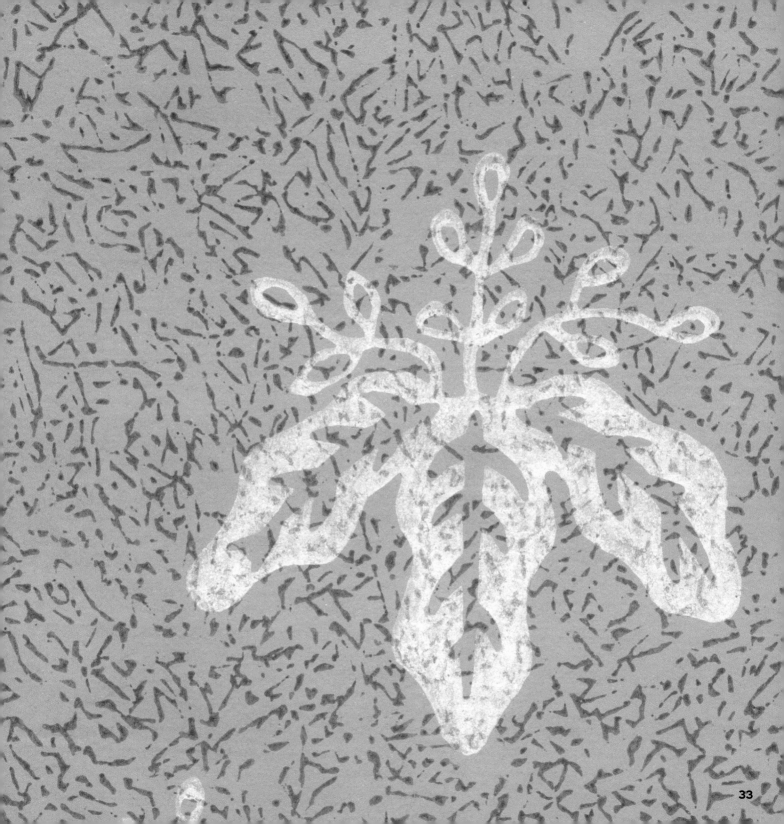

33

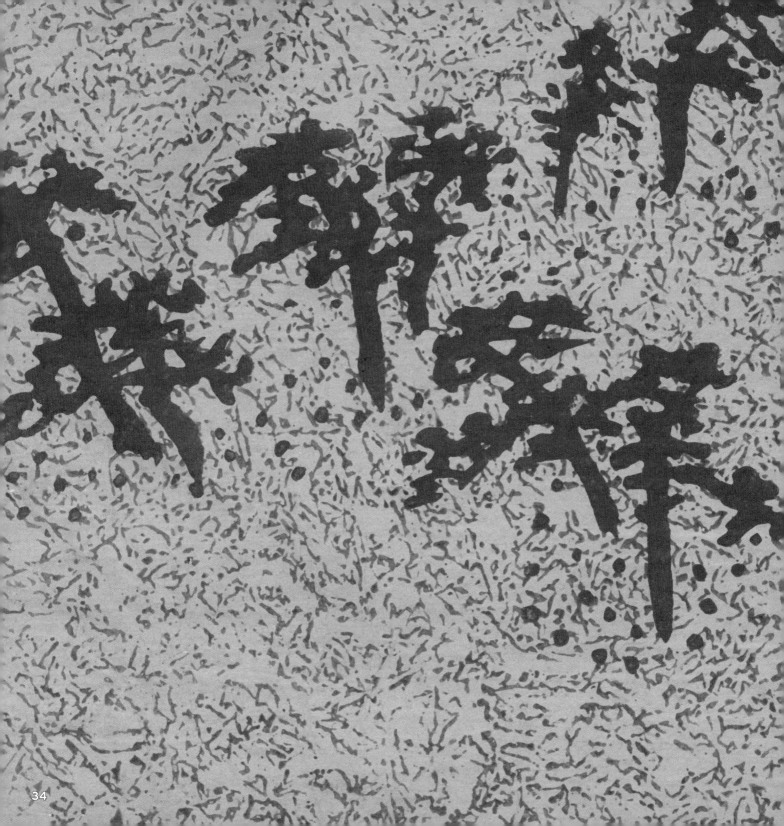

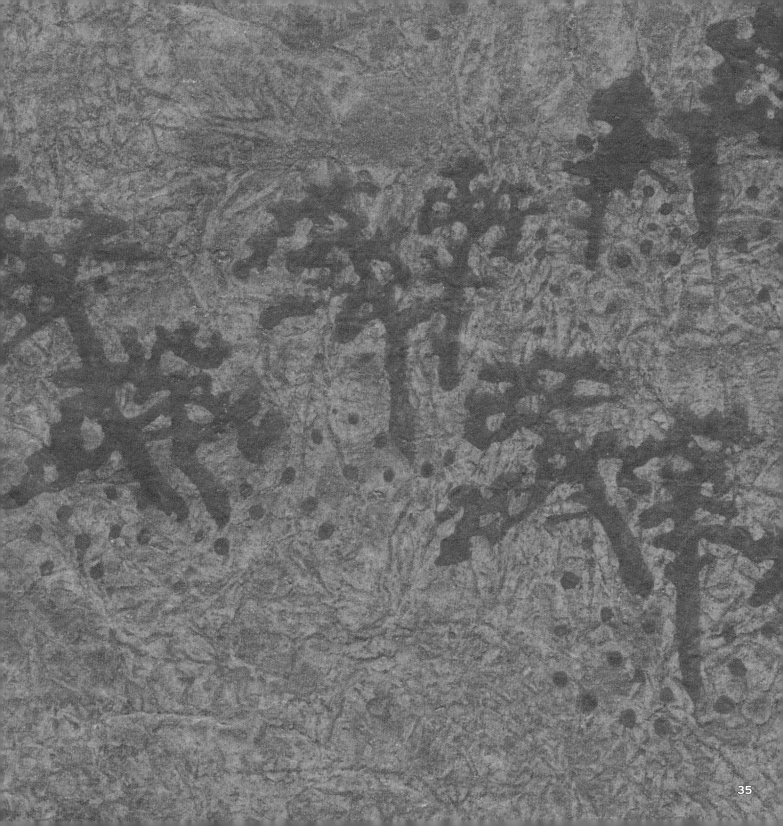

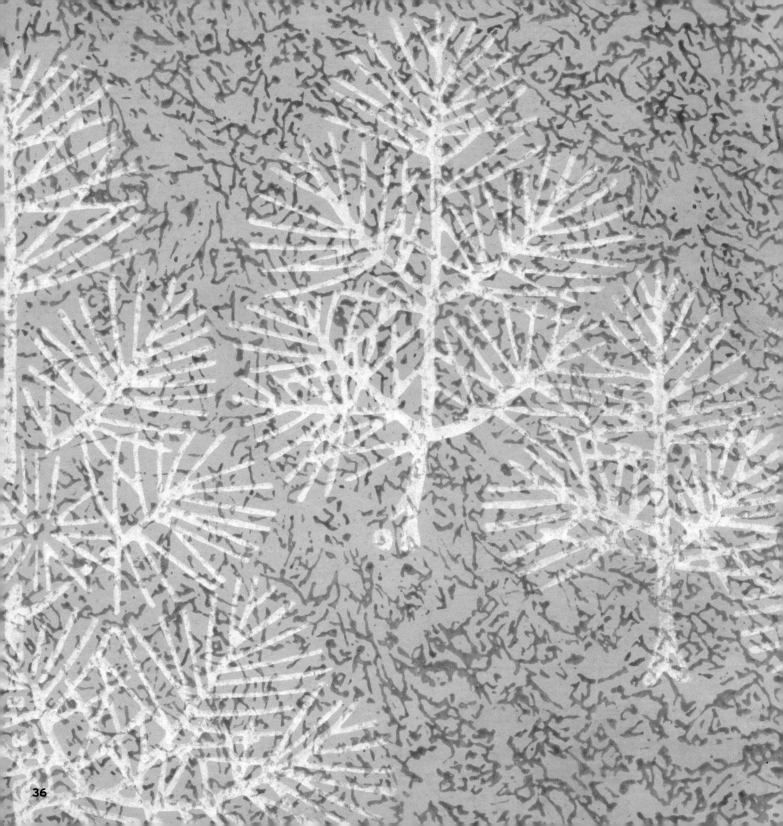

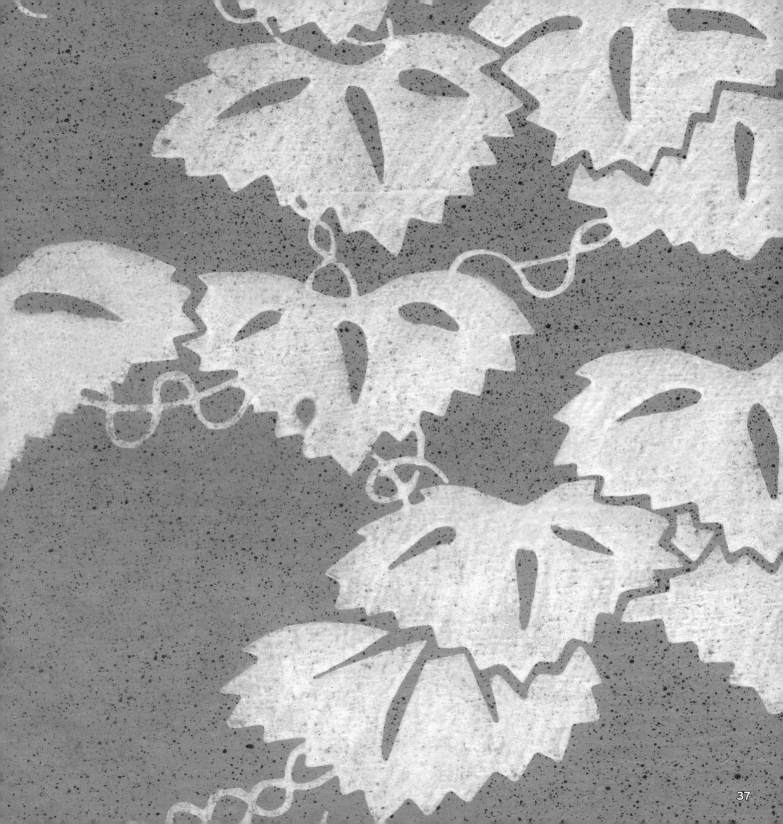

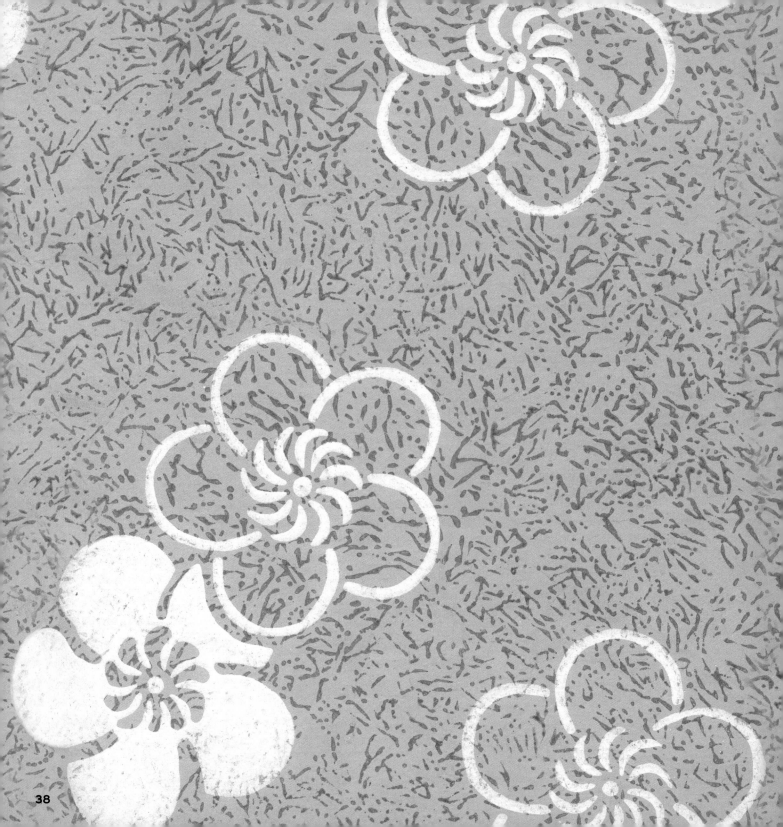

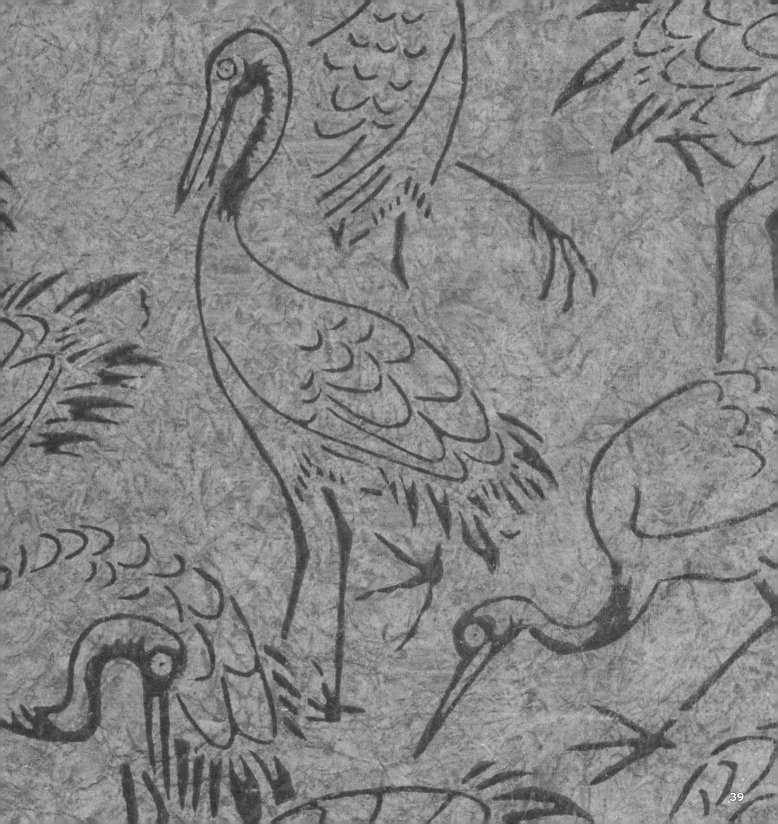

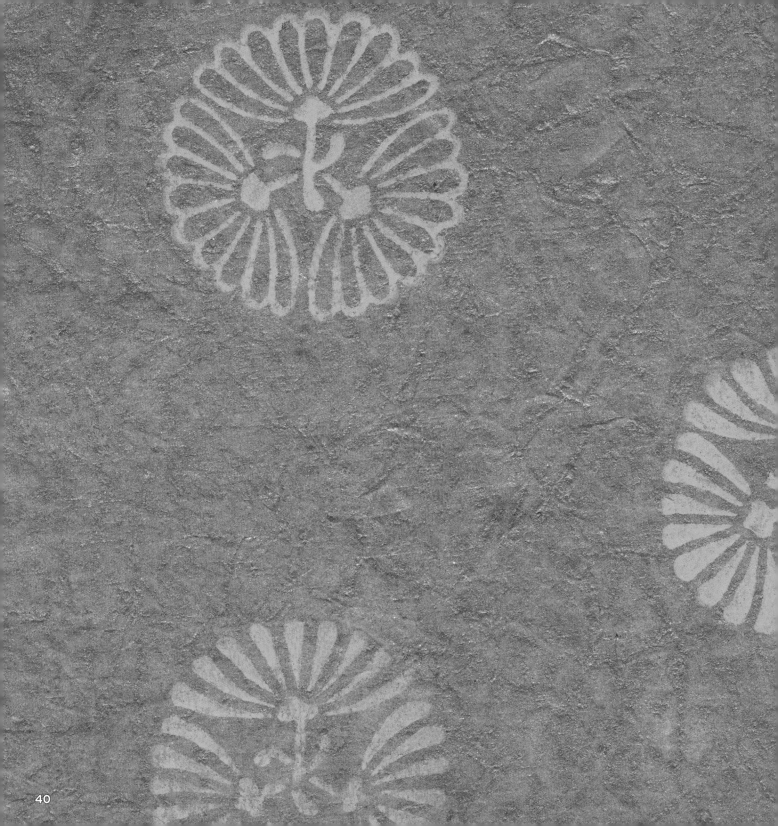

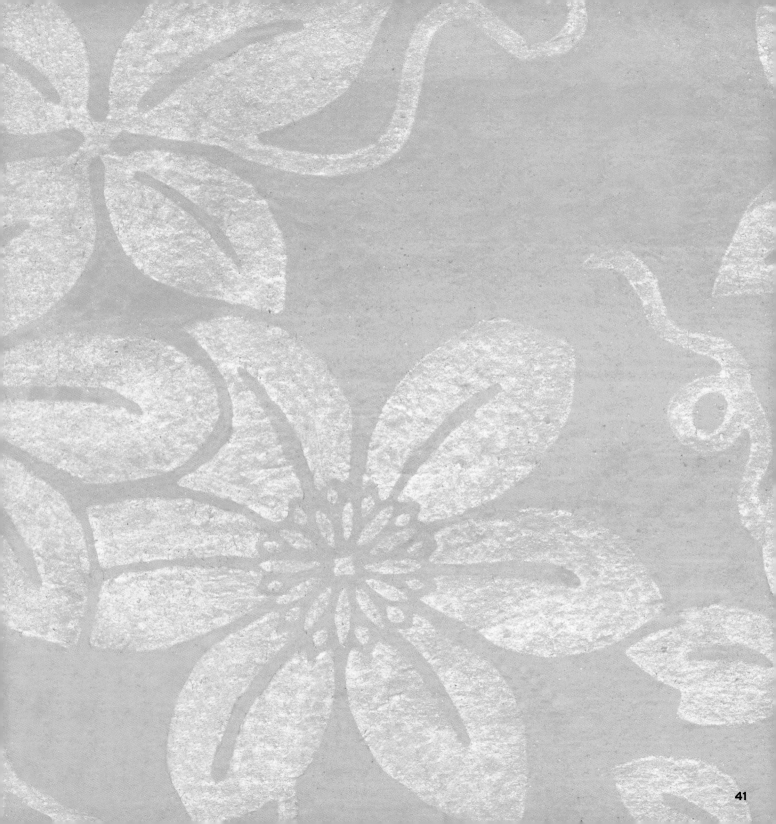

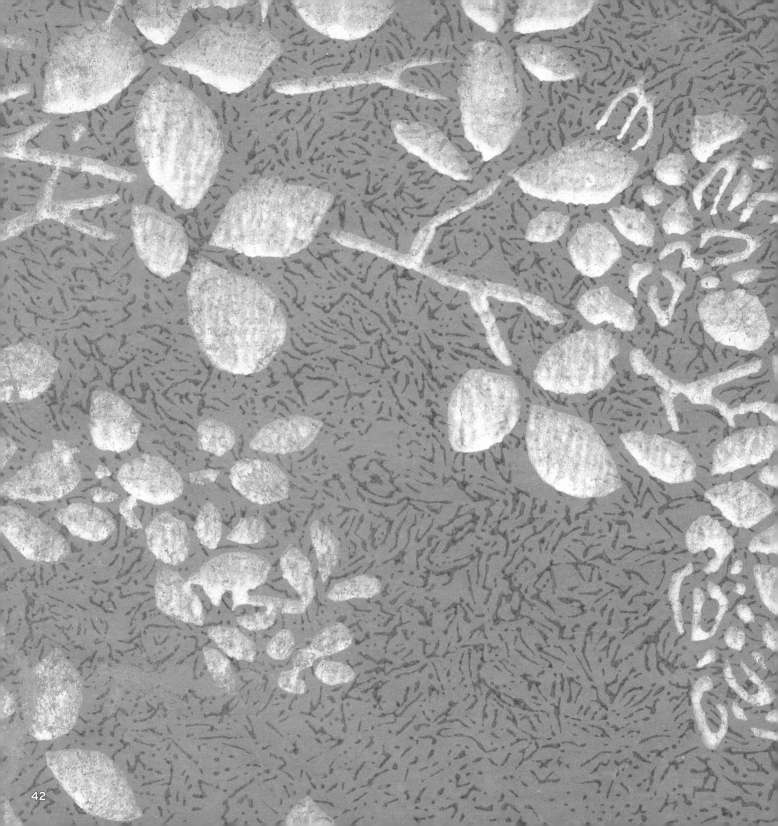

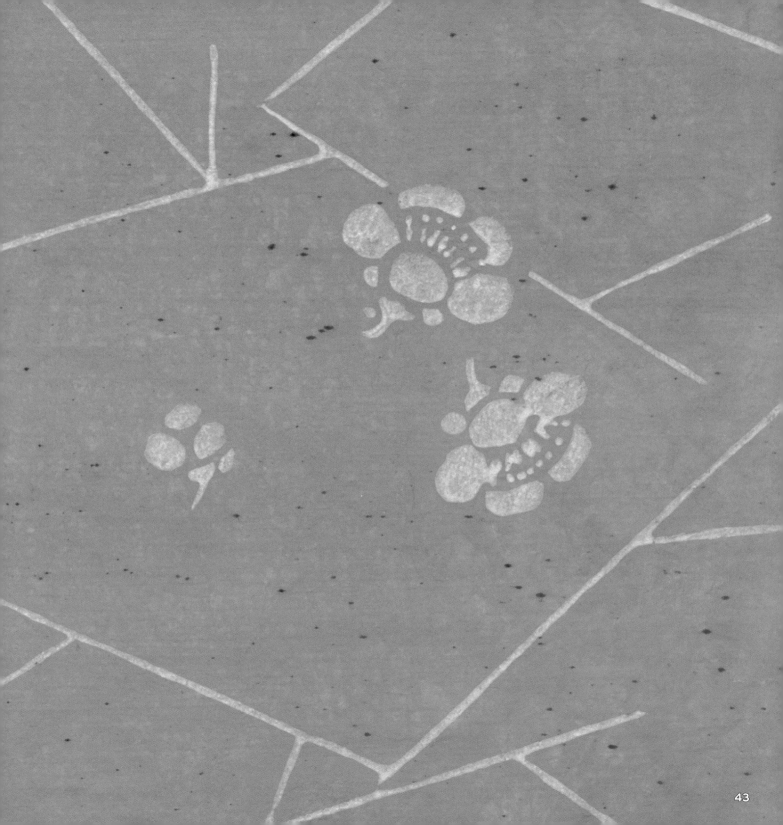

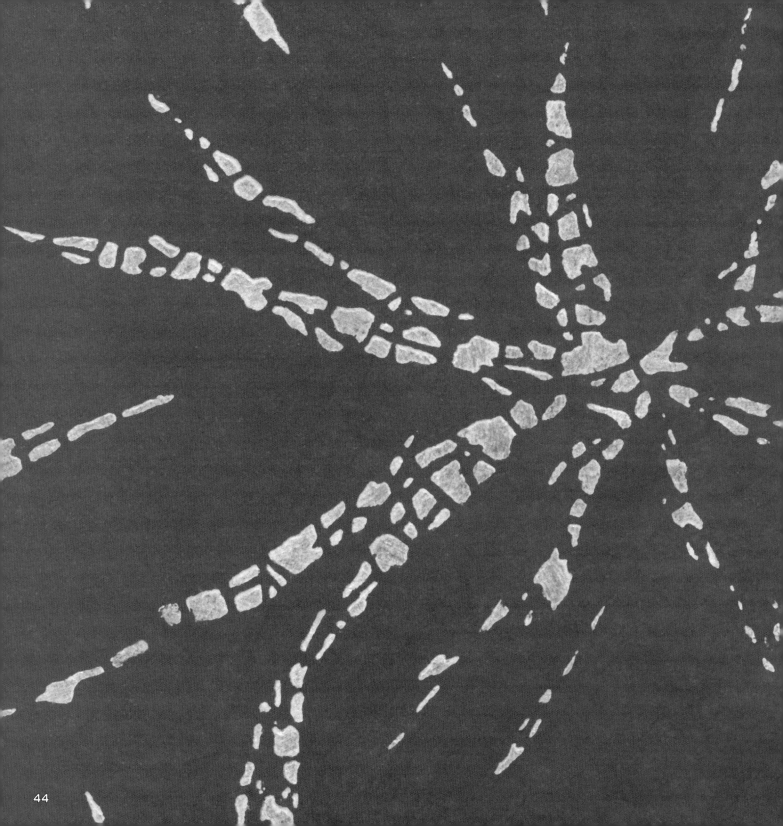

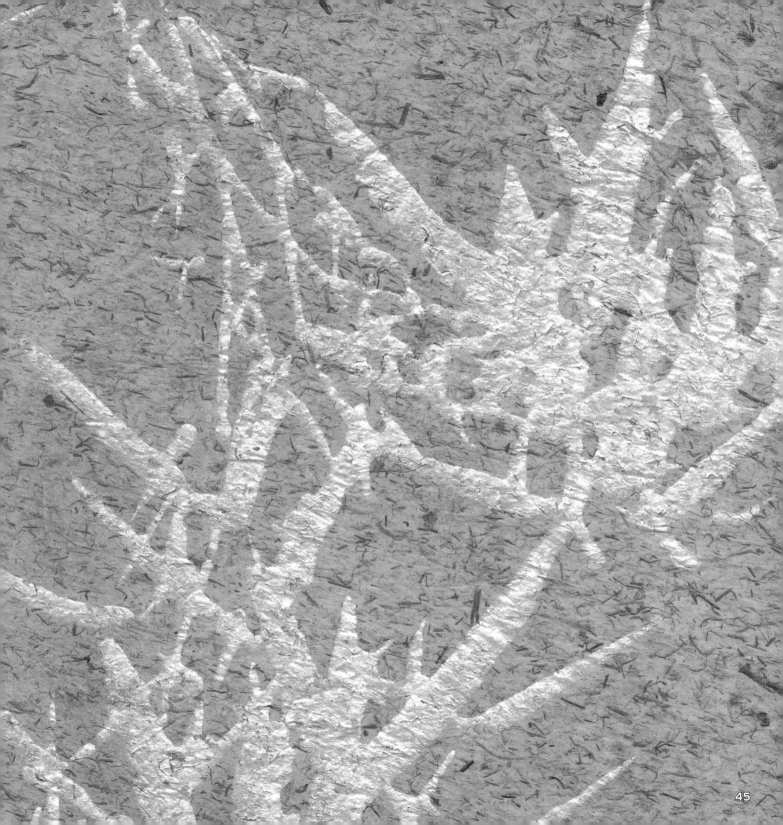

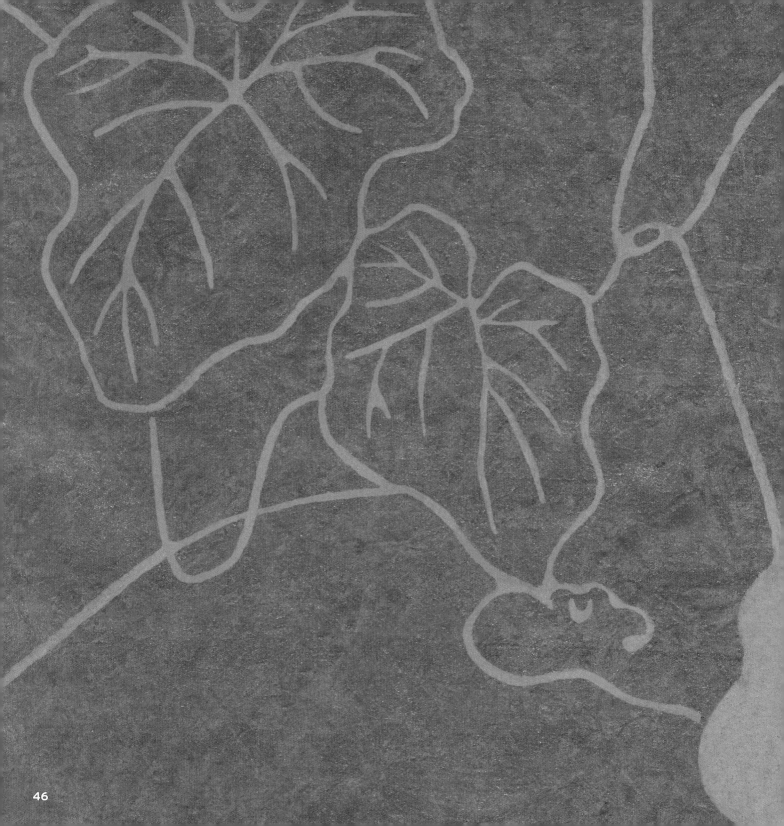

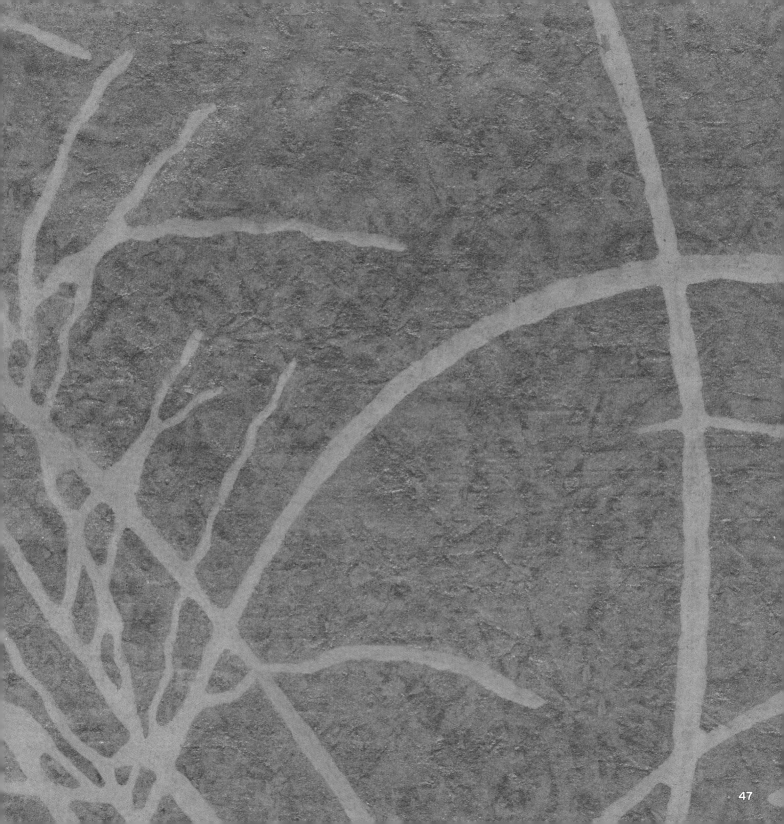

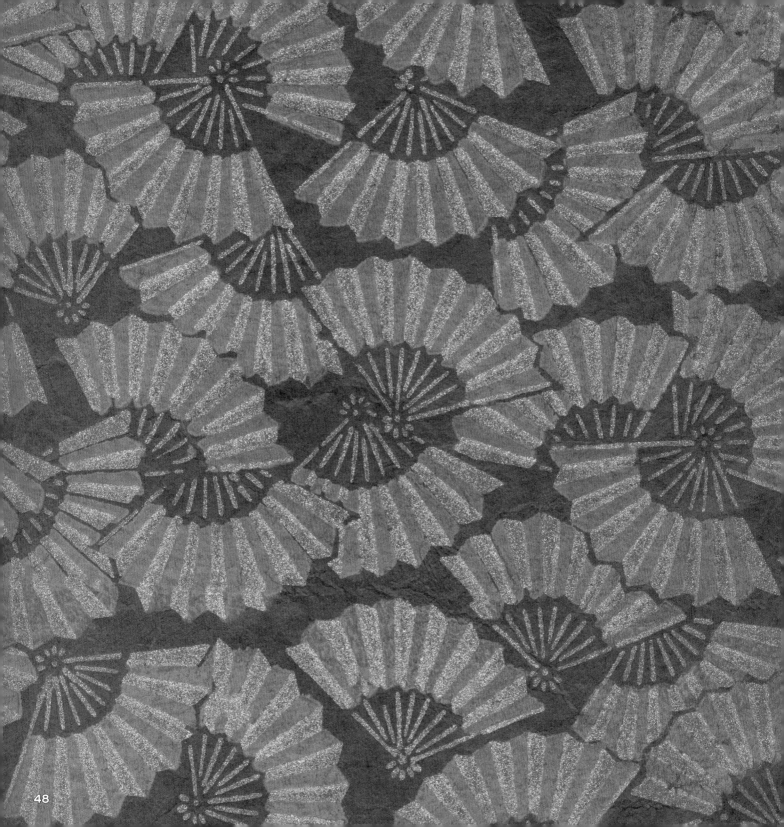

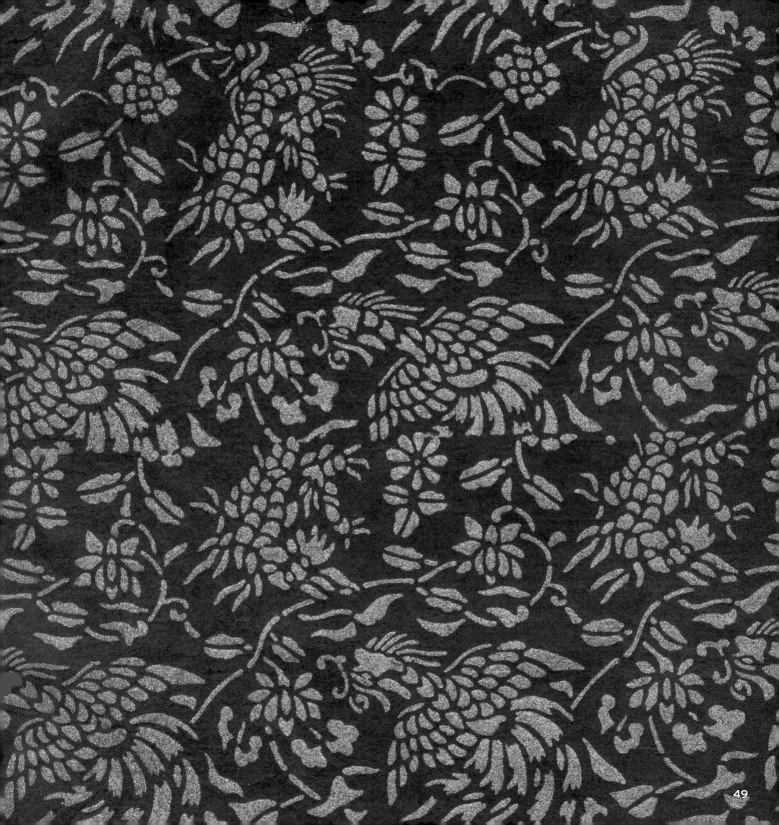

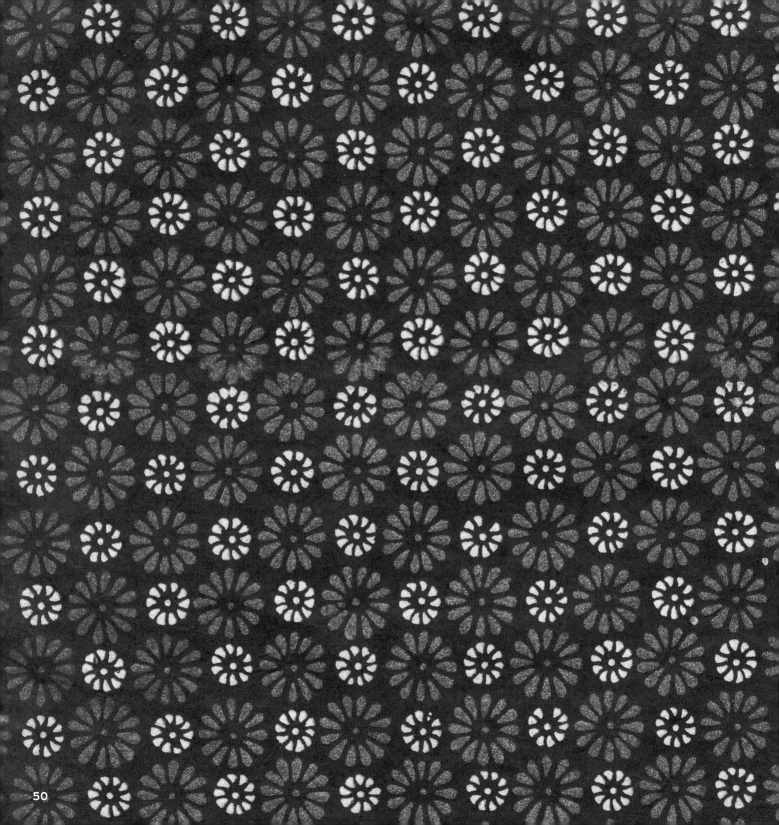

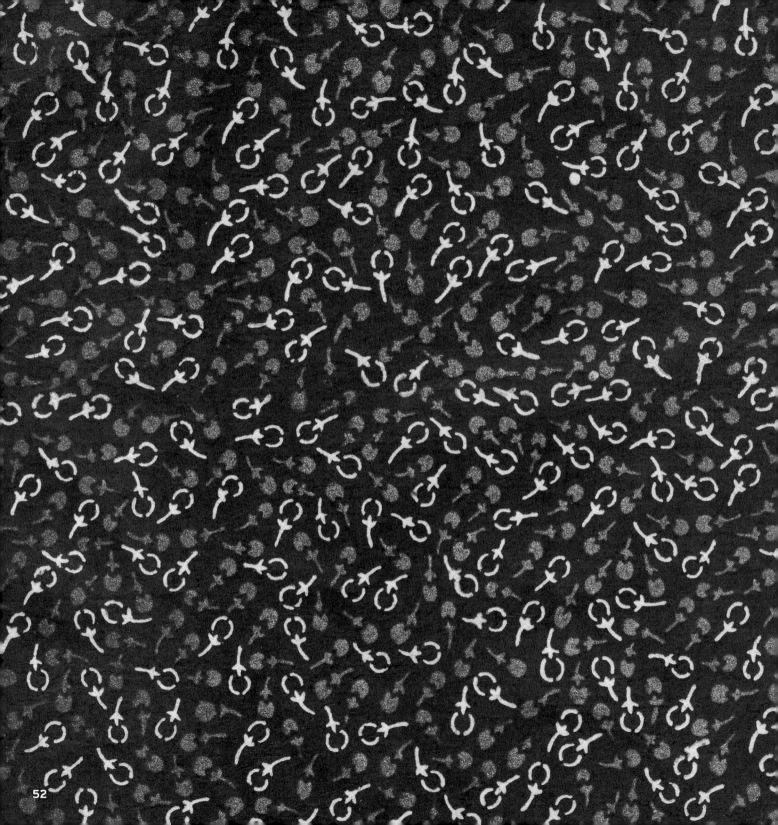

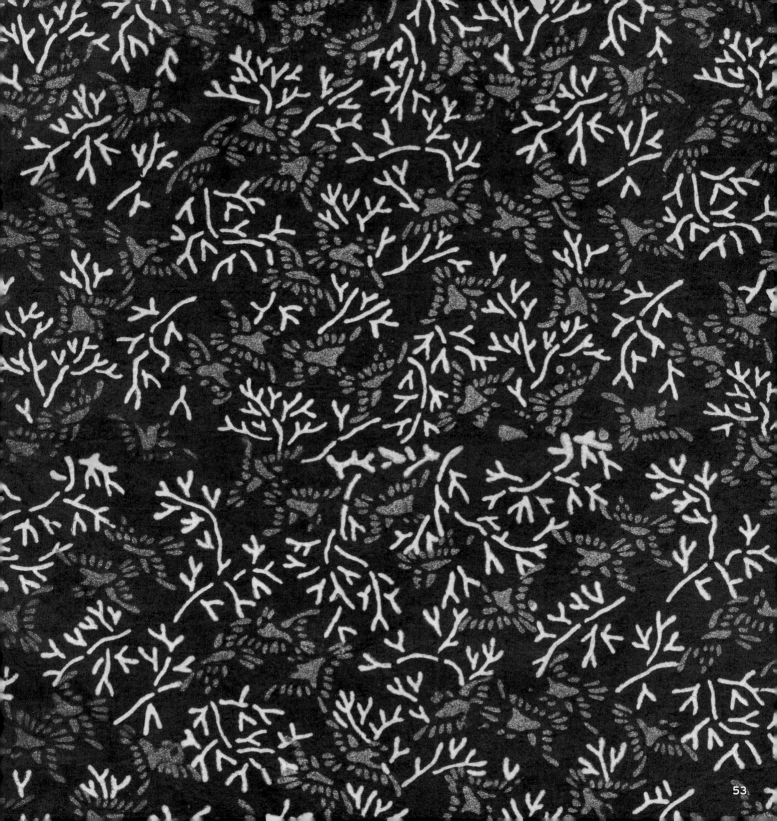

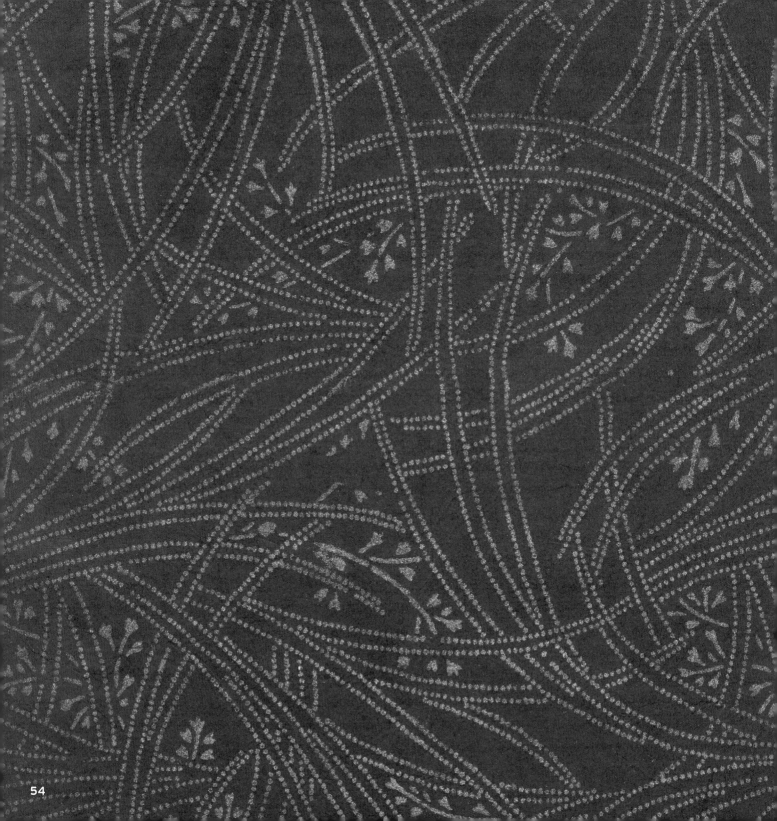

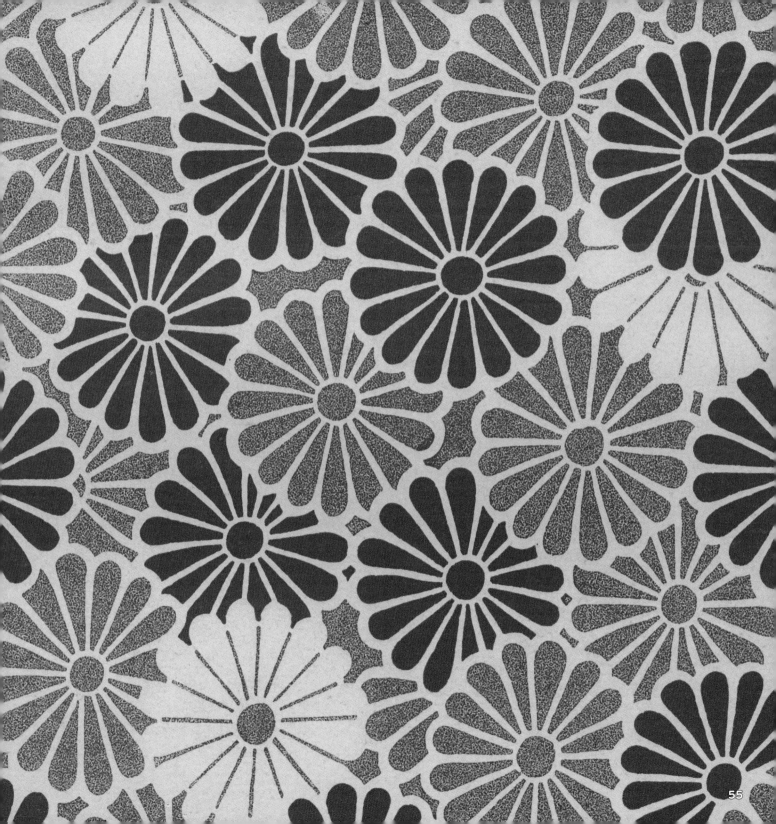

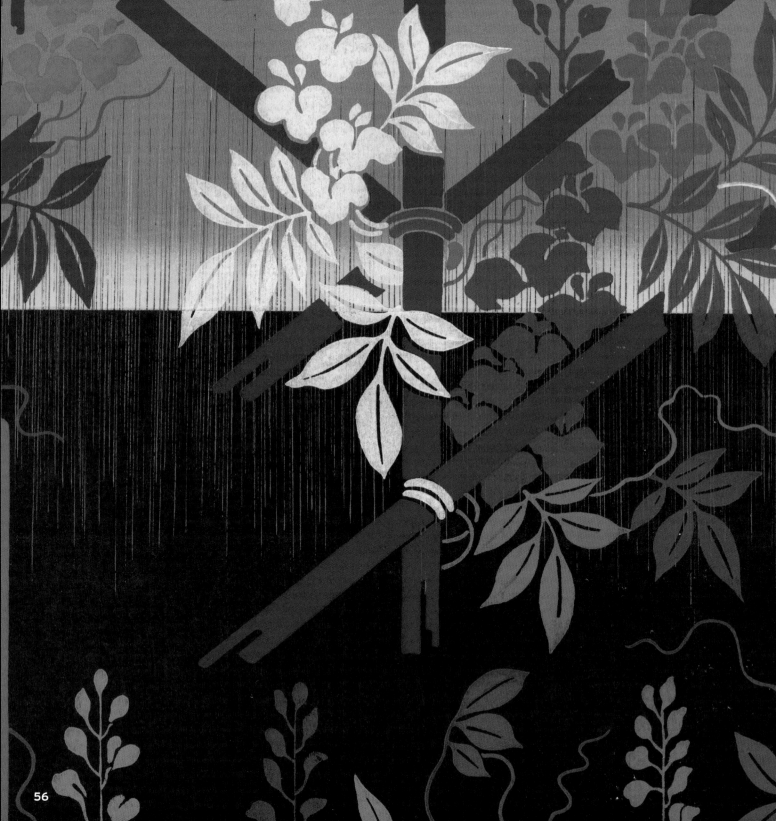

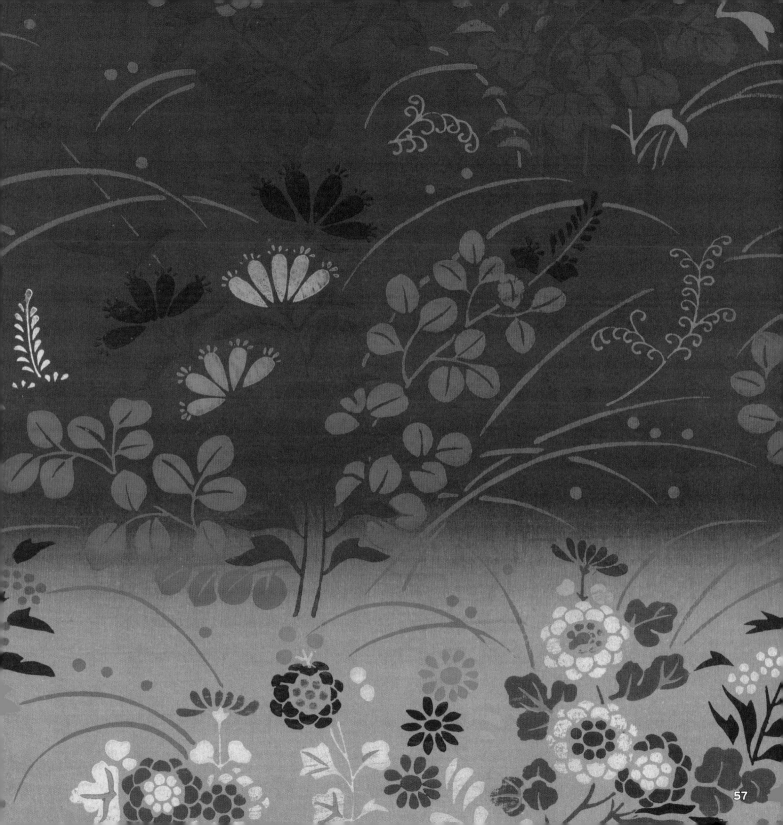

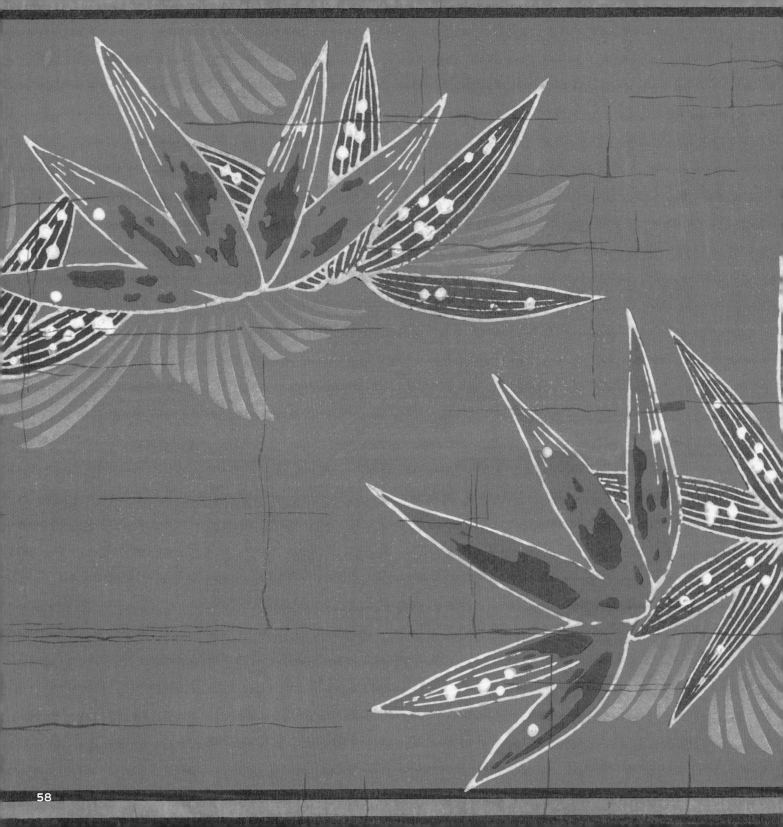

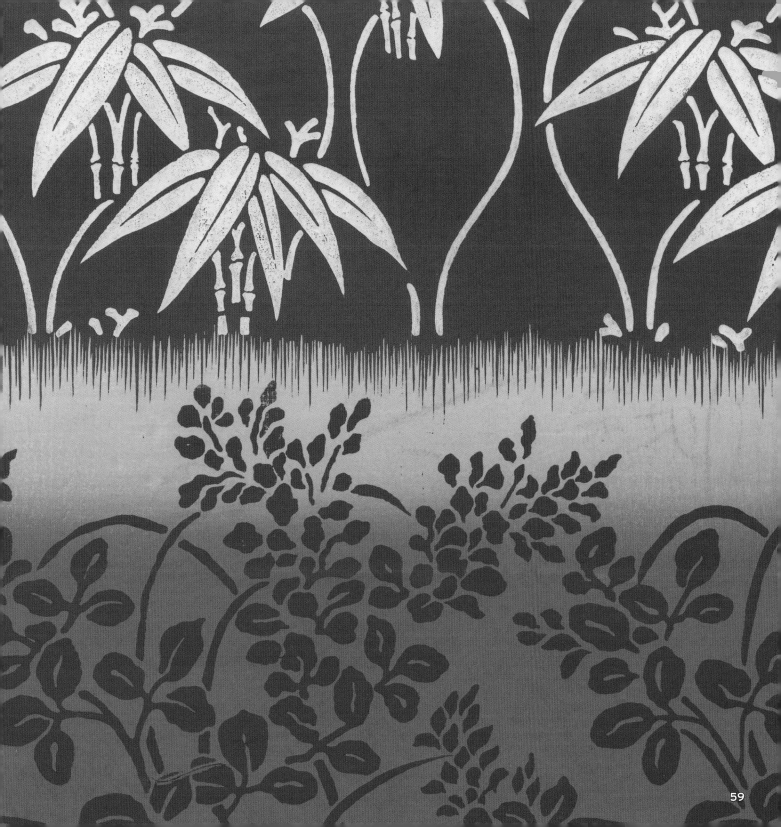

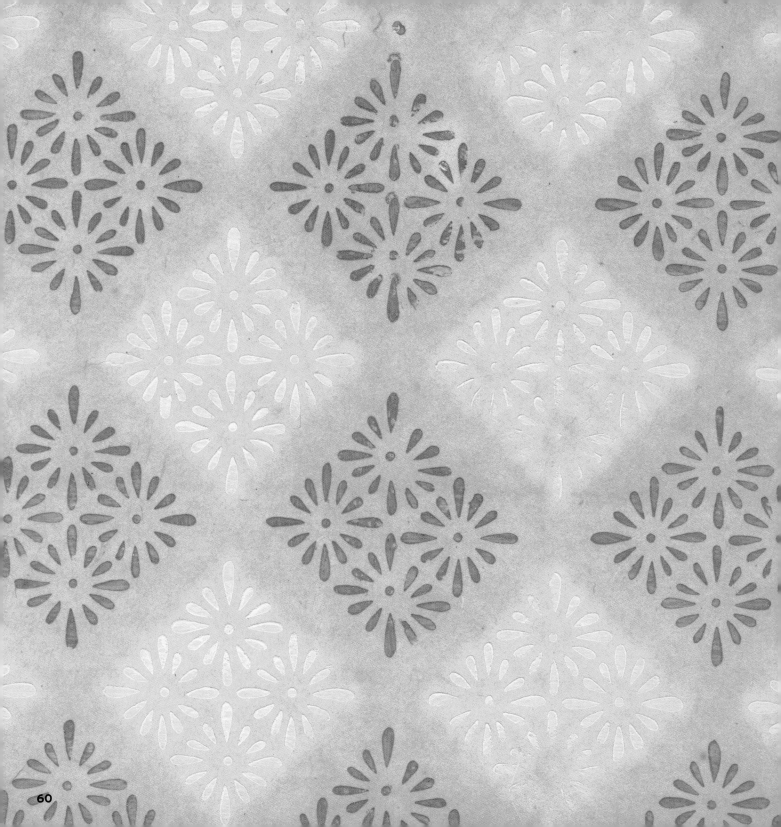

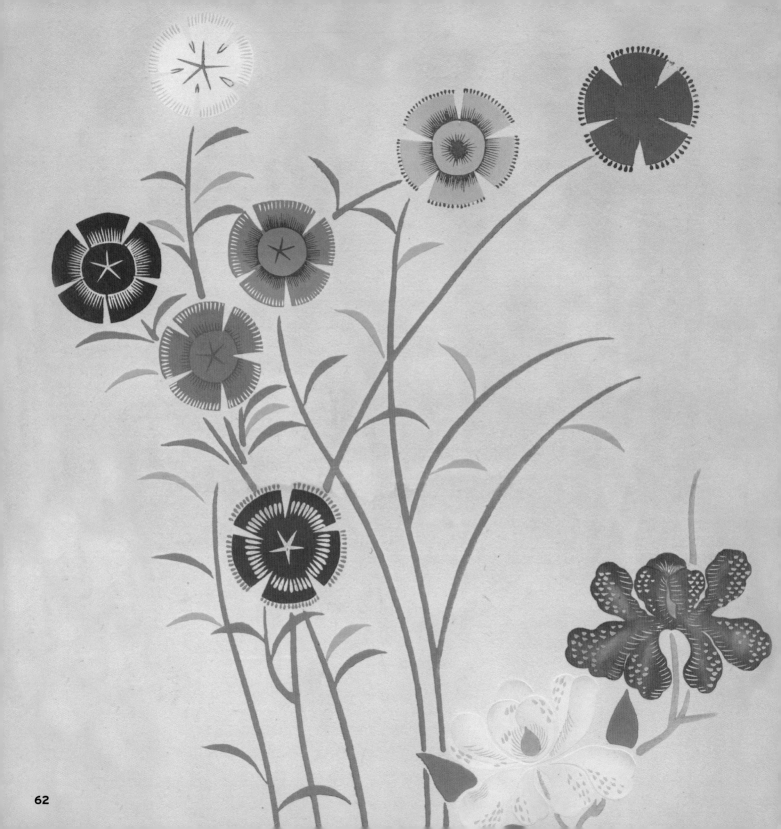

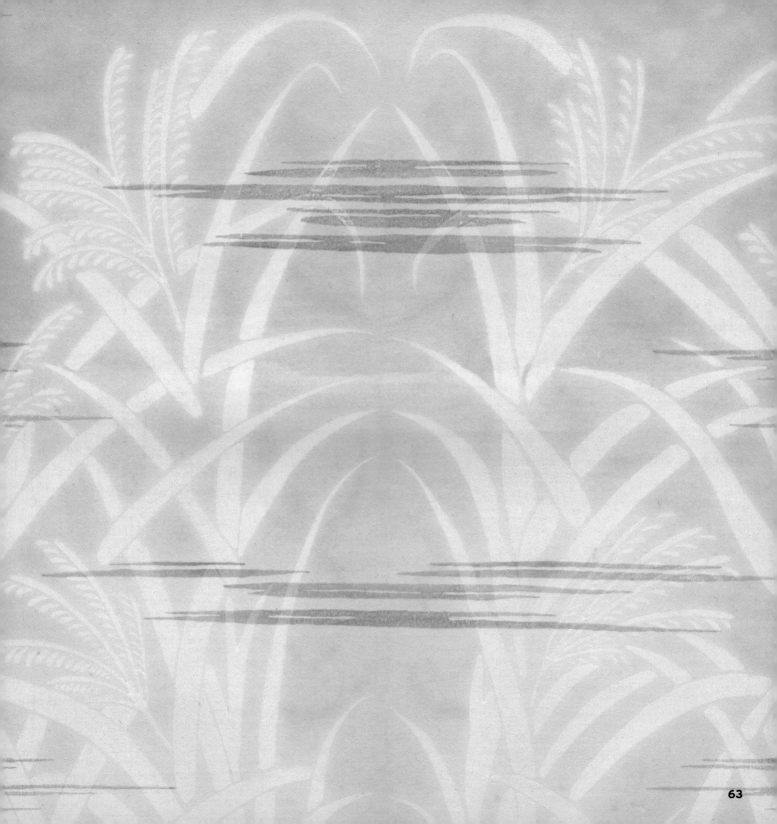

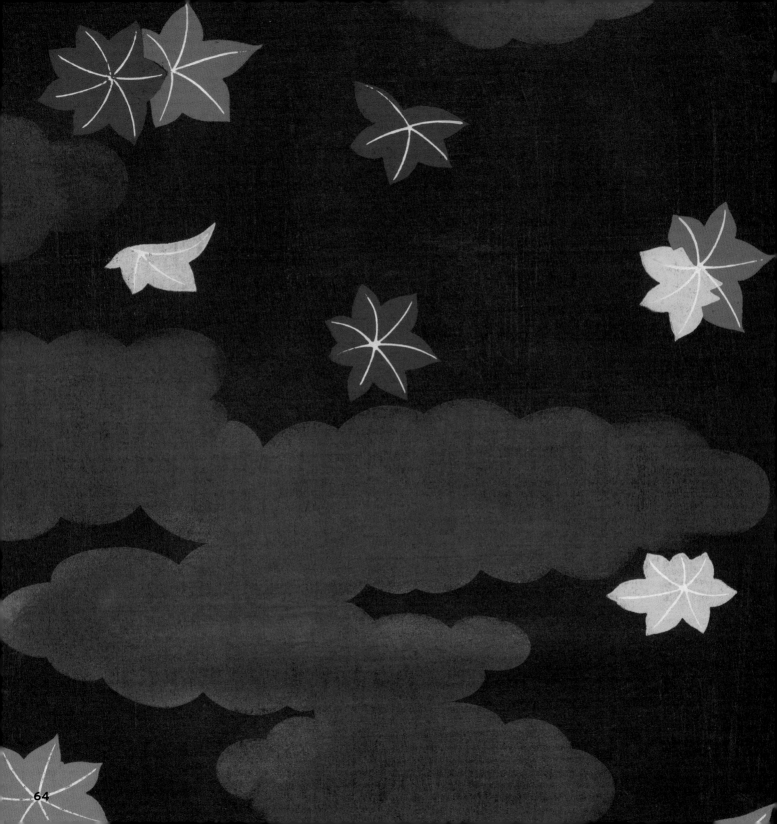

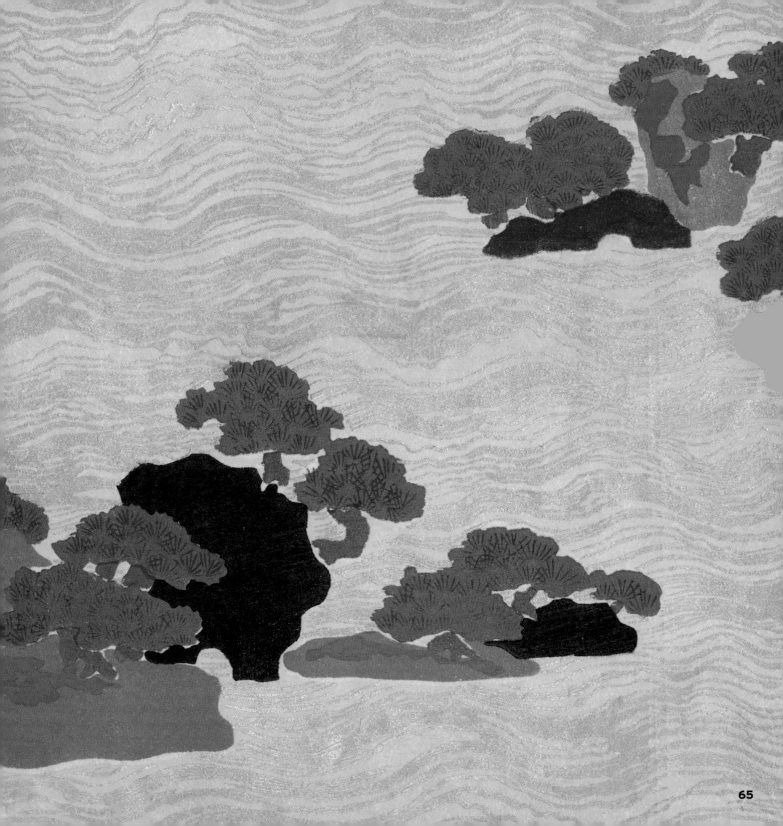

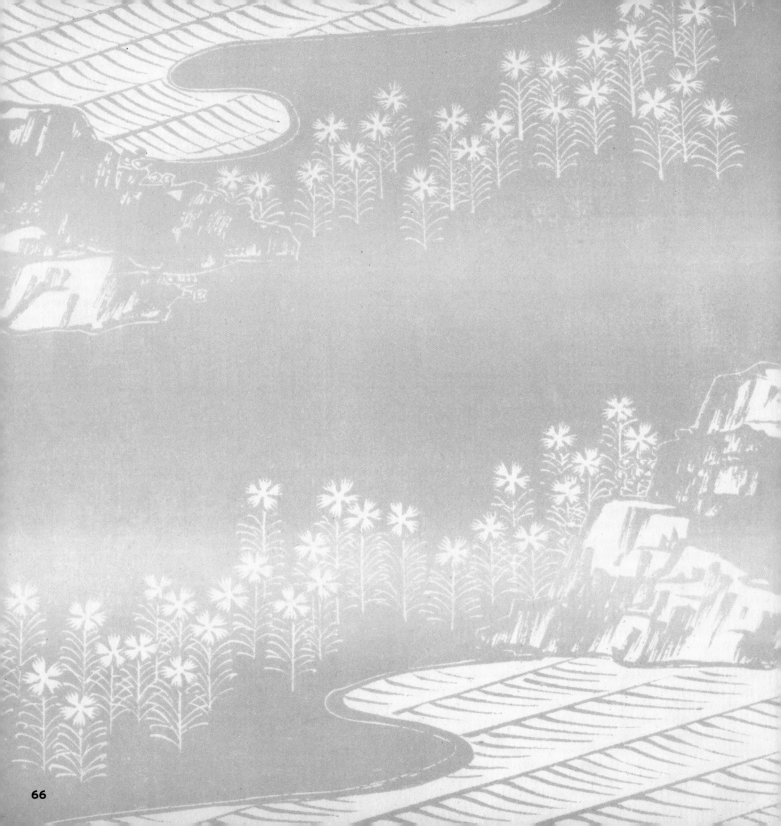

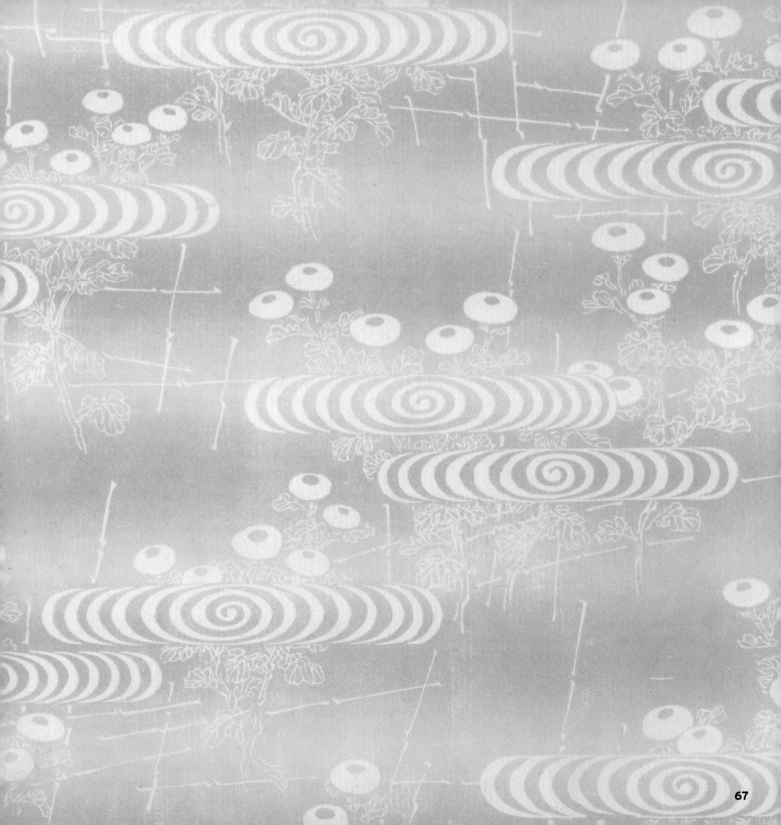

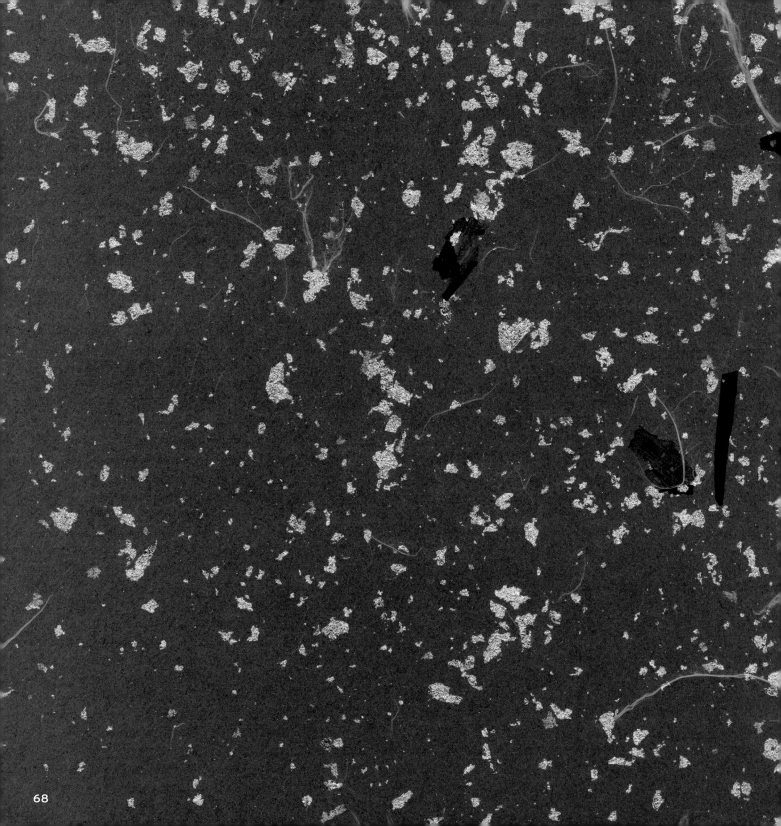

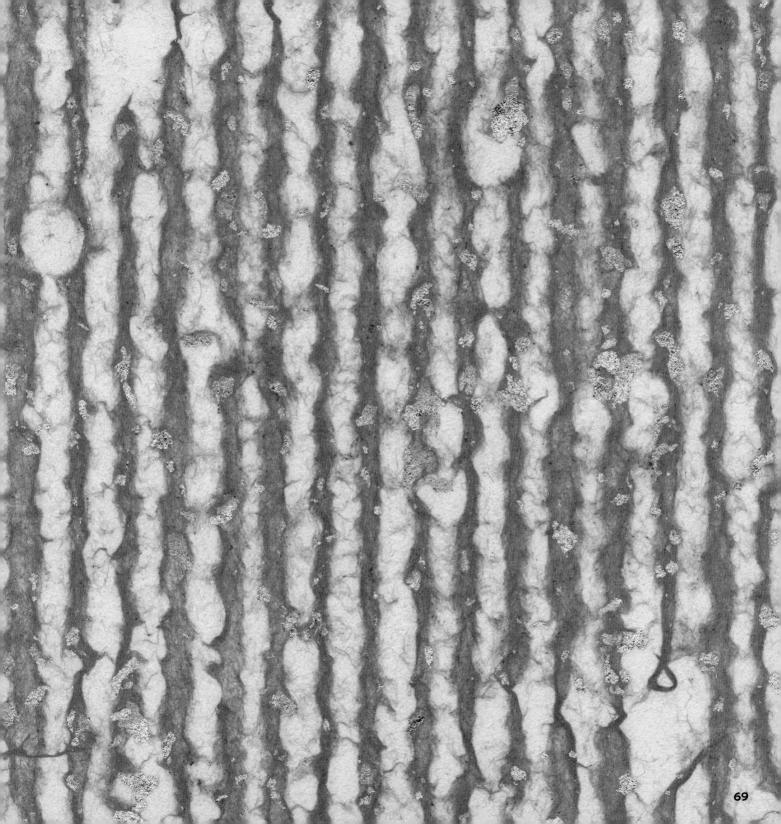

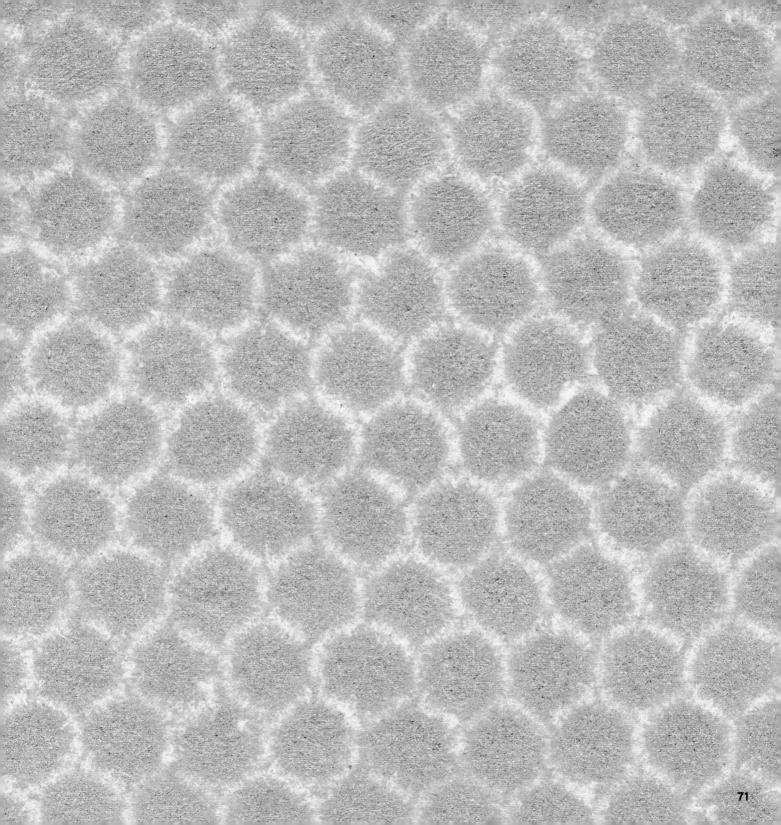

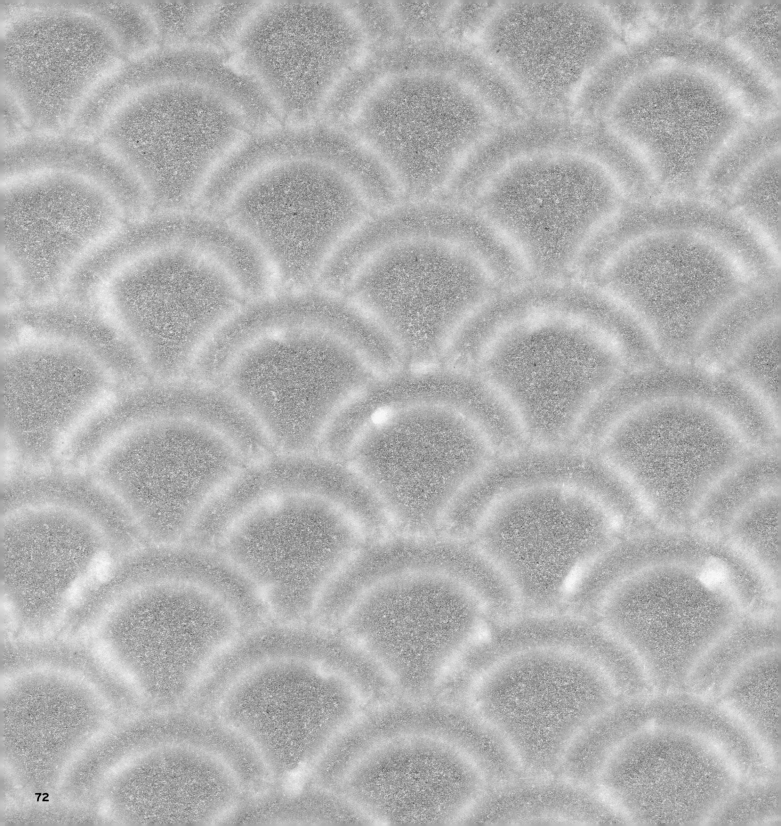

72

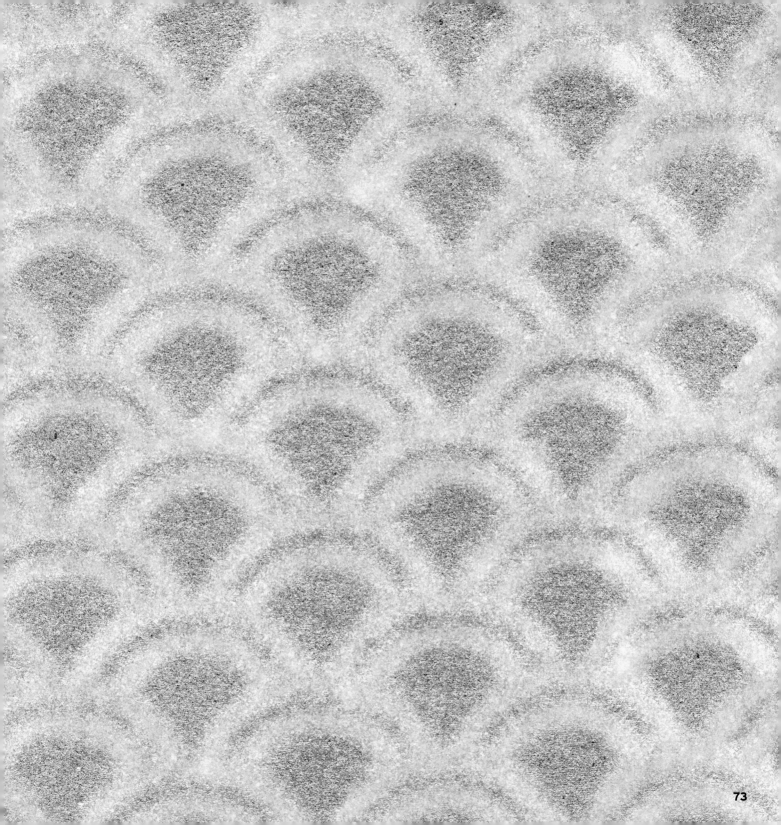

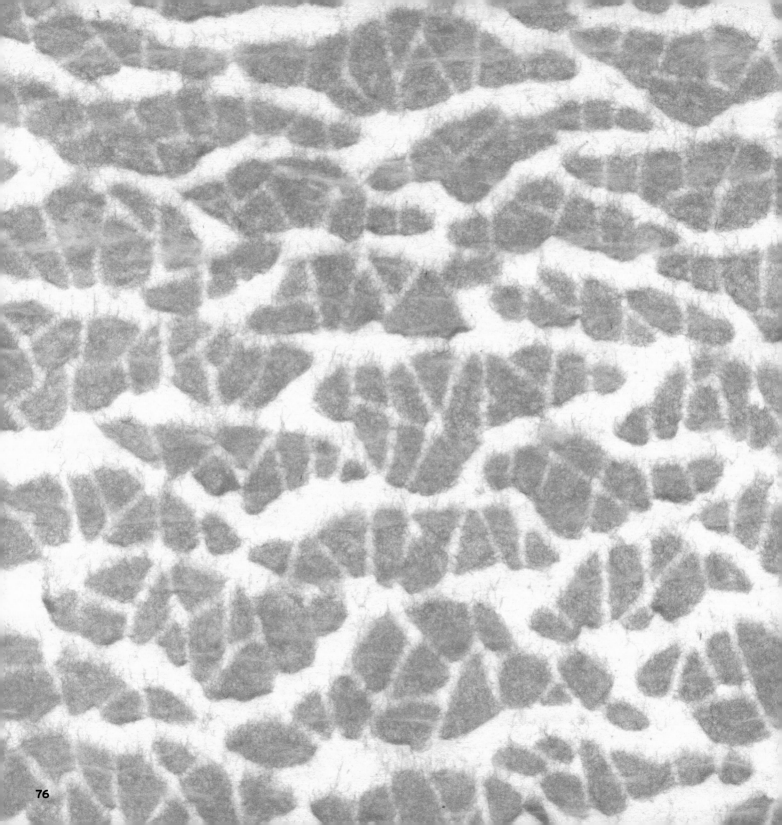

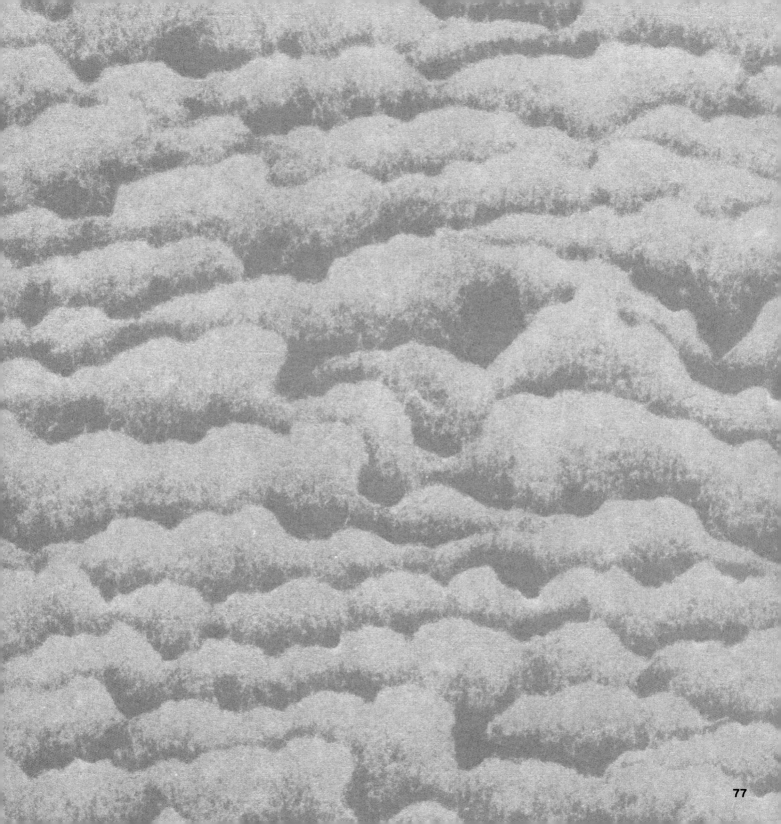

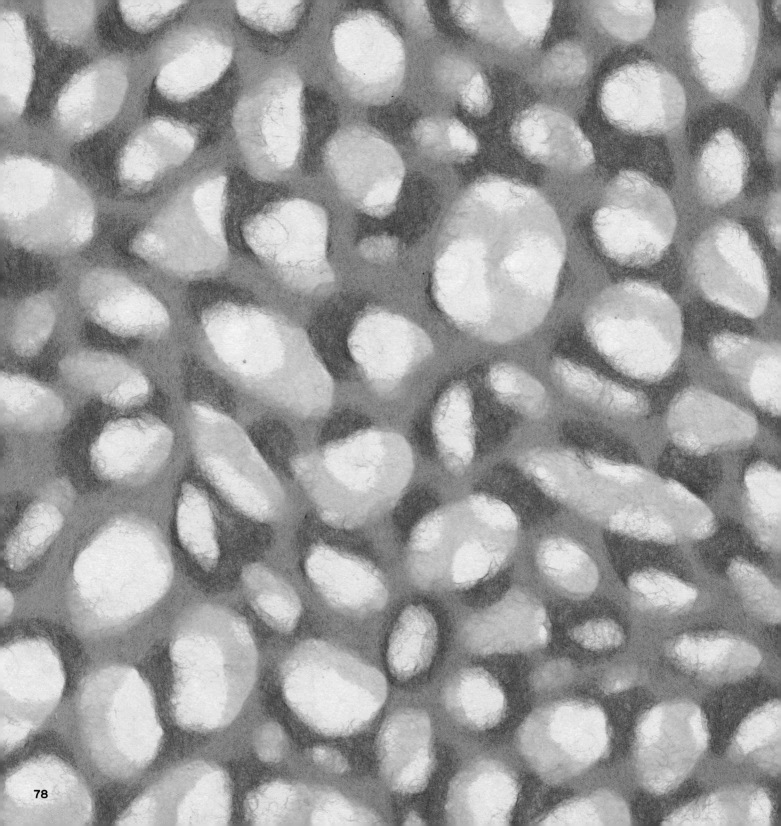

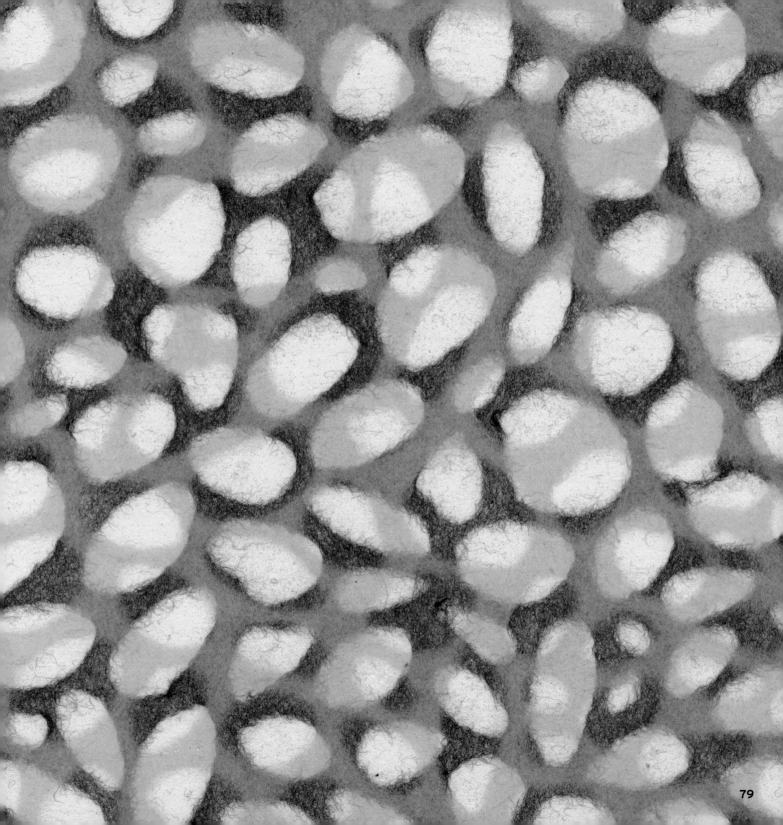

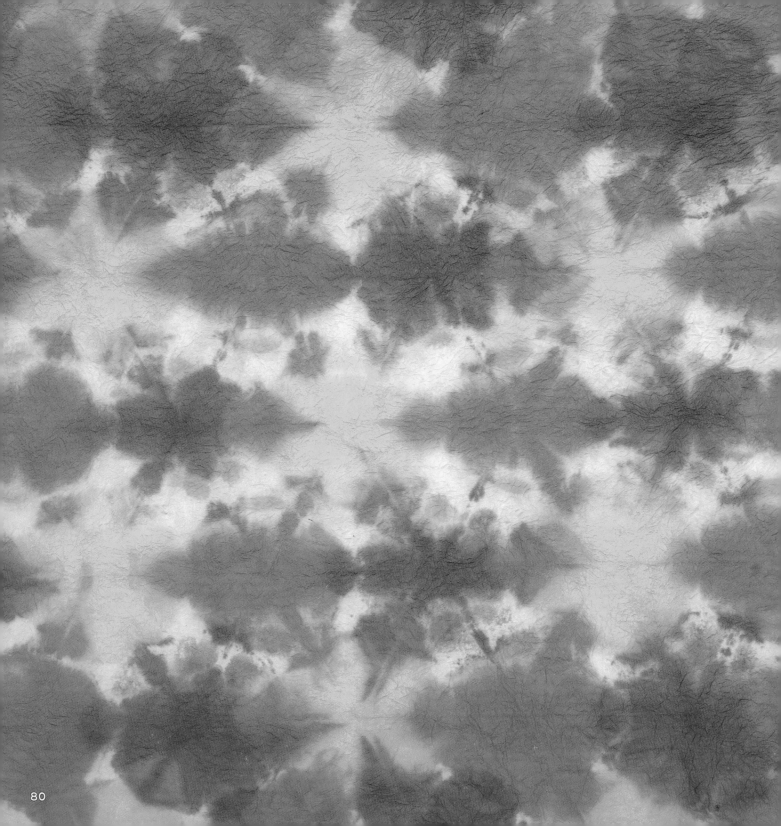

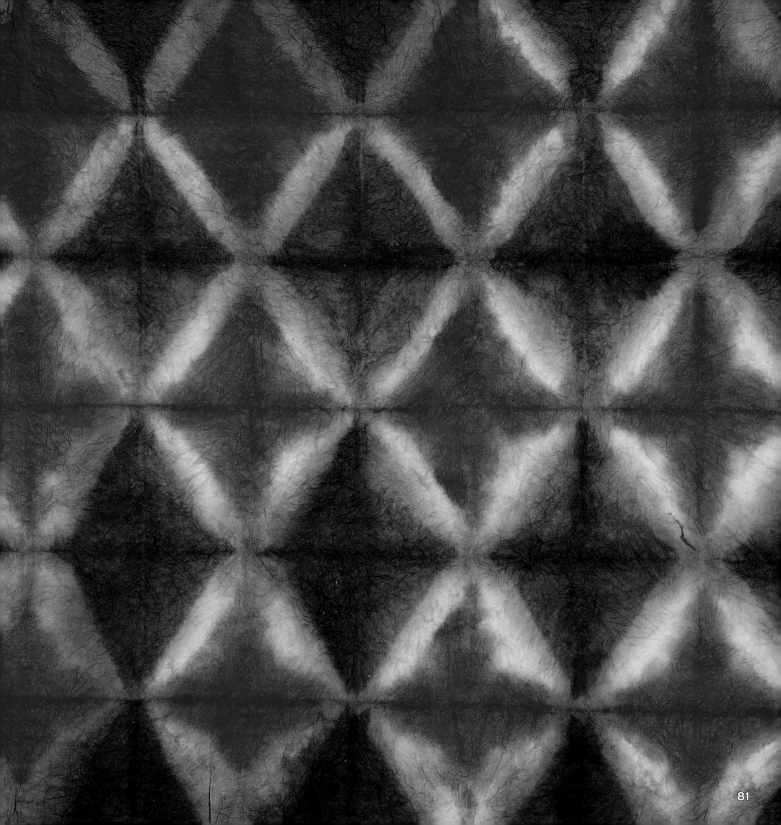

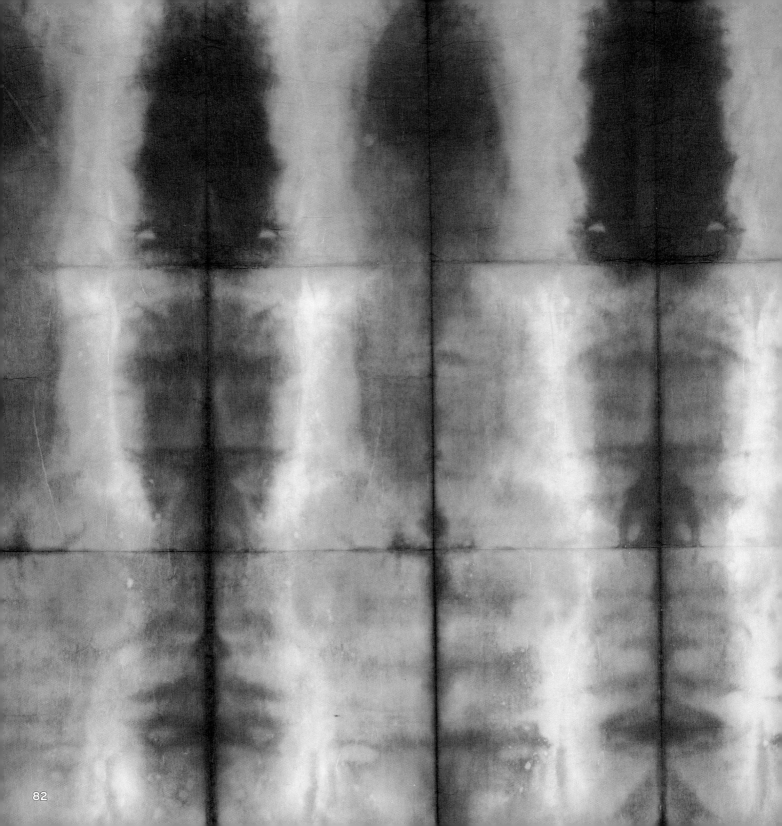

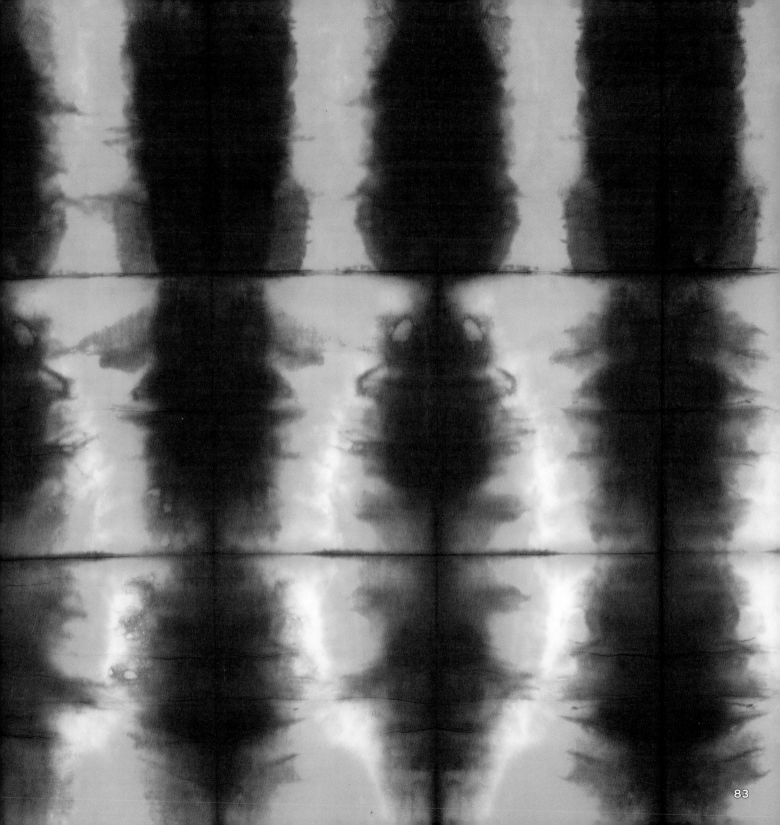

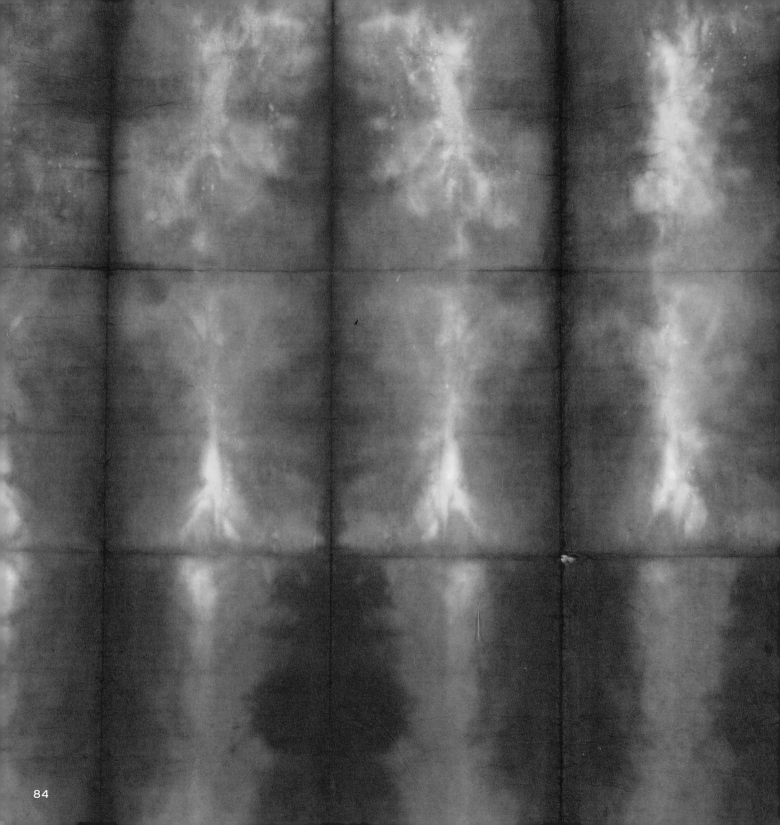

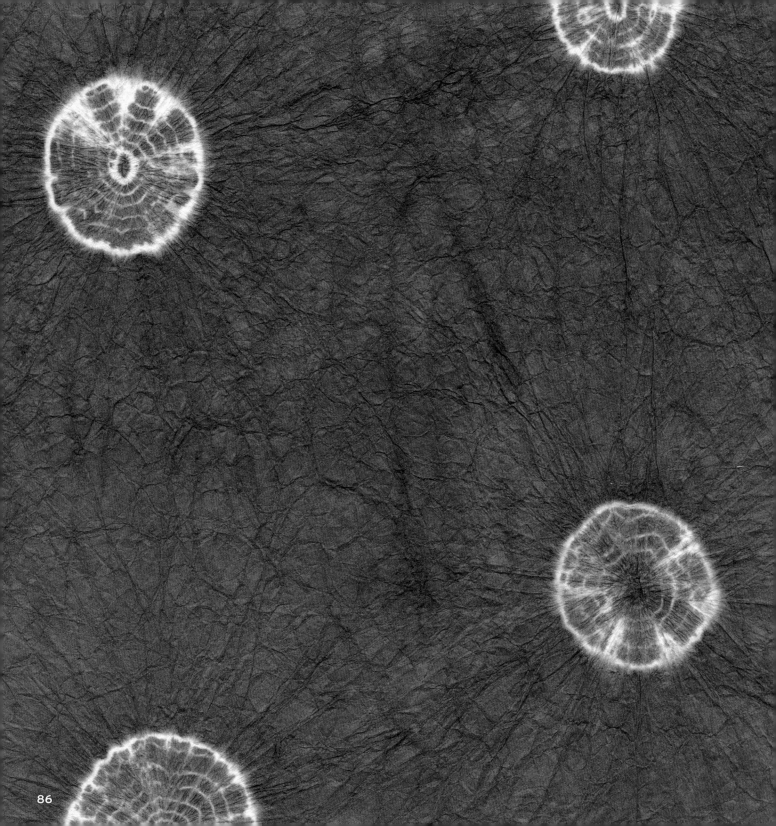

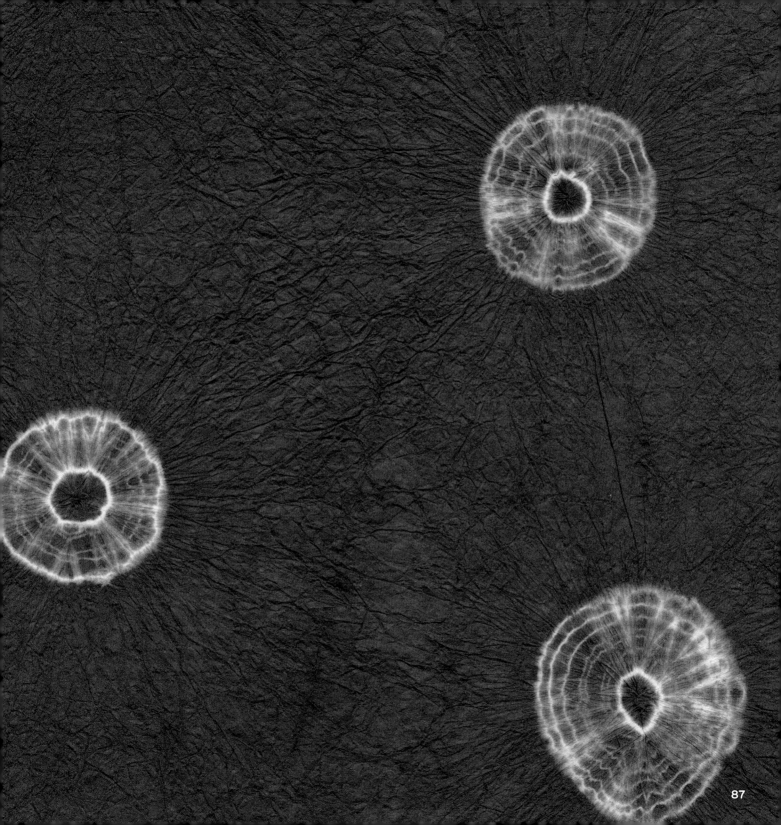

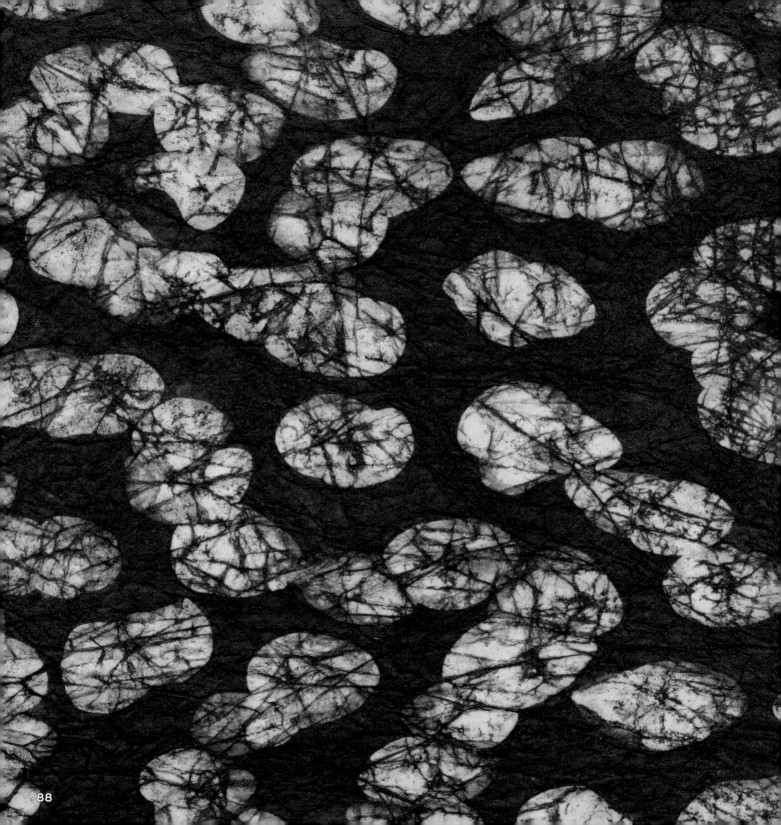

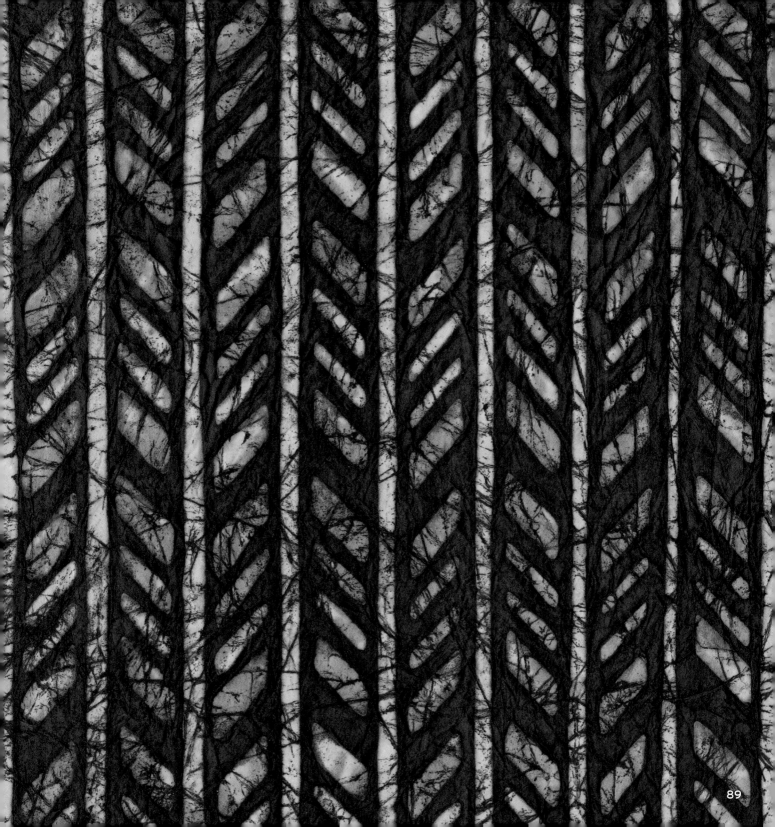

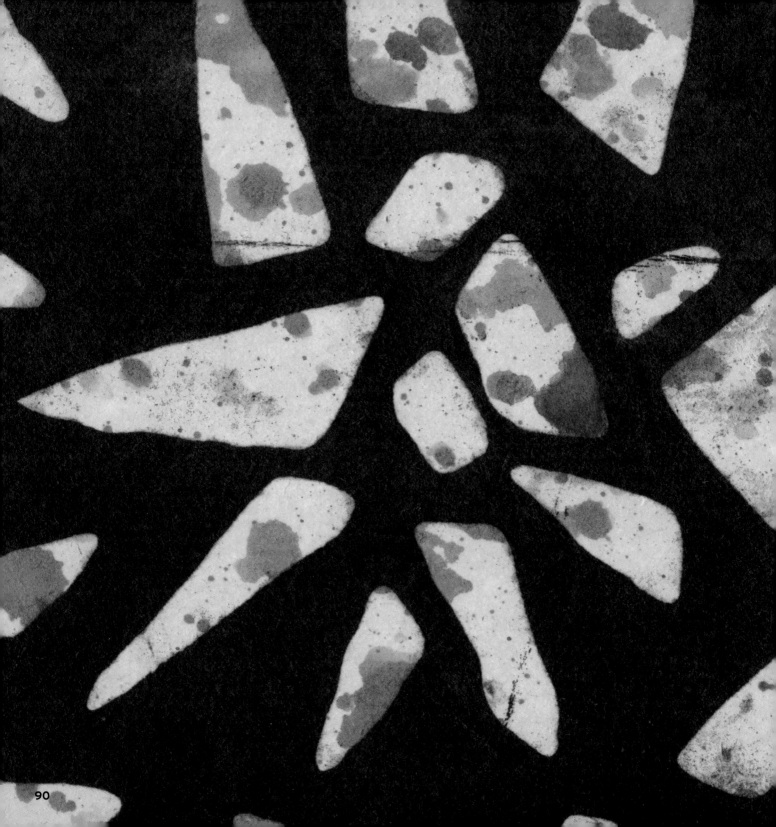

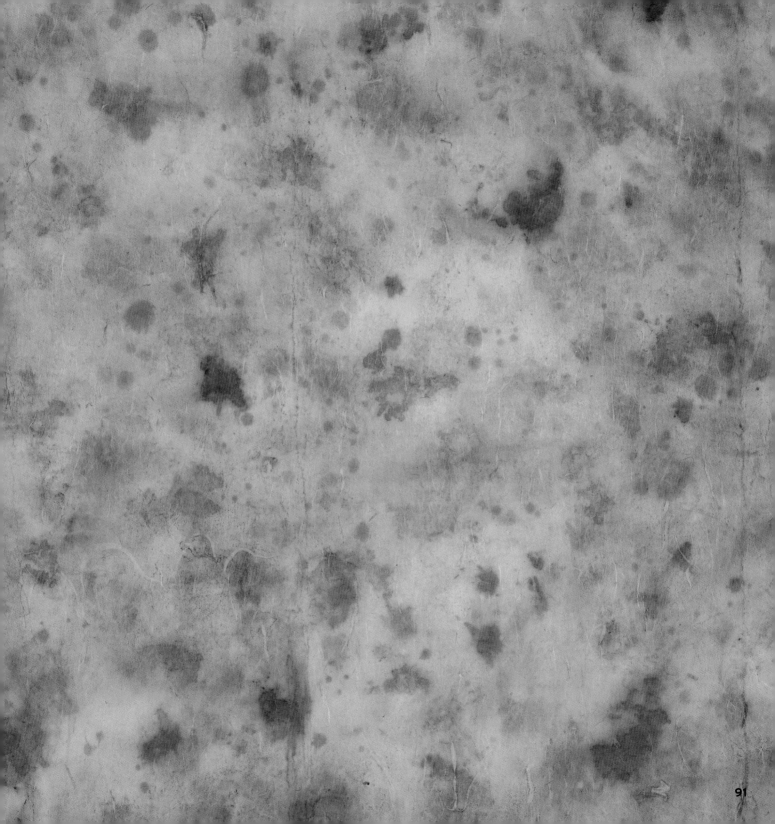

91

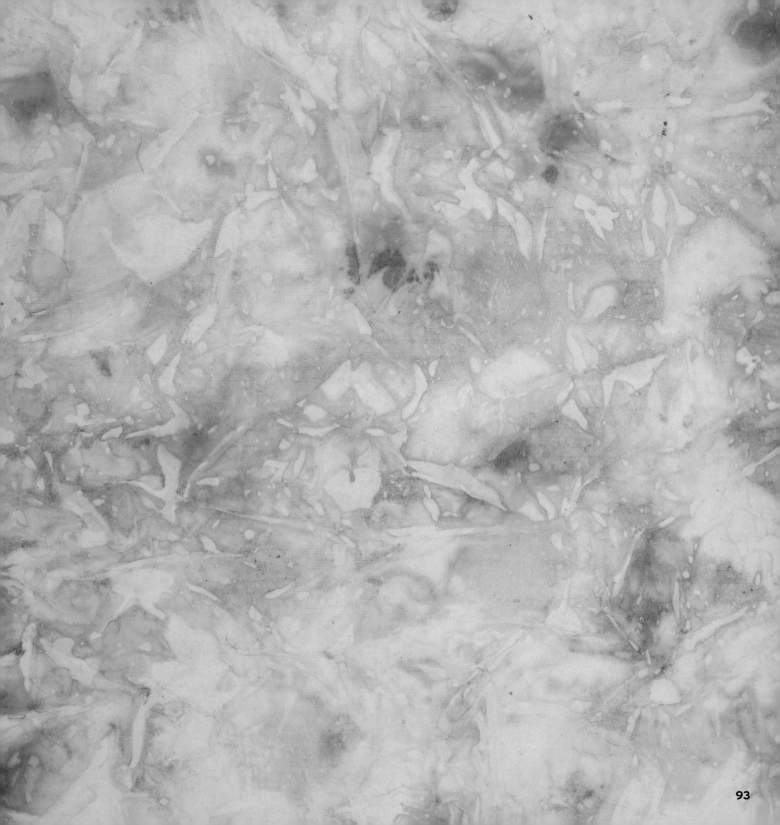

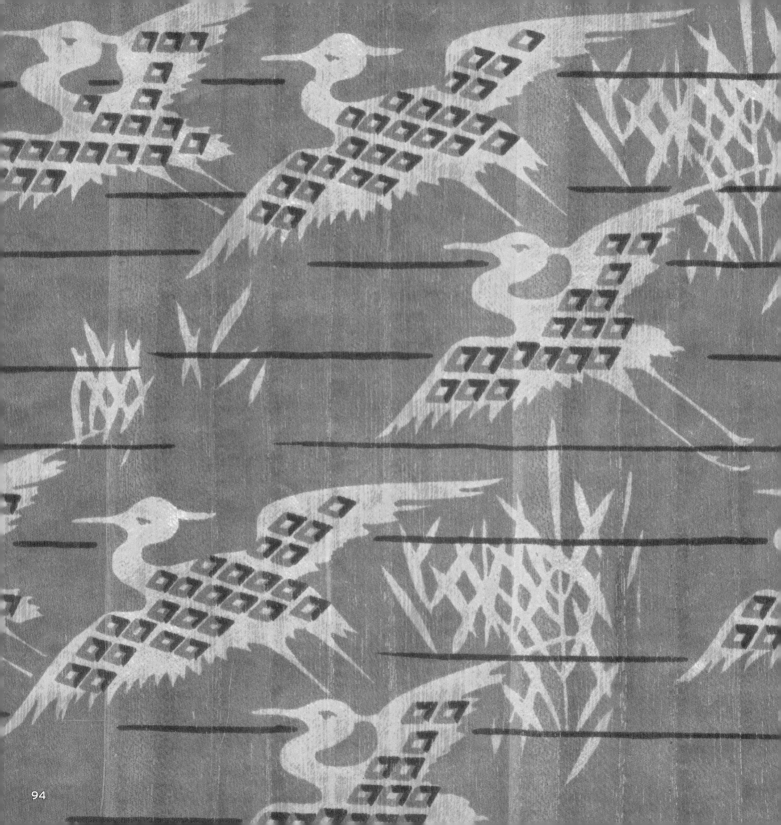

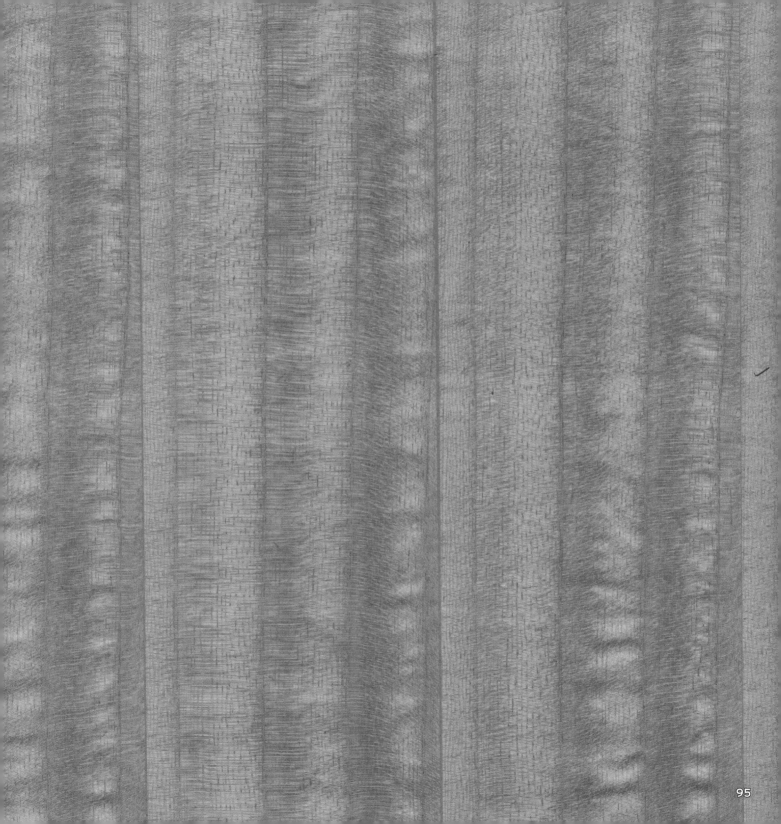

95

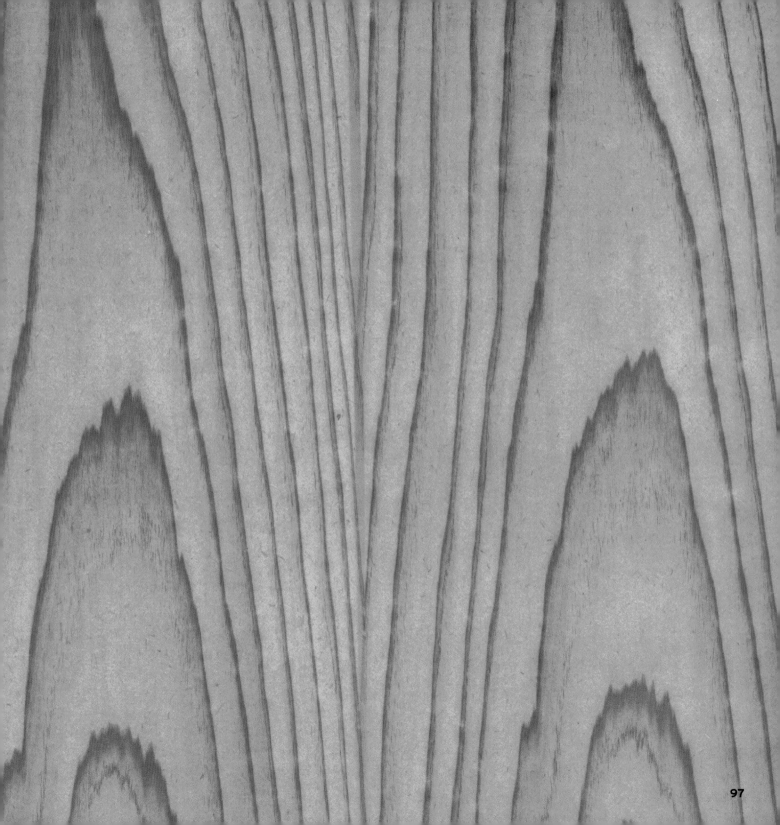

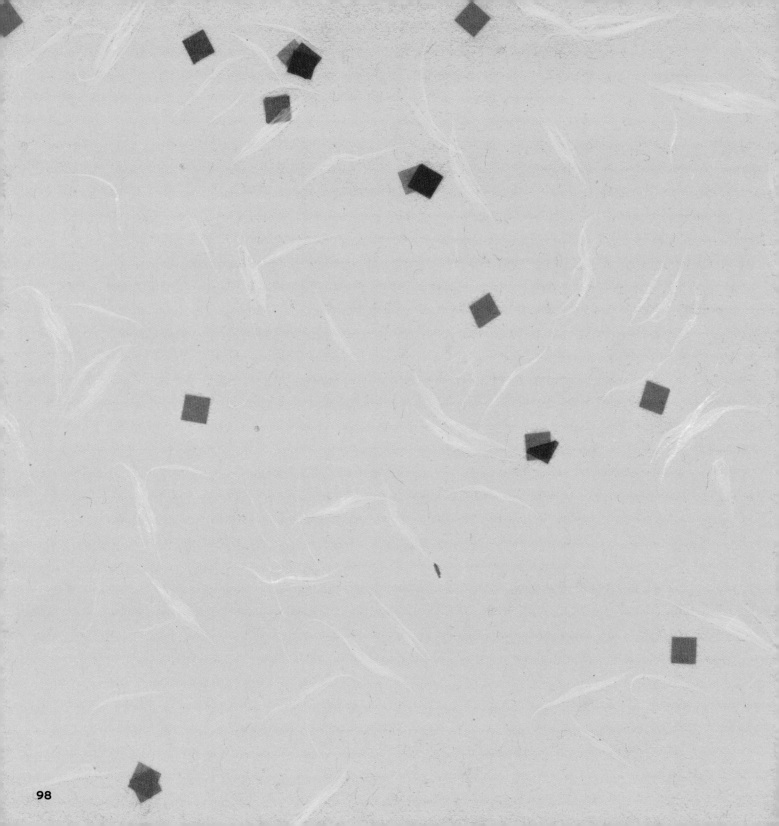

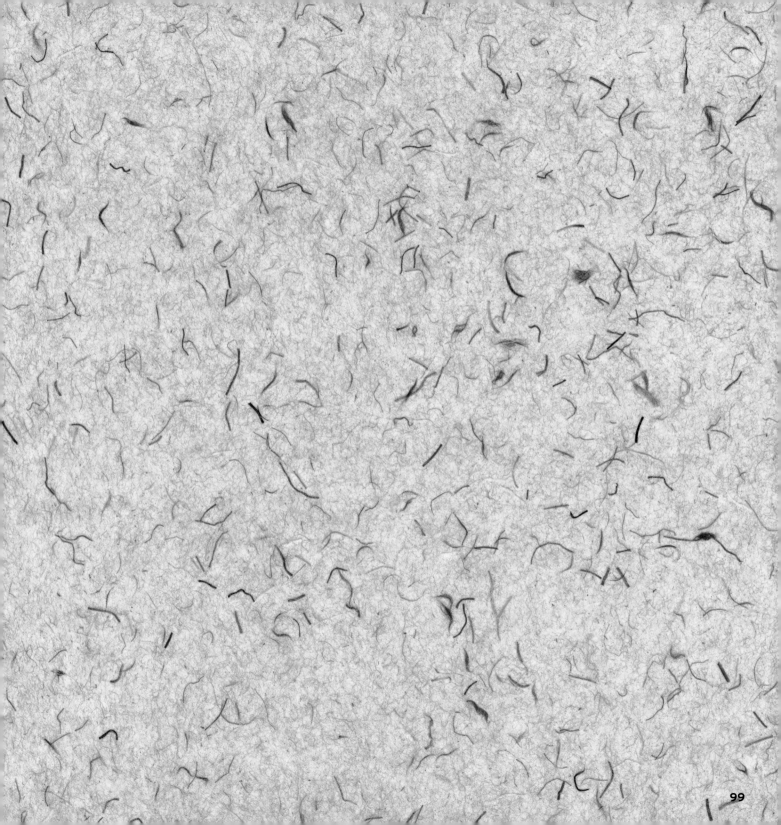

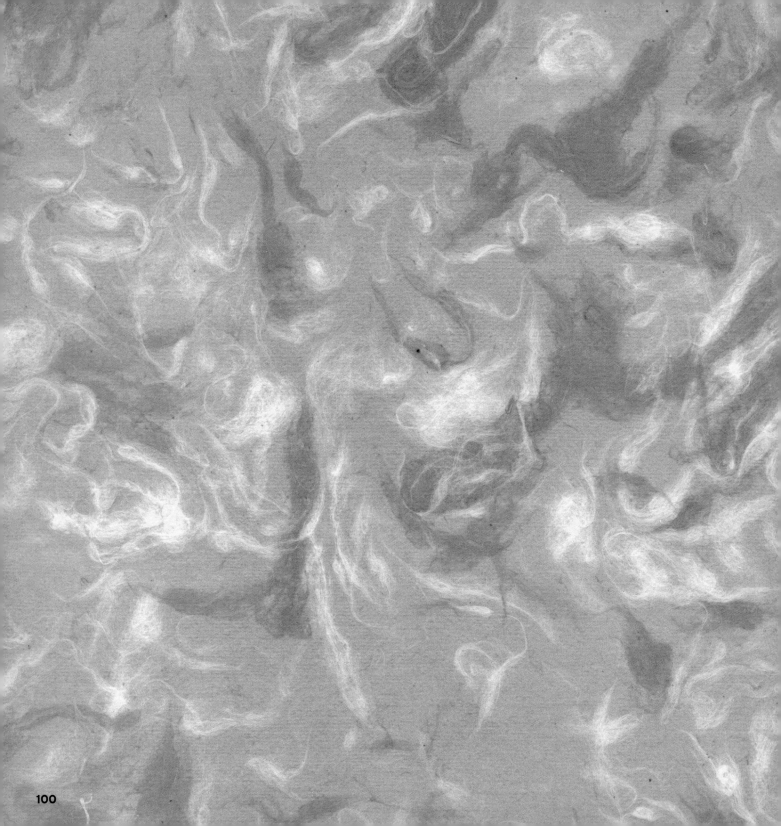

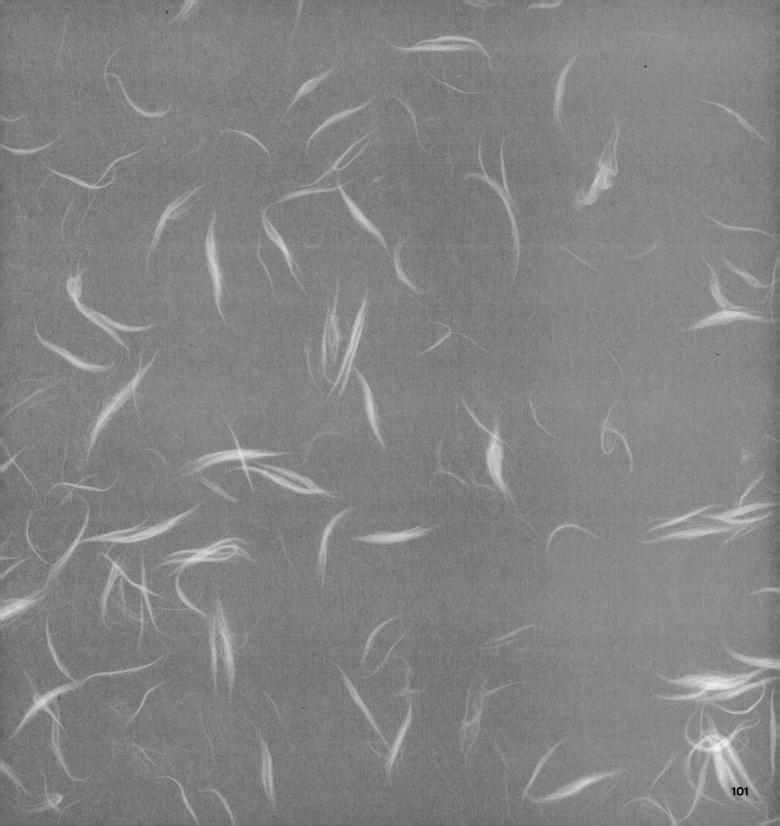

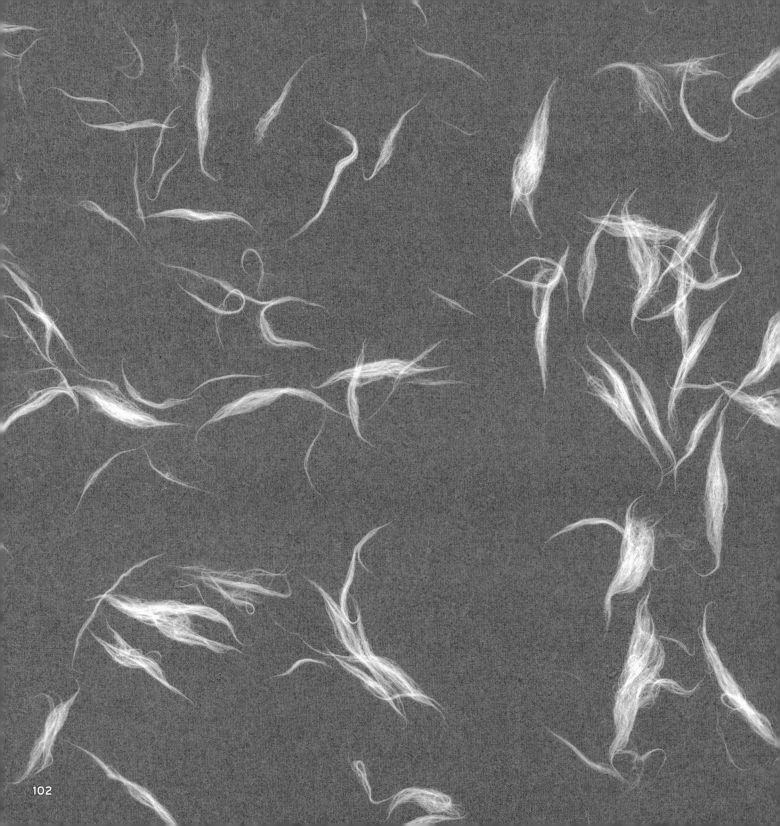

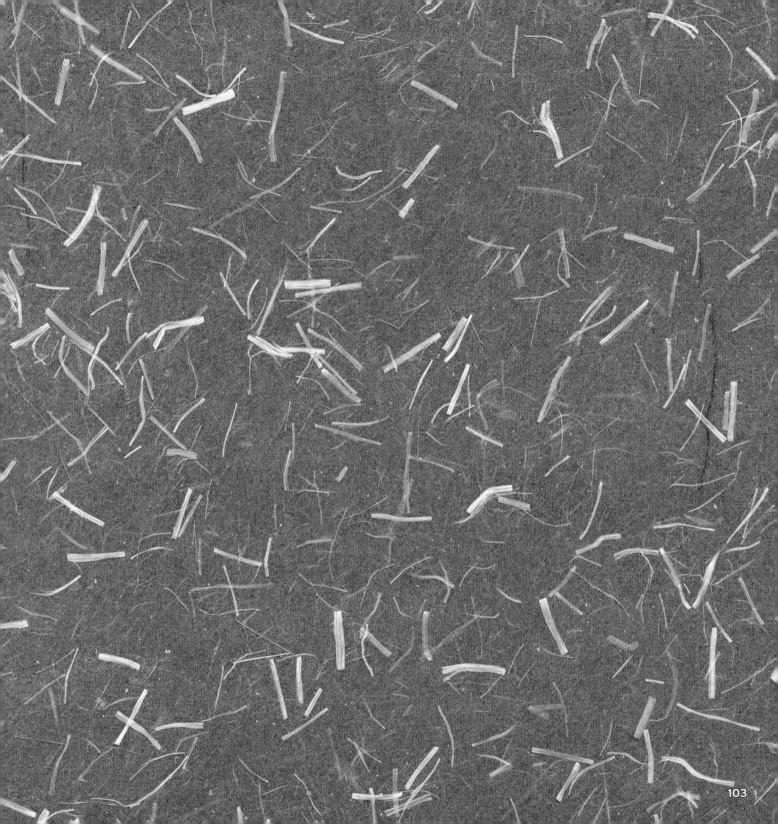

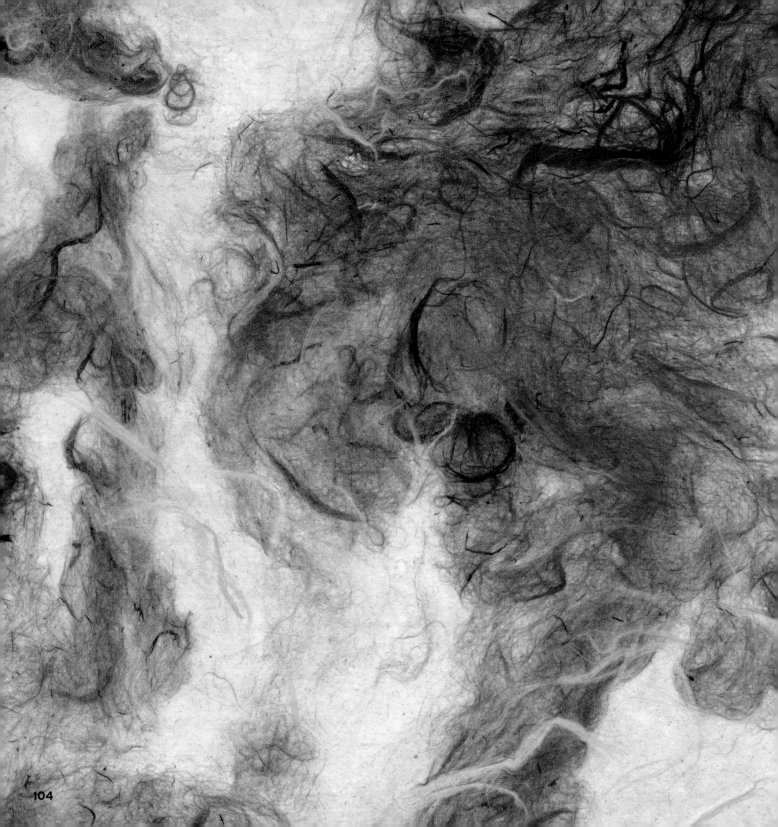

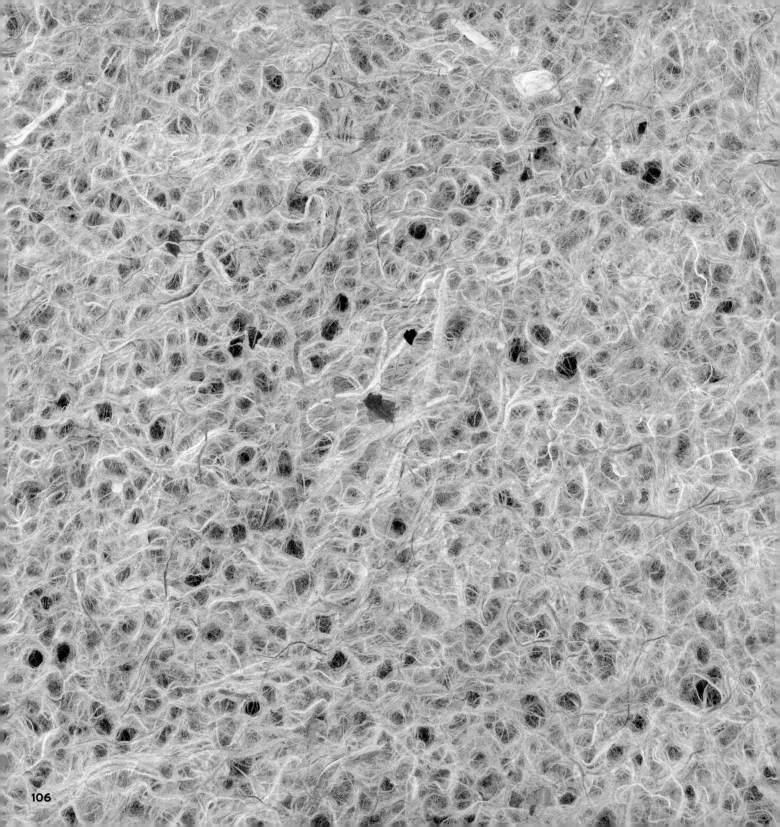

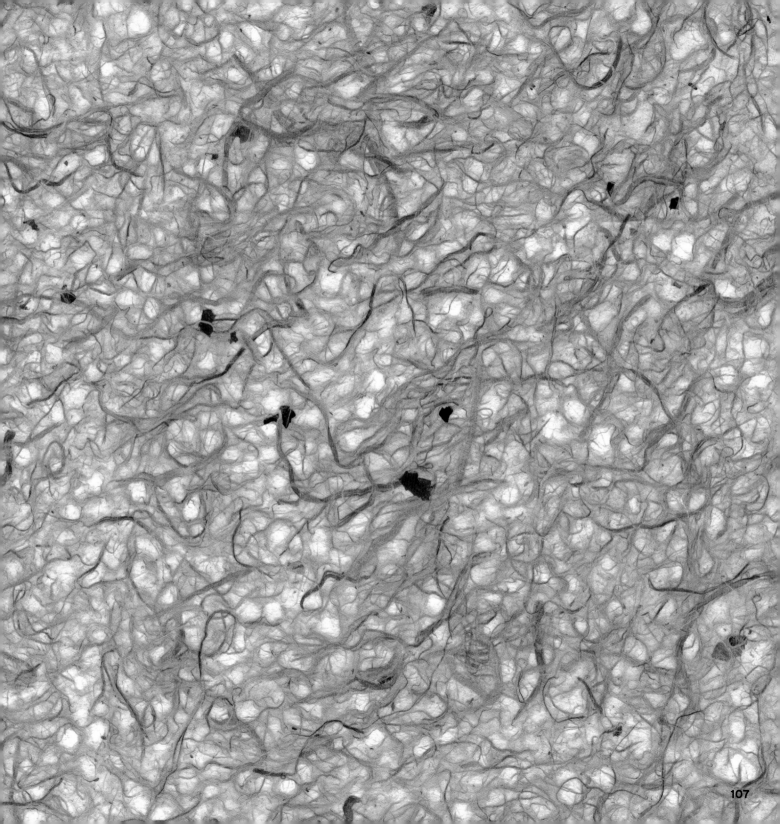

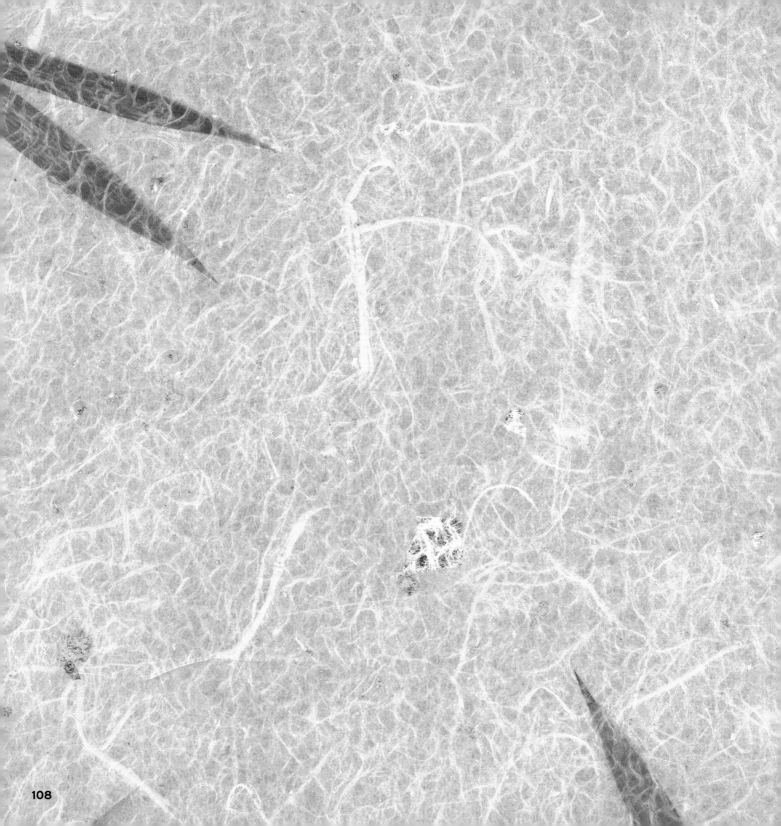

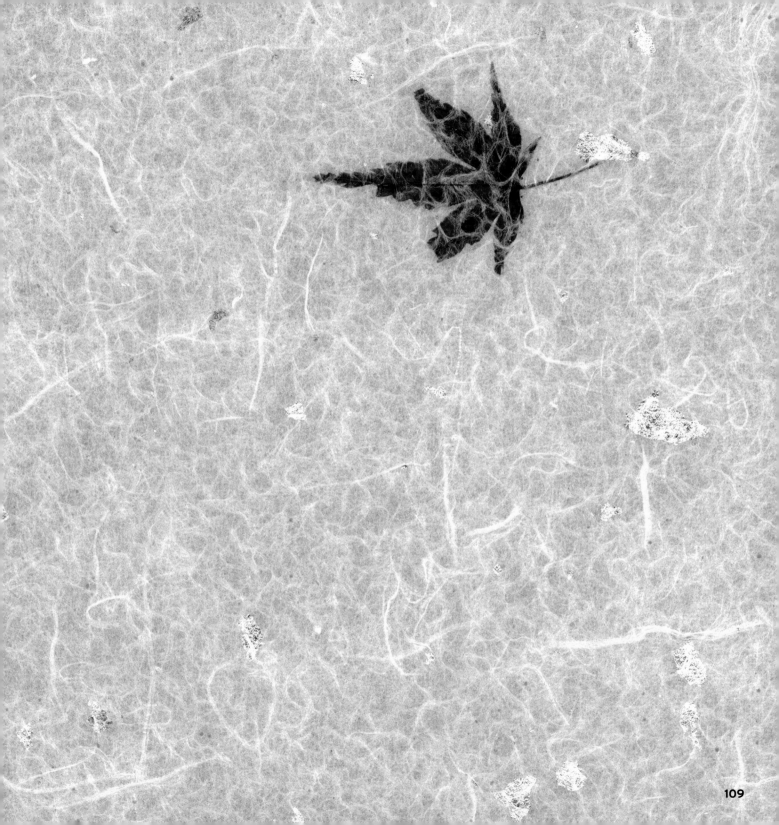

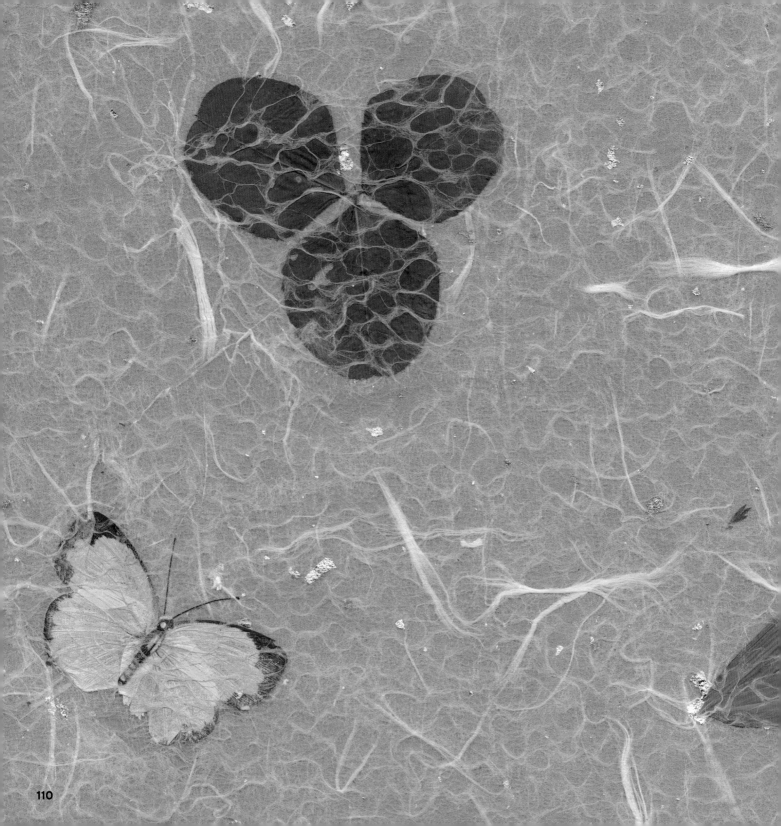

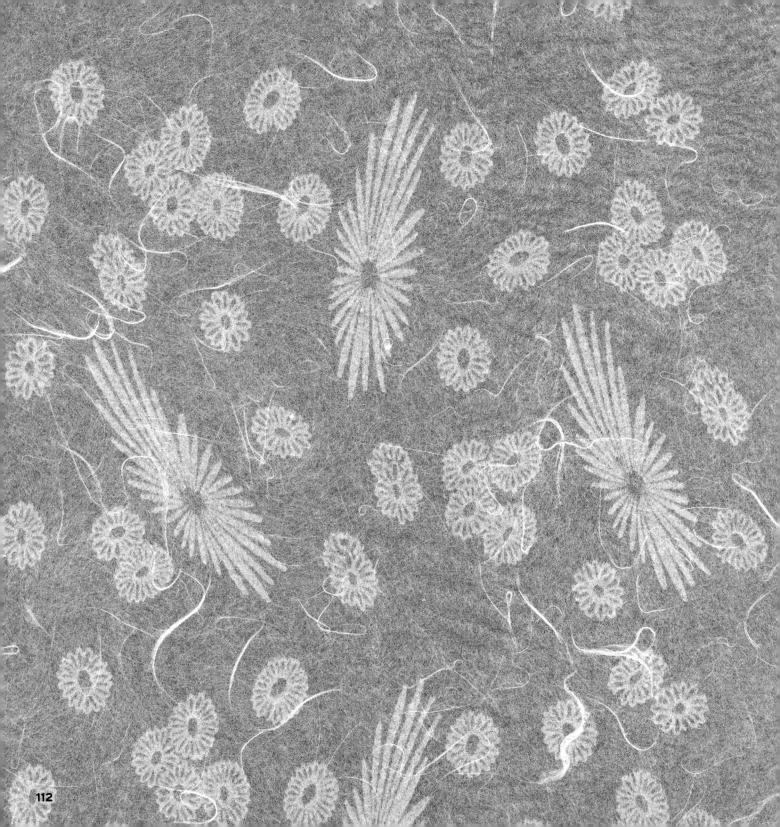

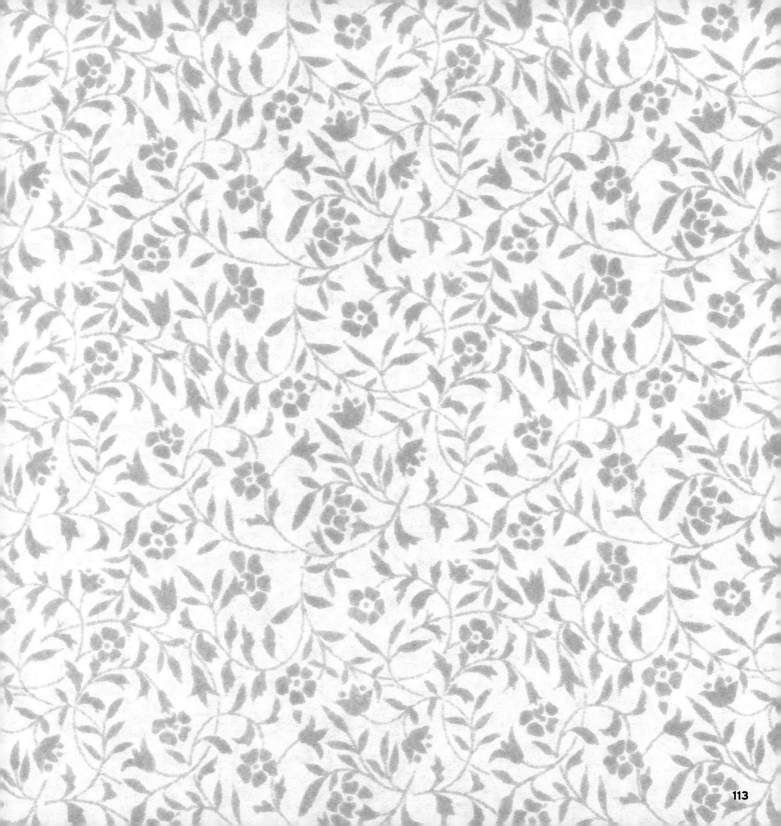

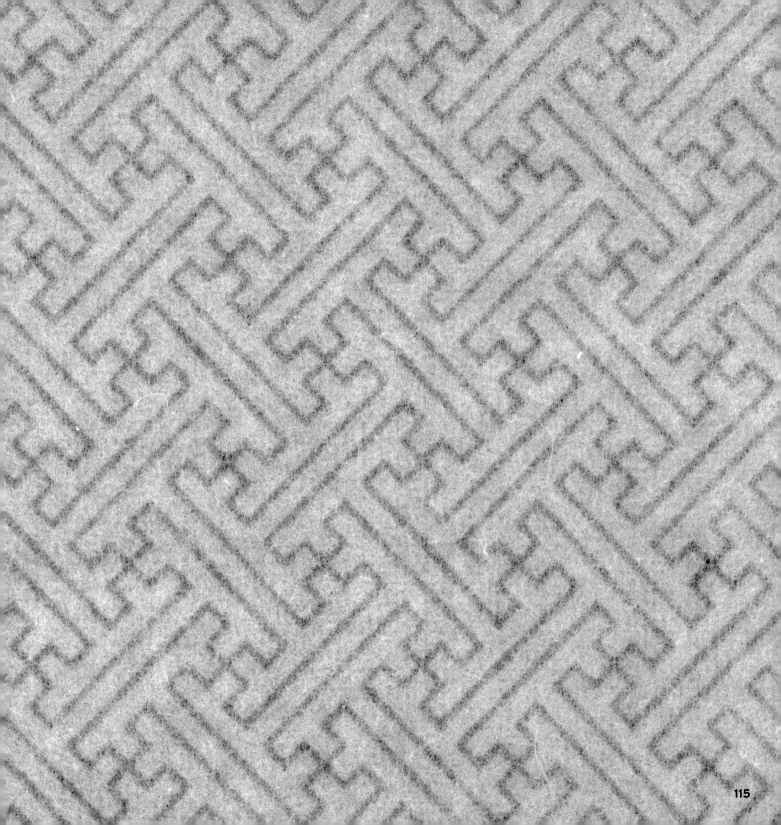

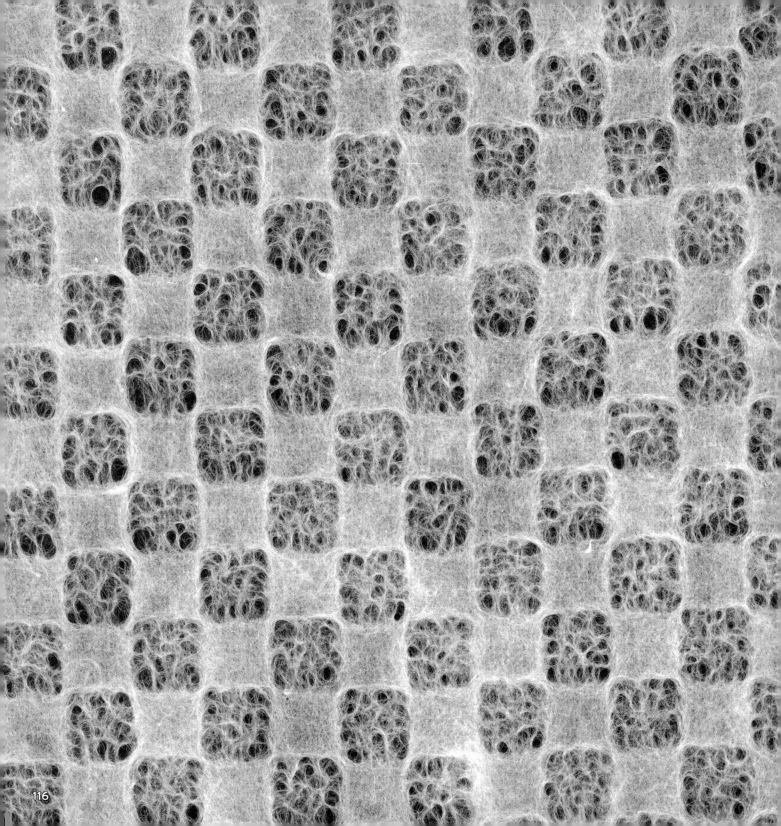

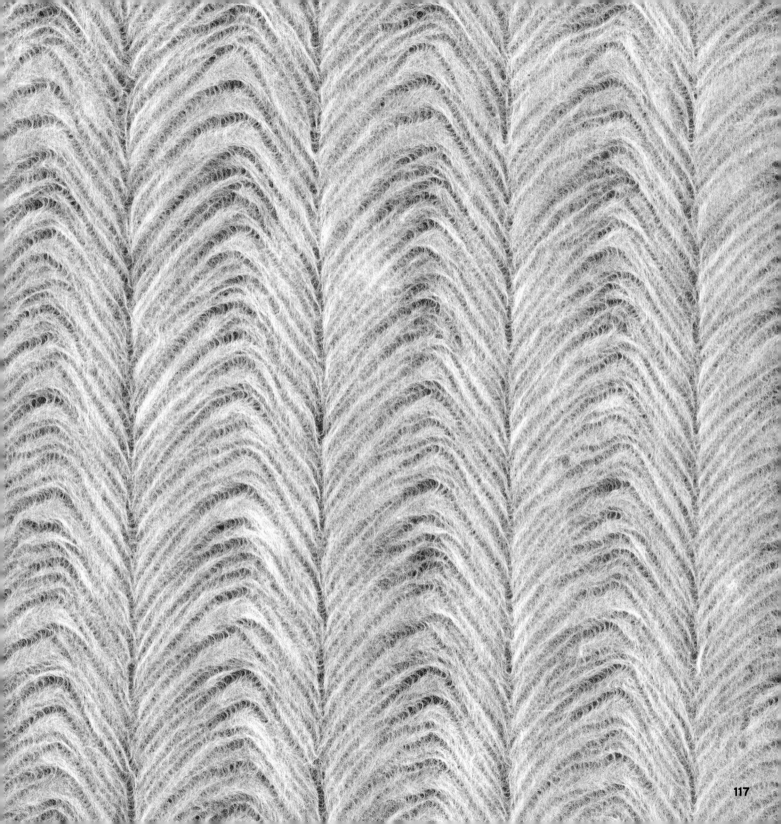

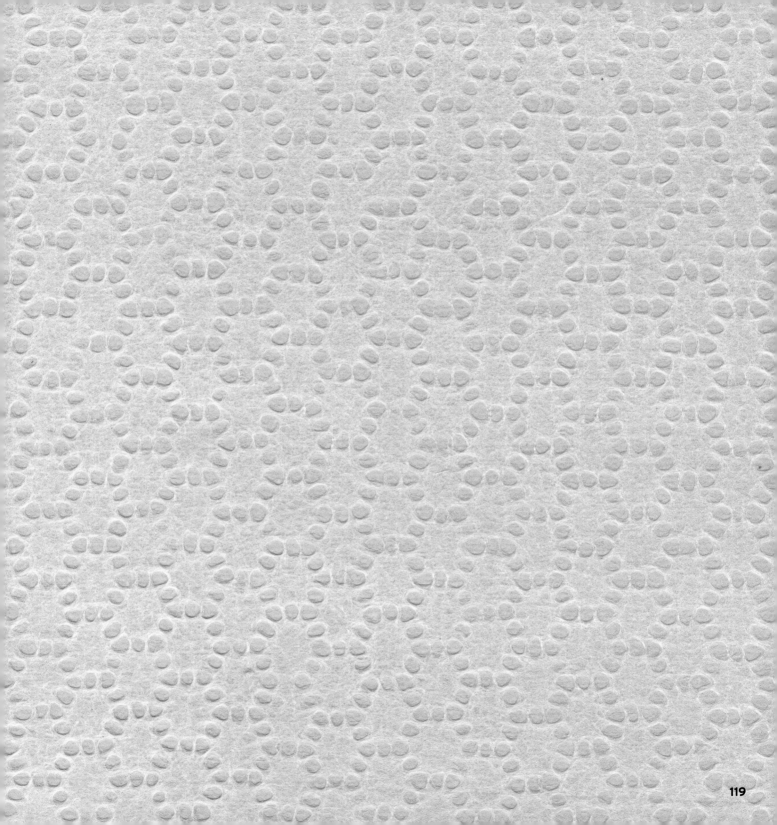

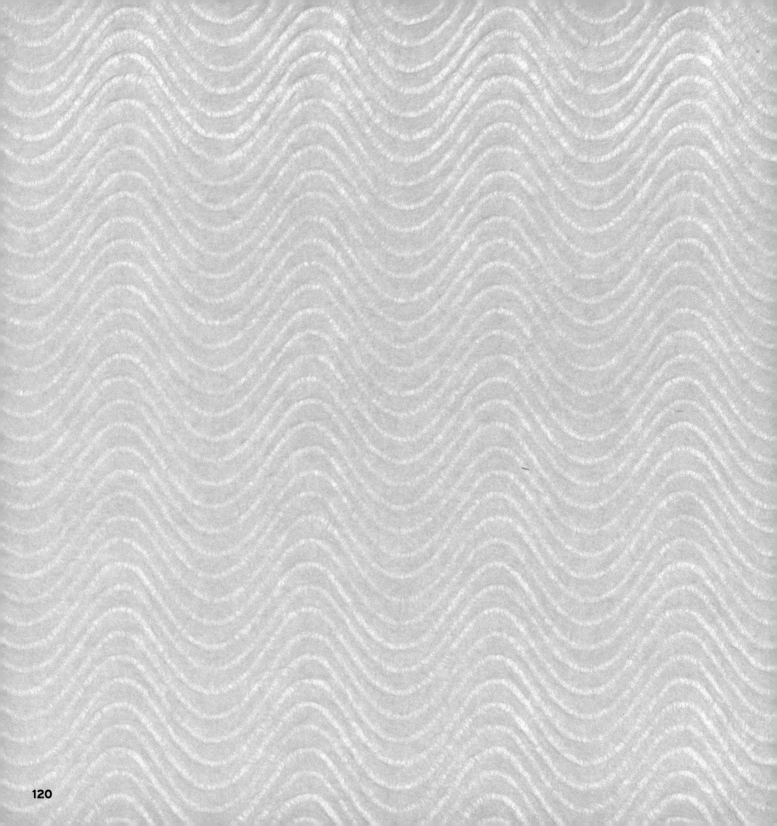

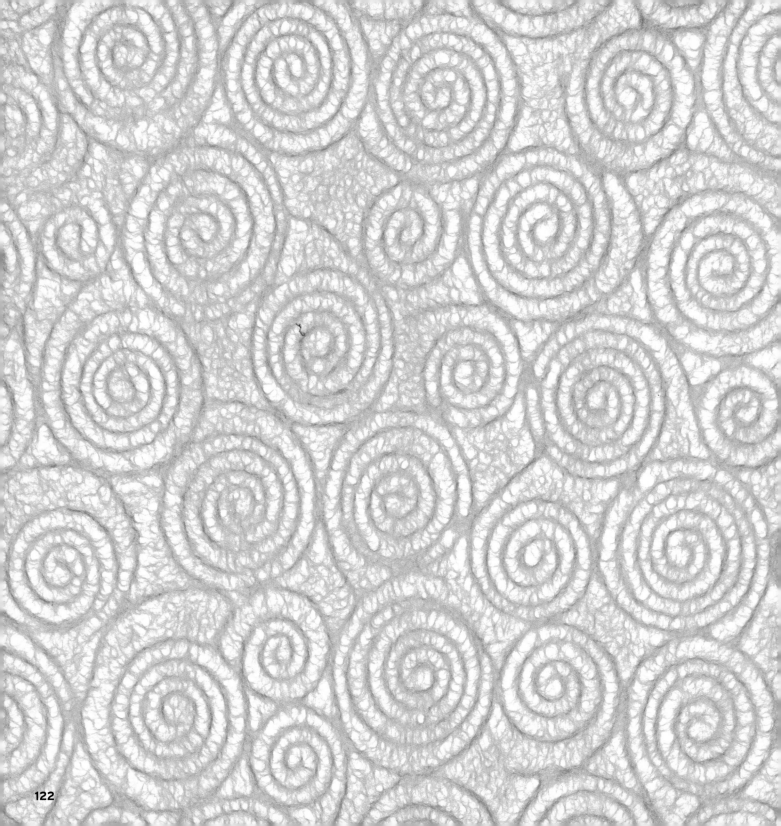

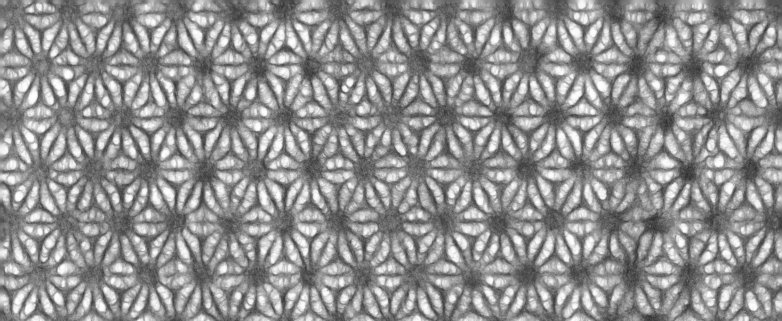

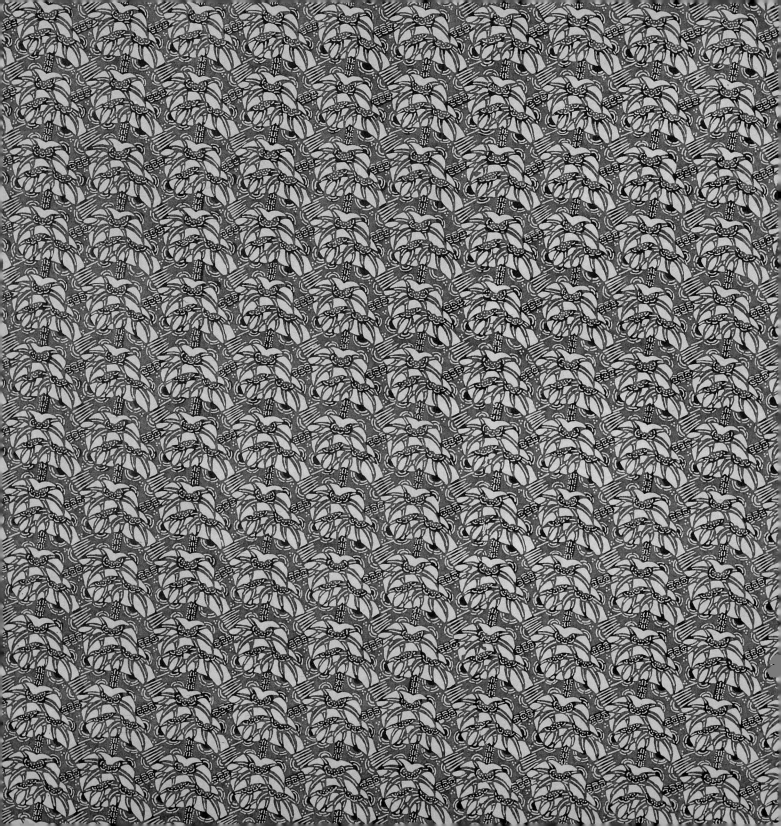

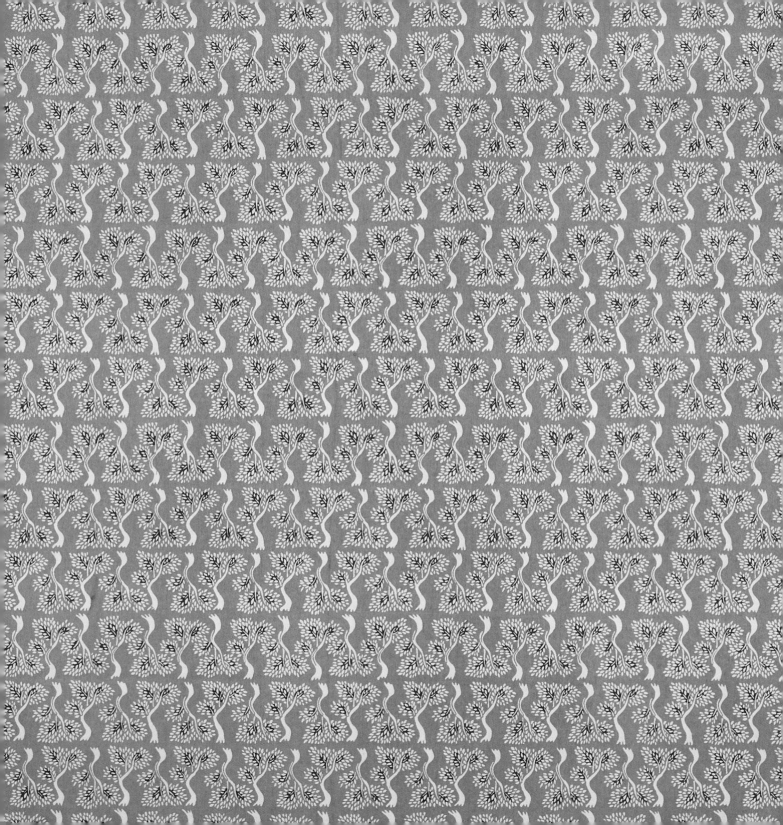

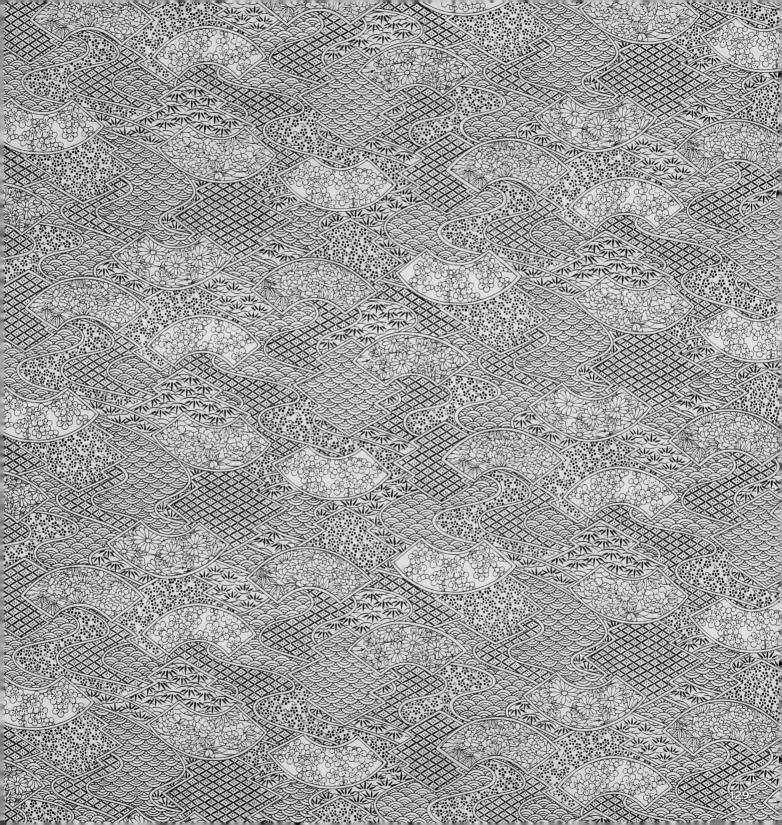

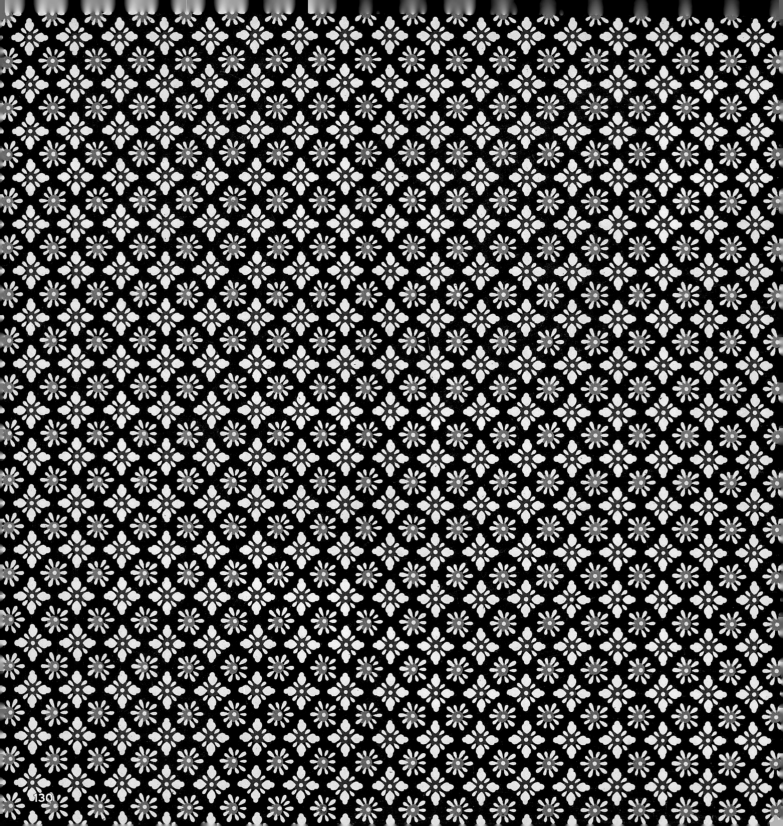

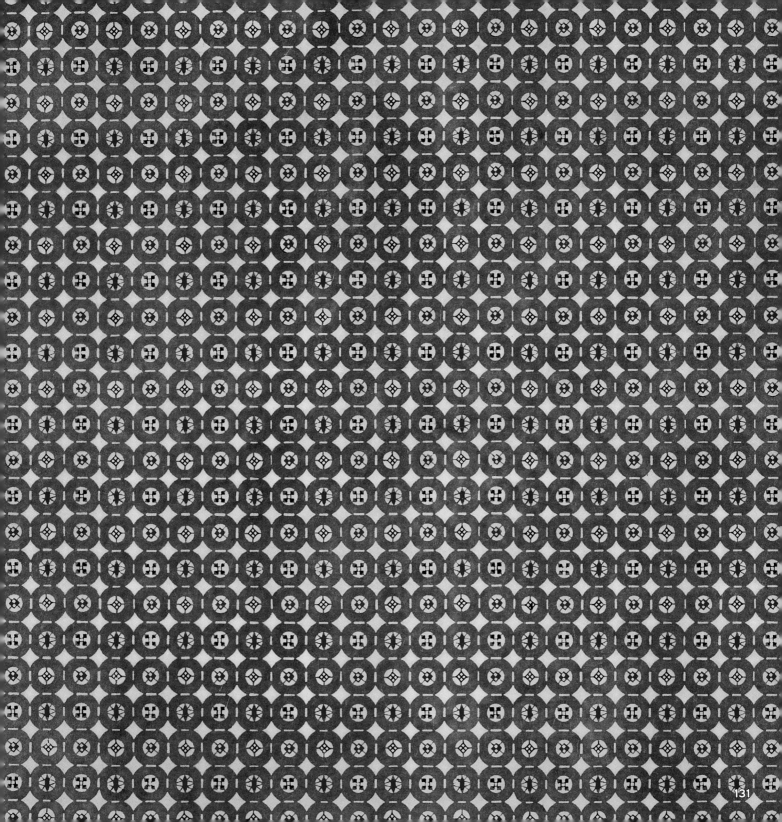

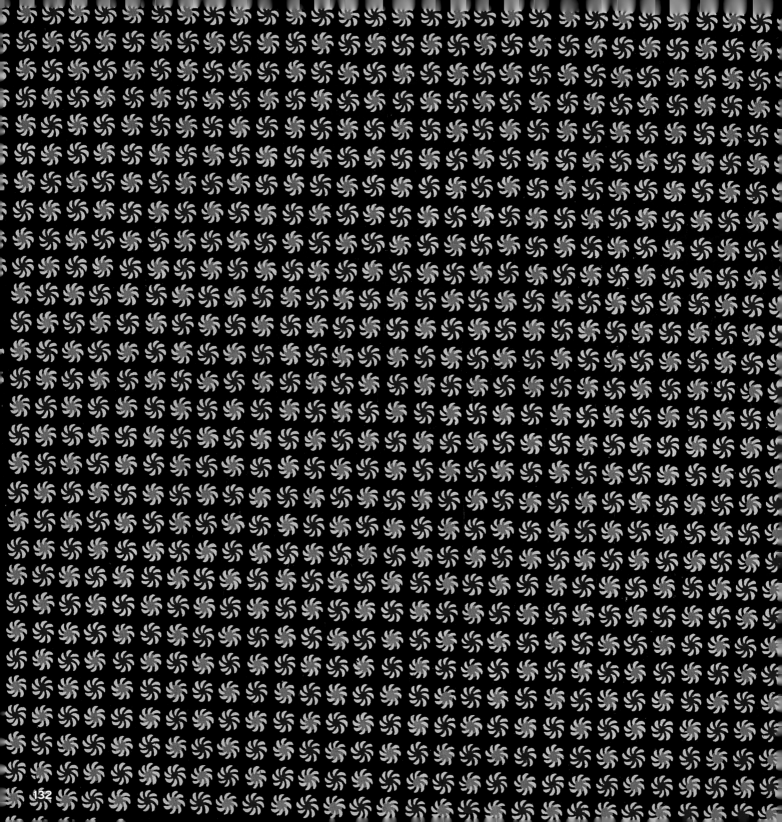

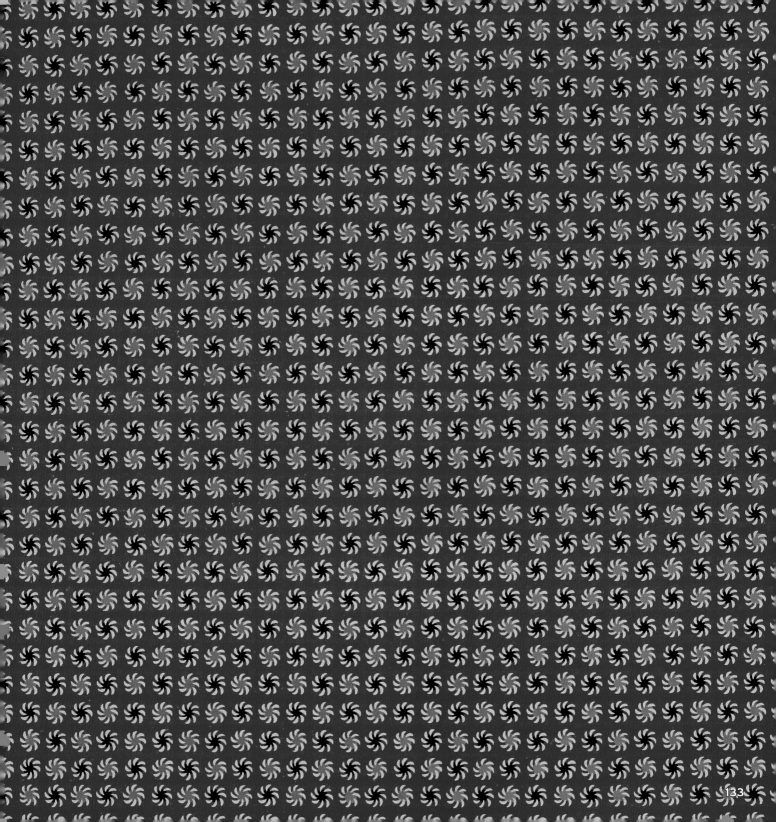

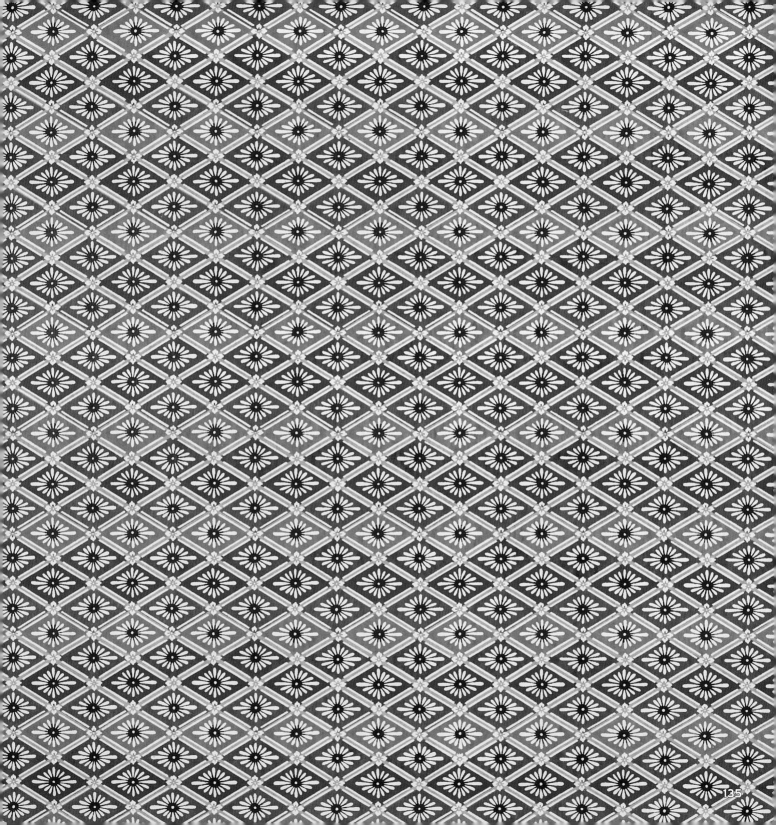

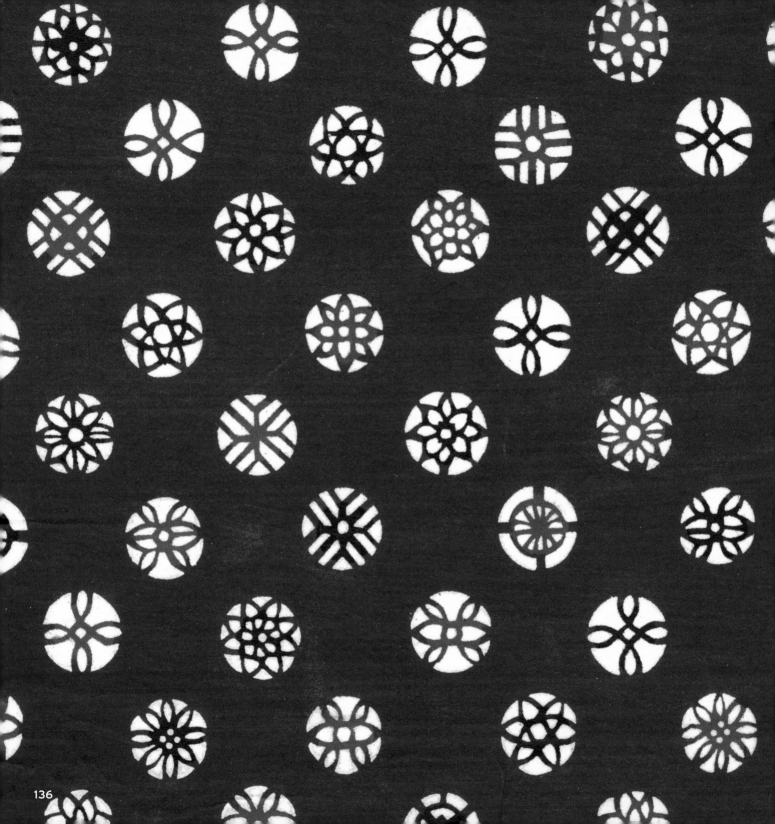

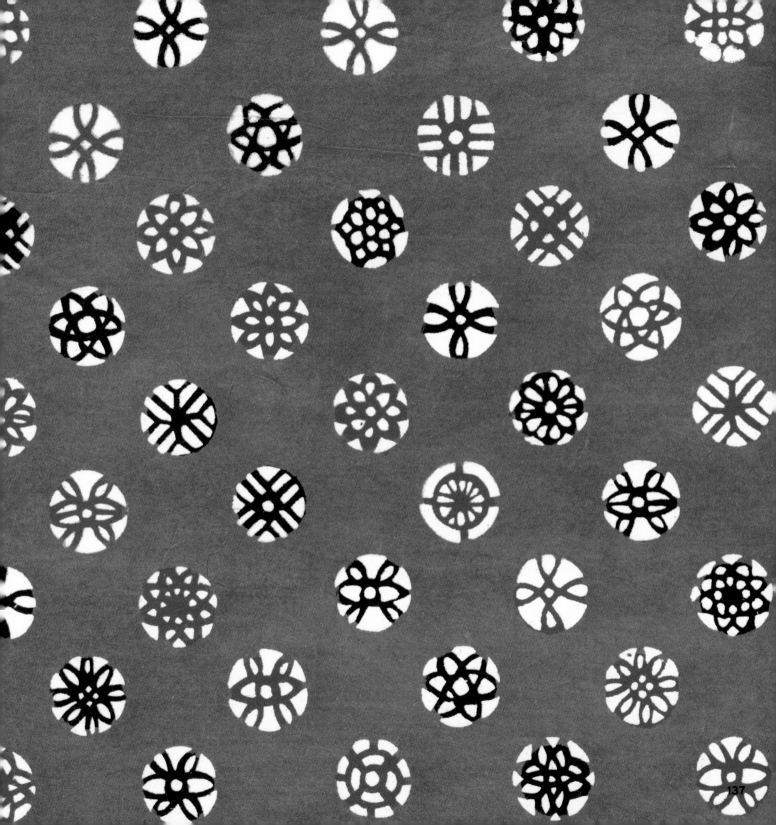

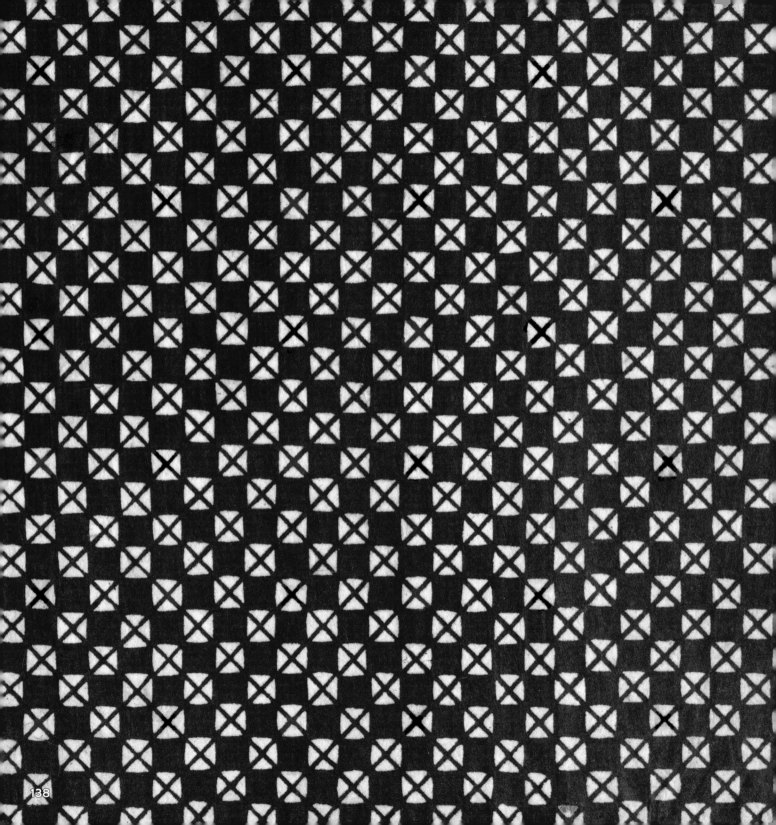

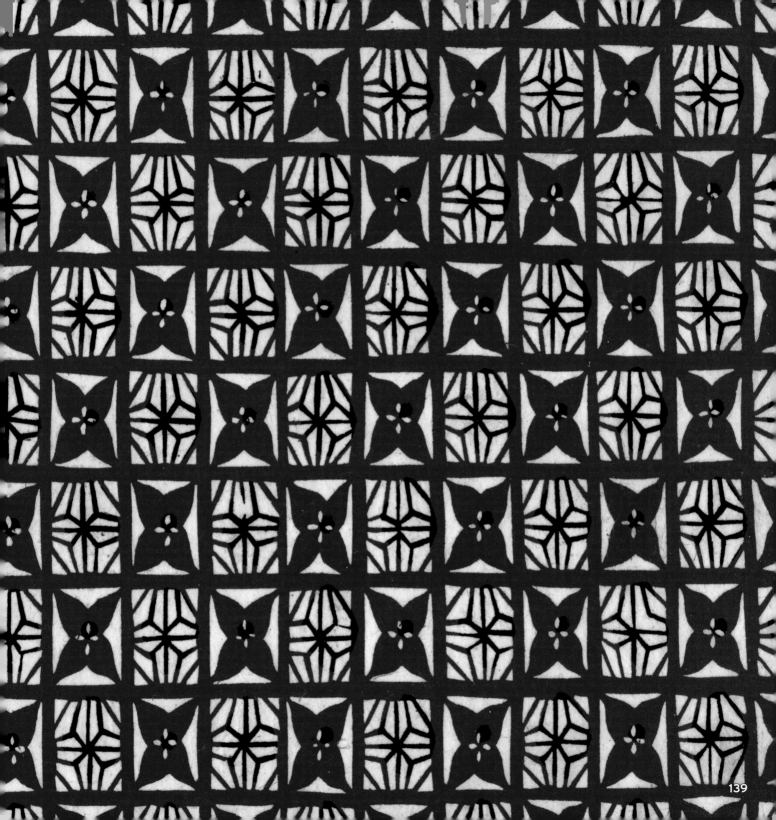

139

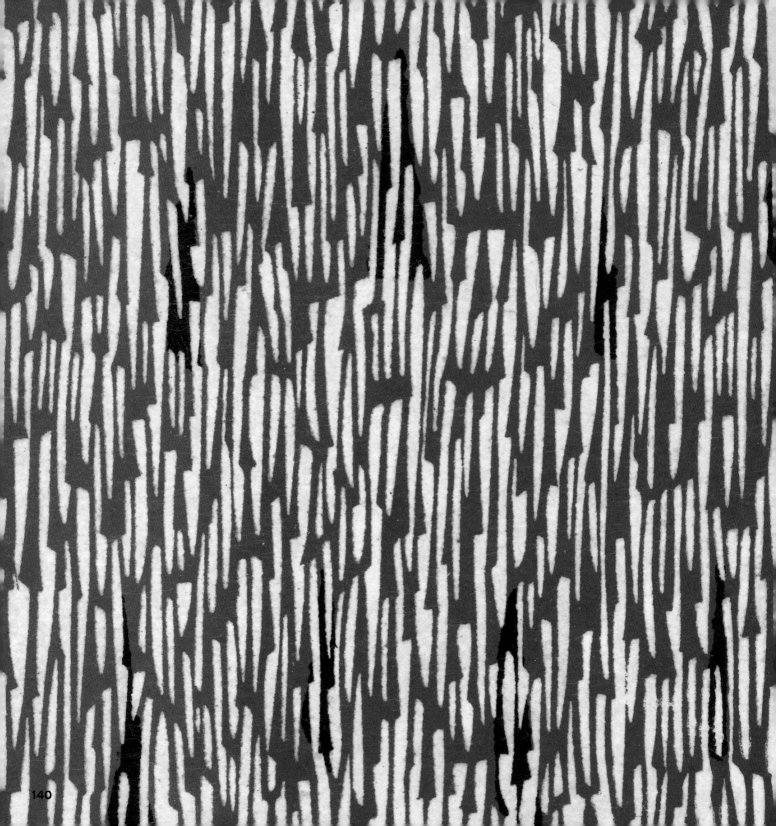

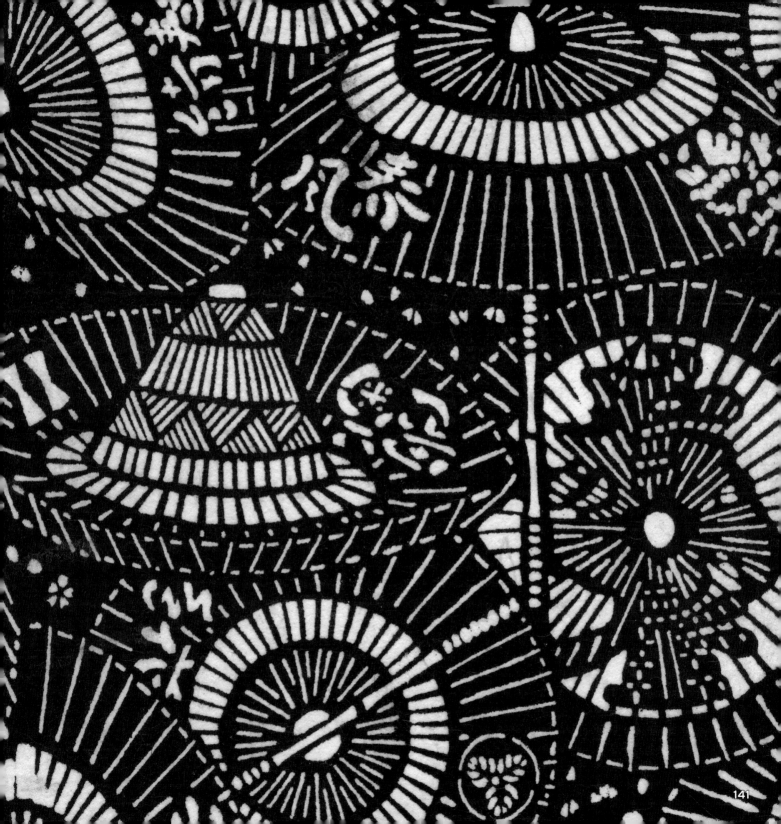

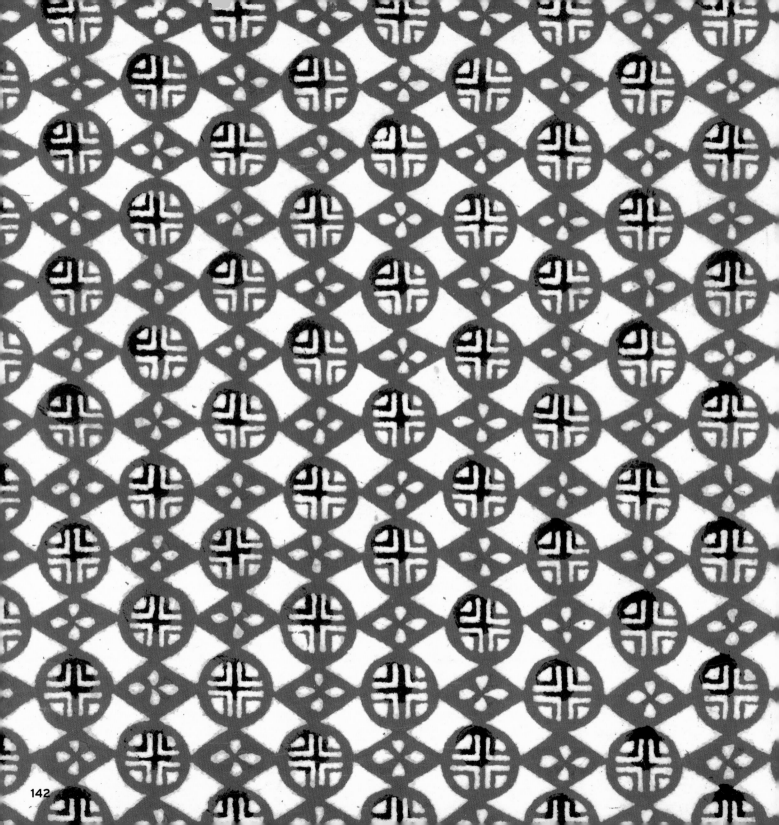

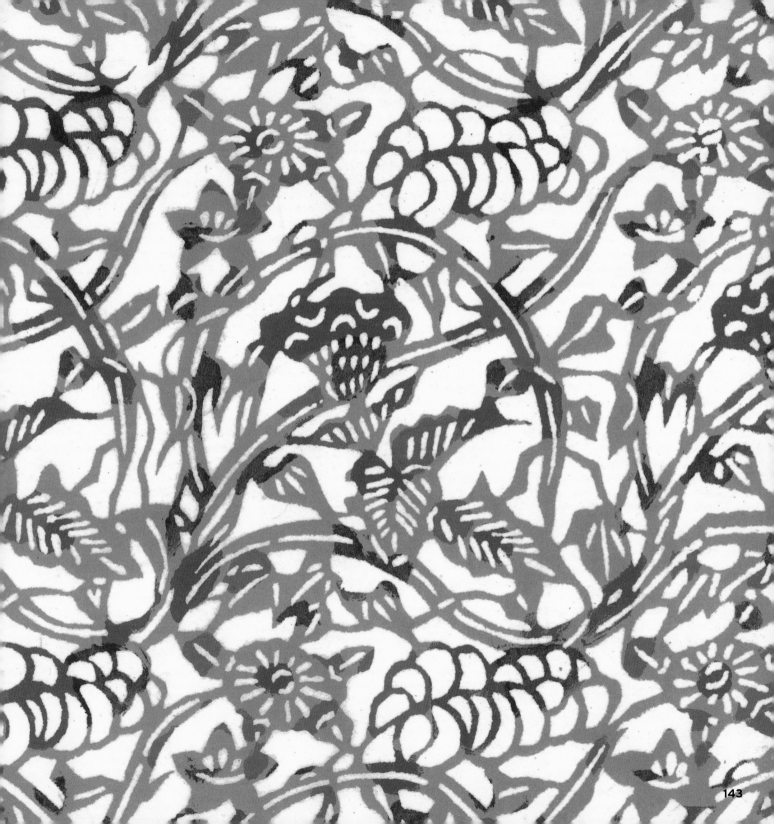

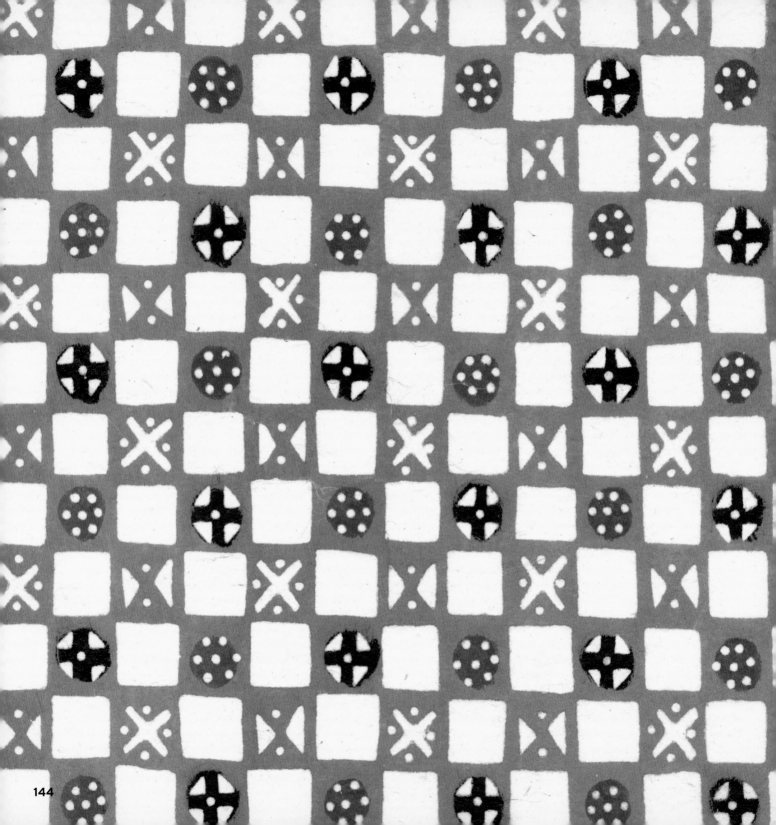

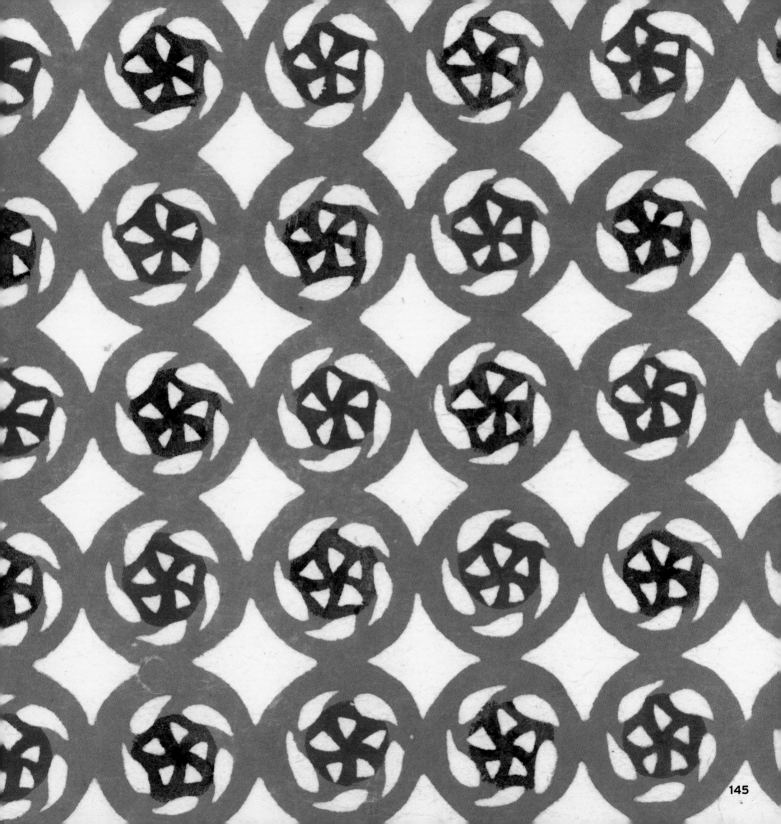

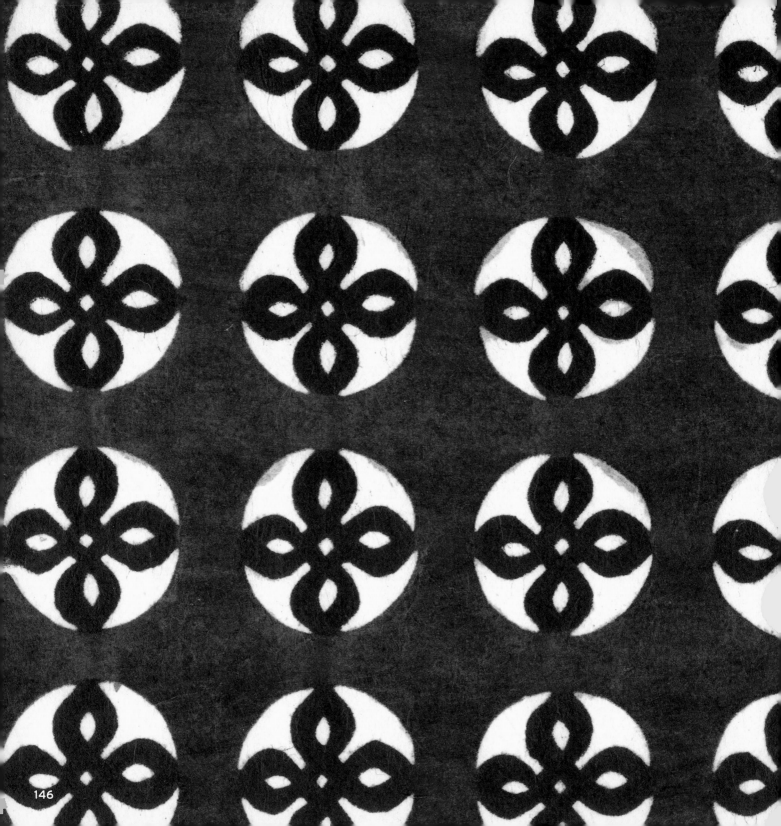

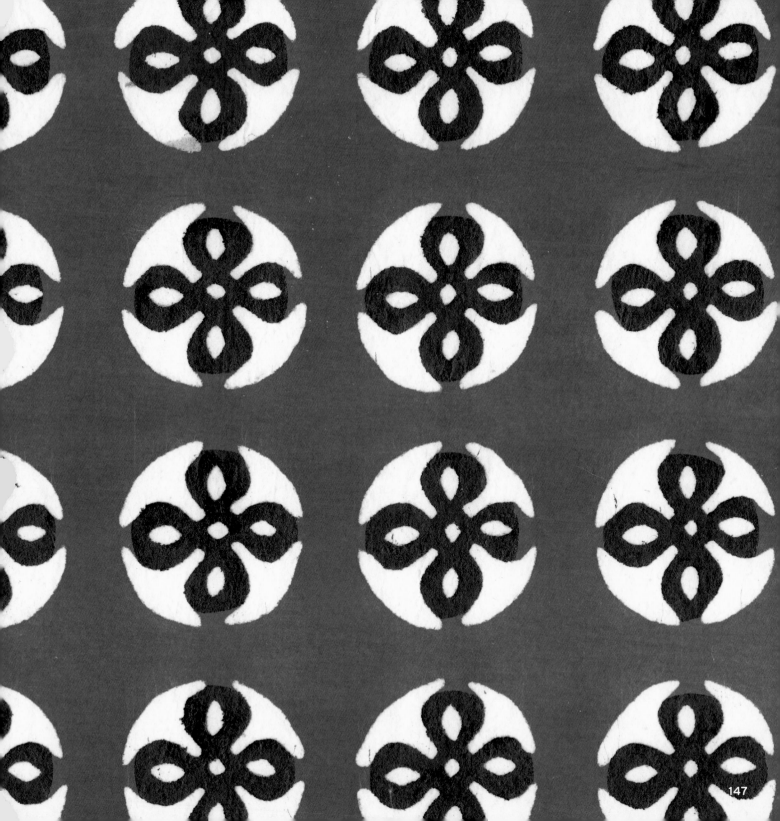

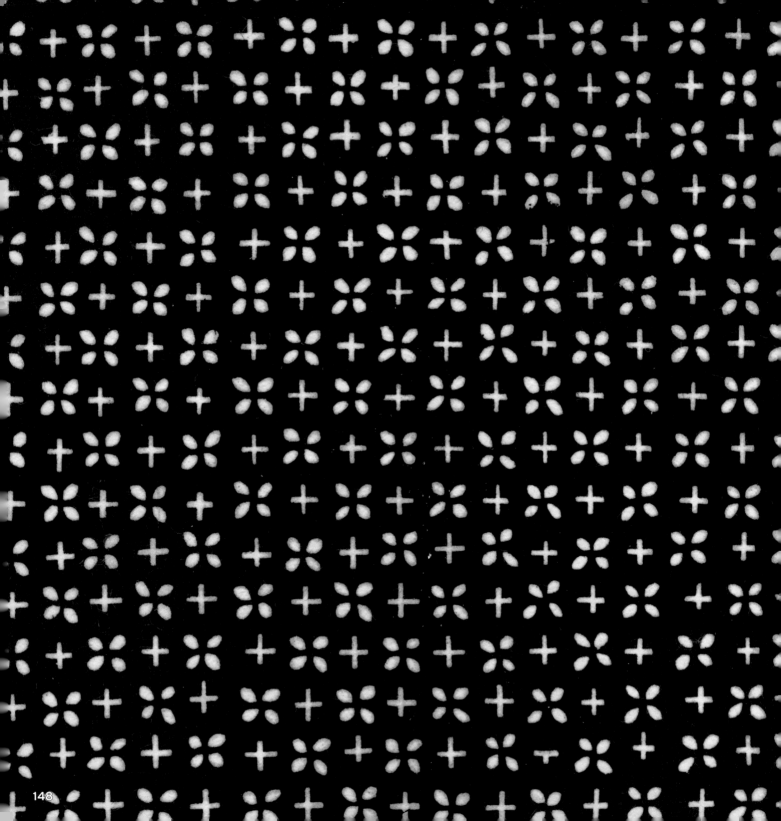

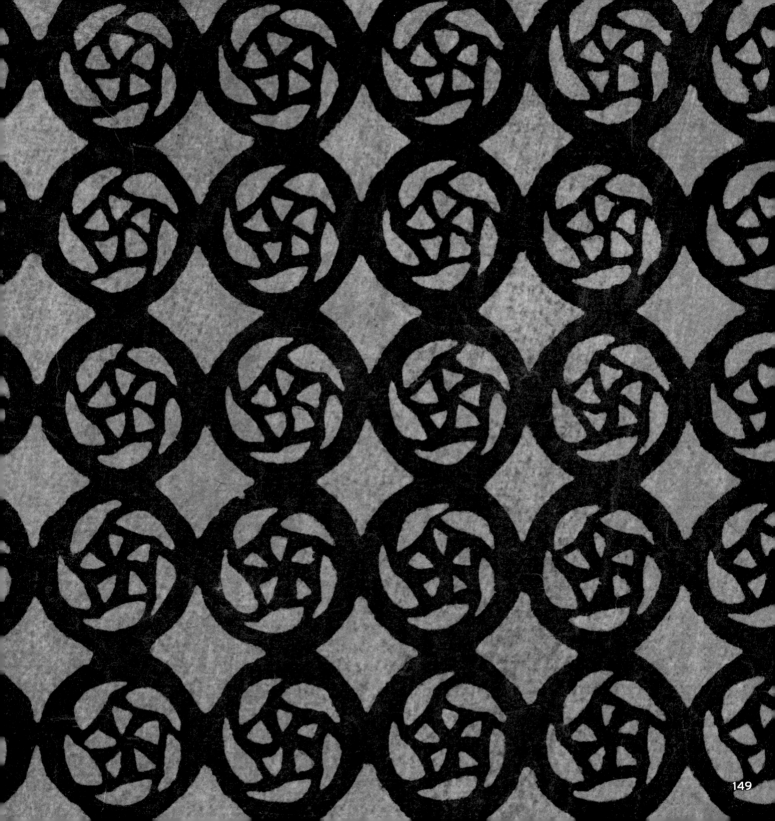

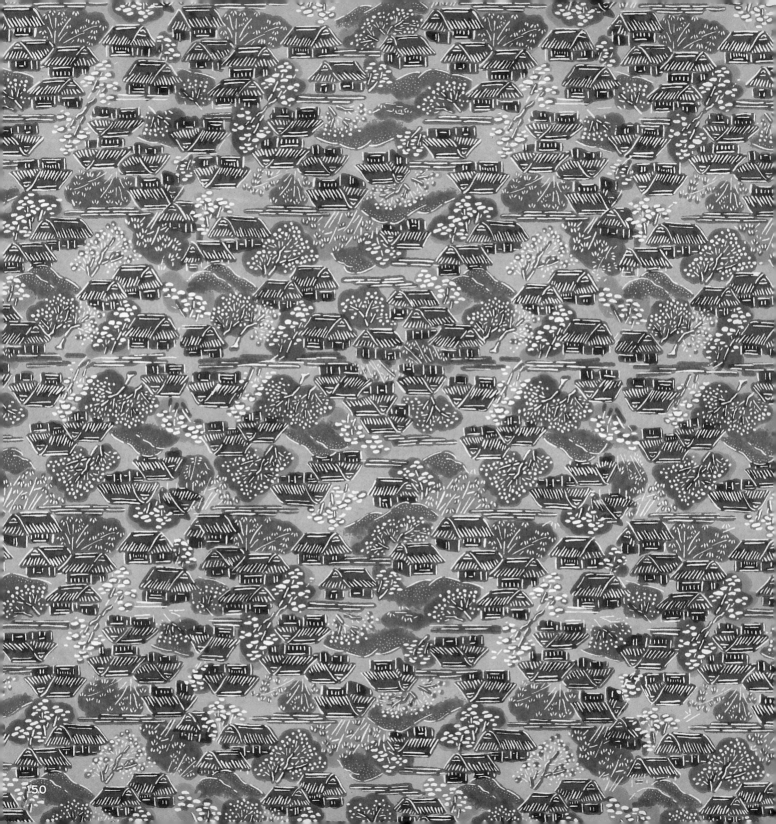

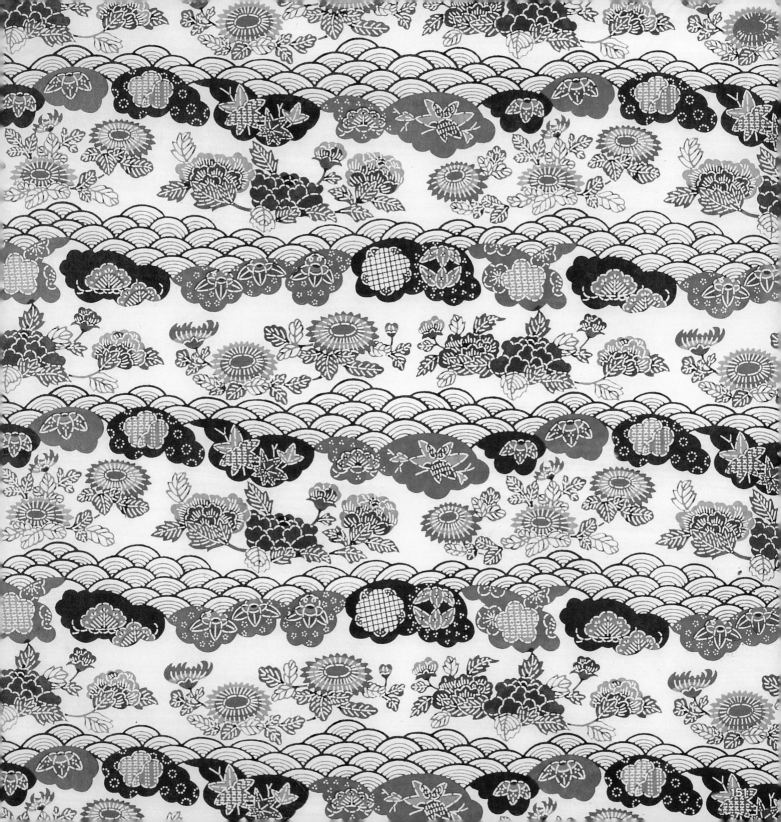

151

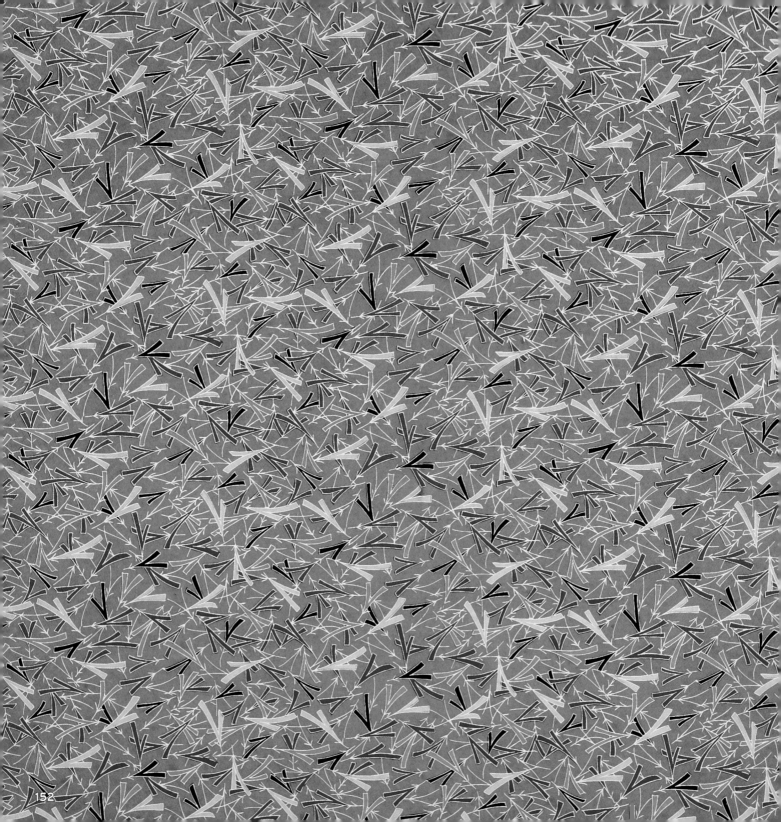

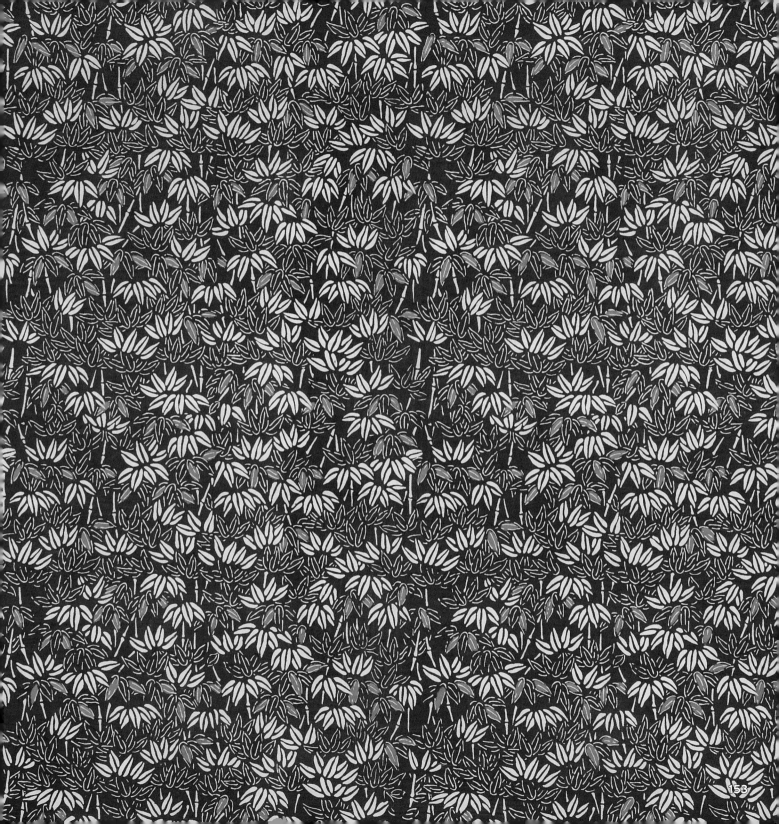

153

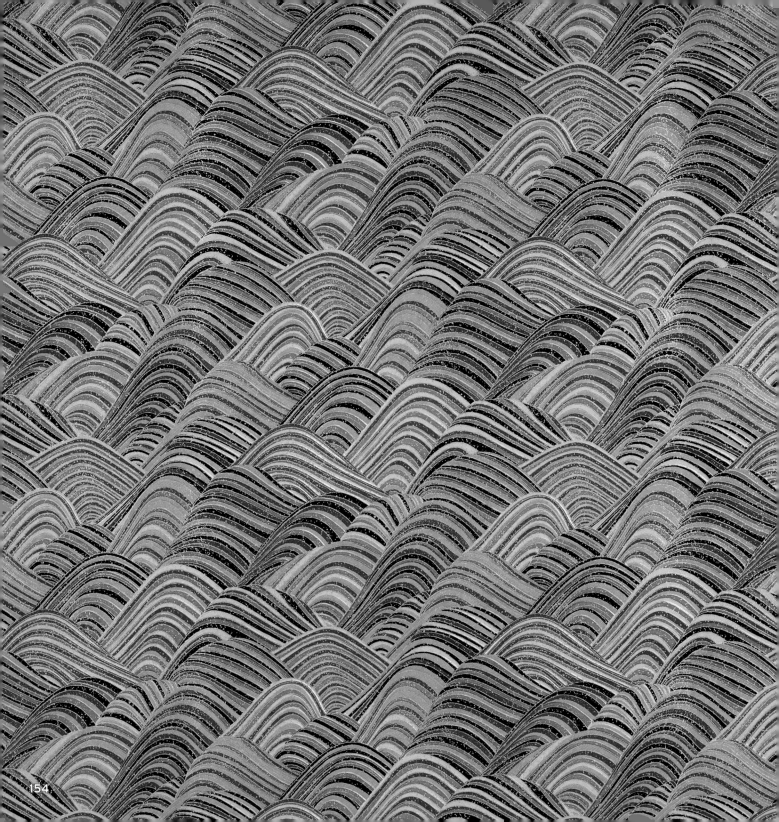

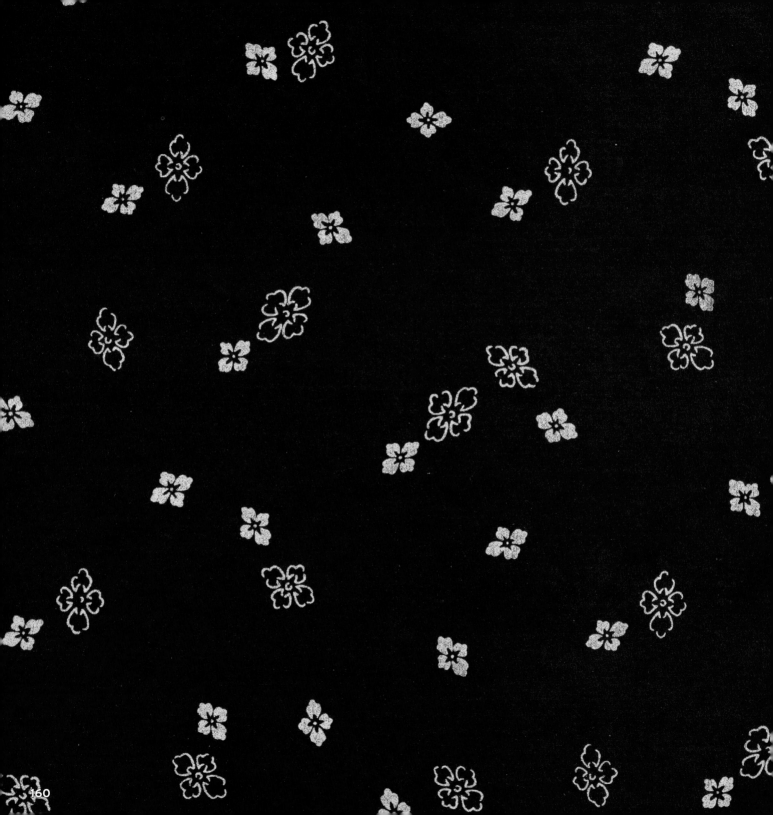

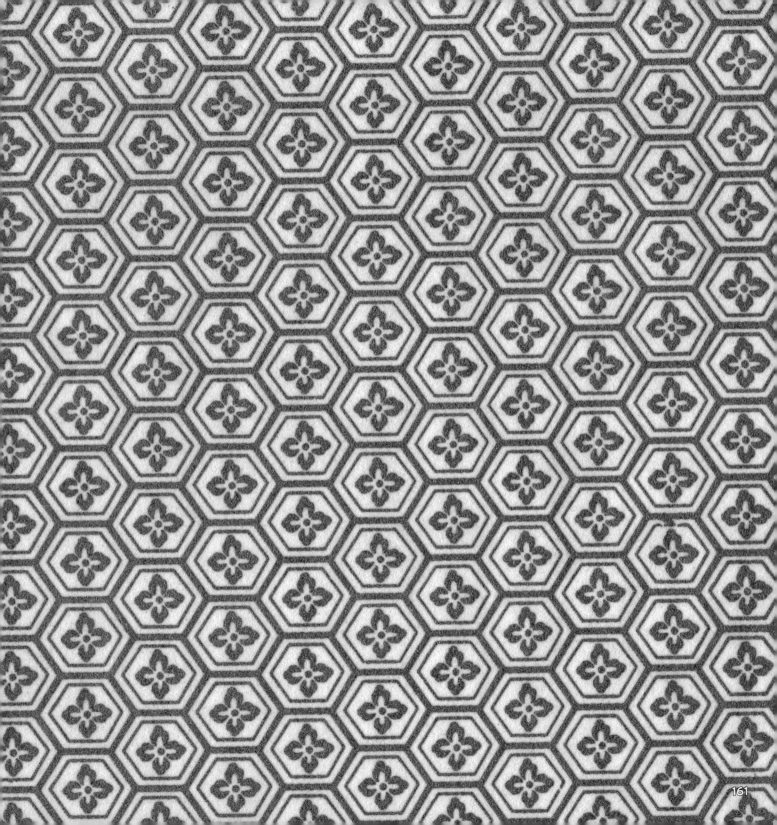

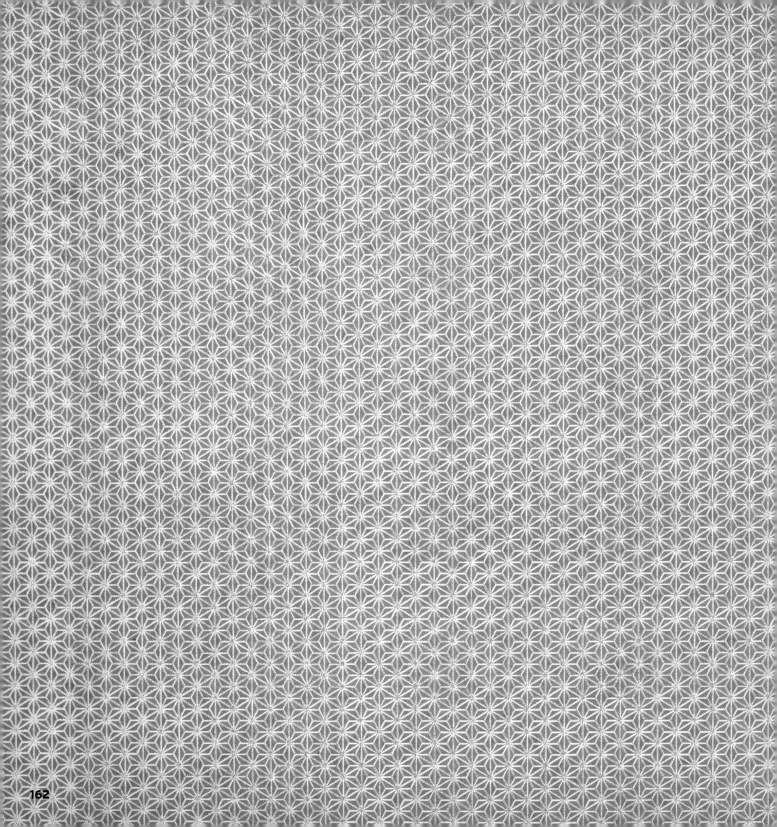

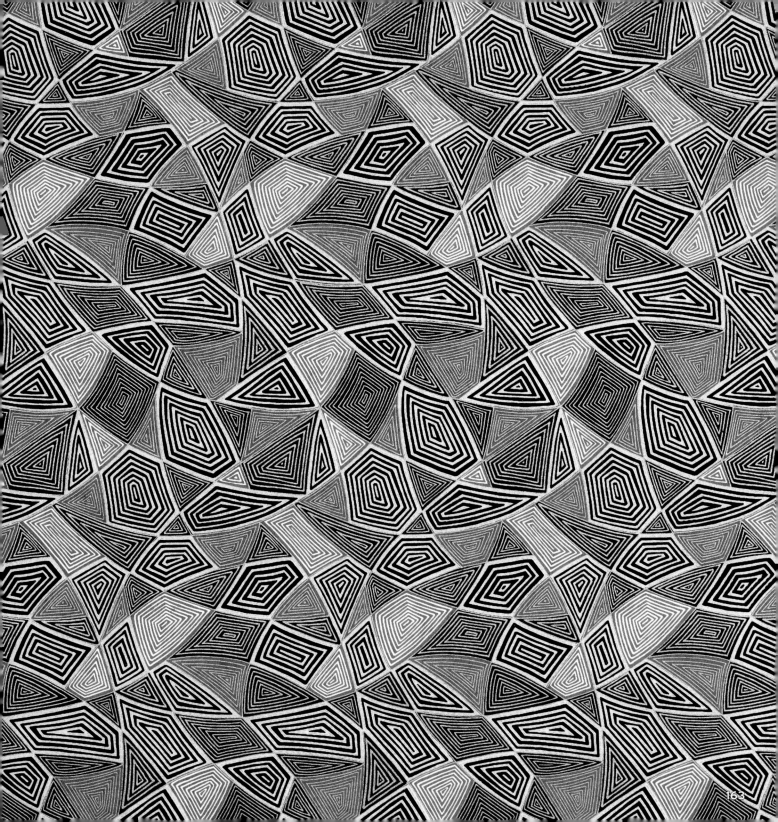

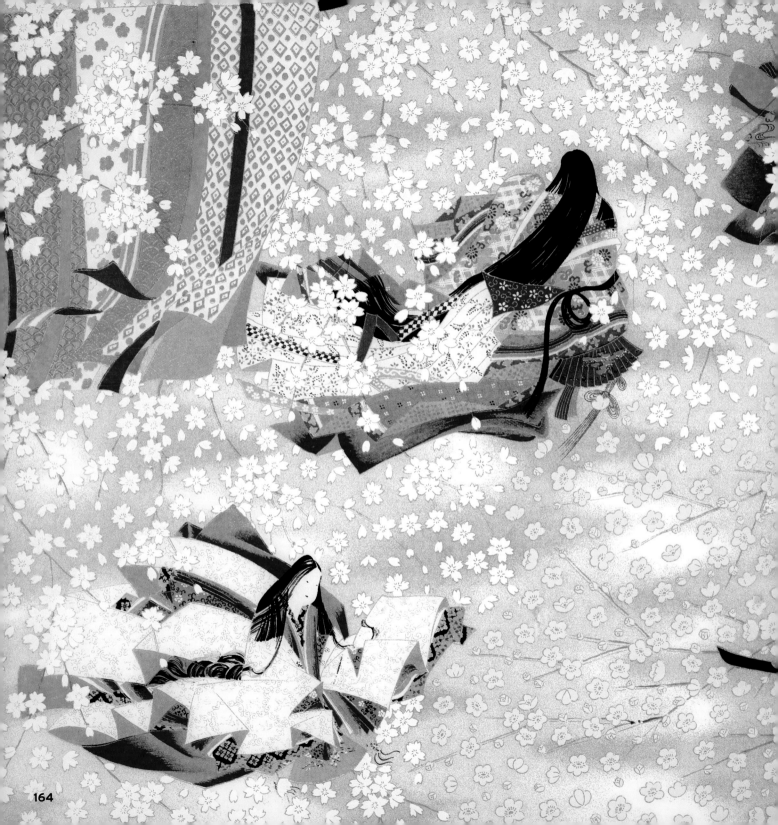

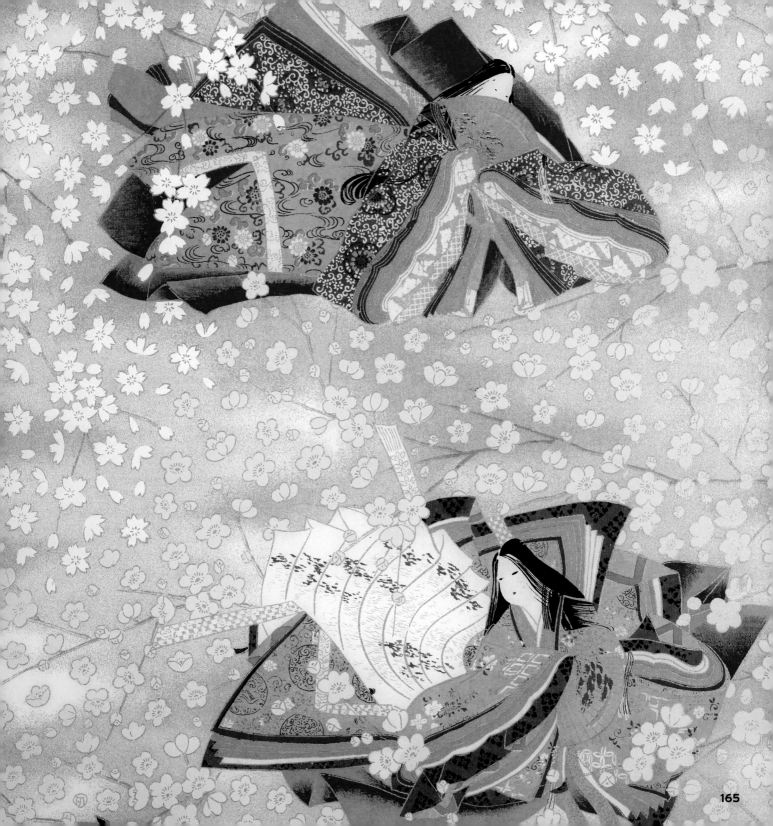

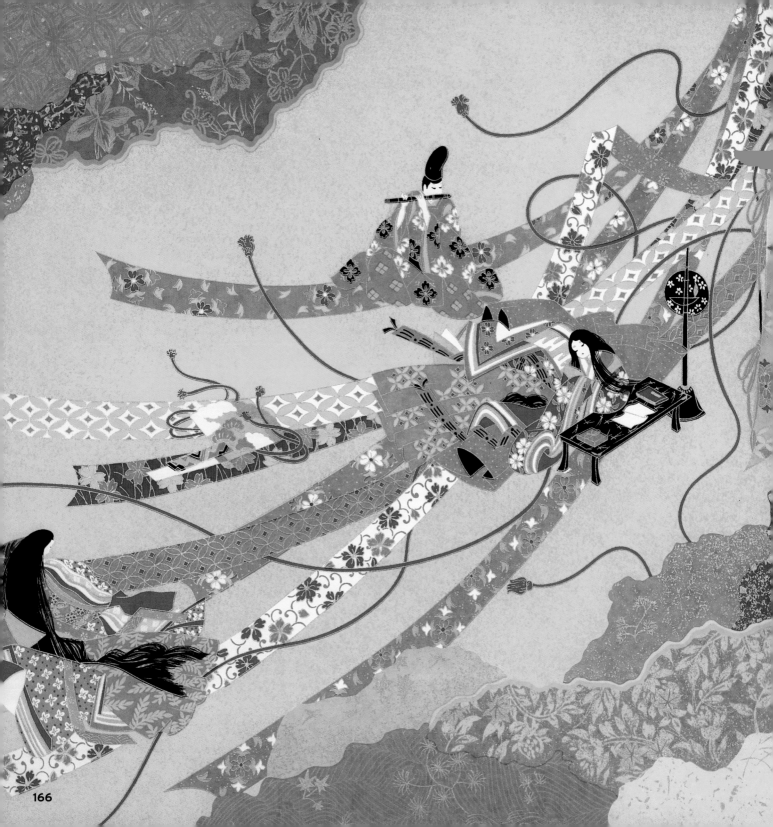

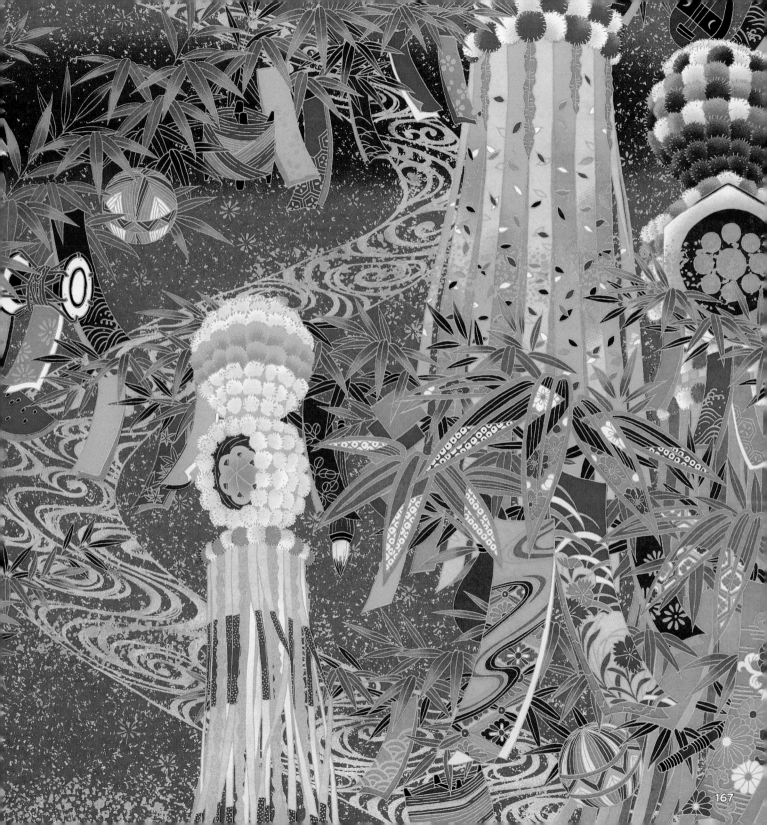

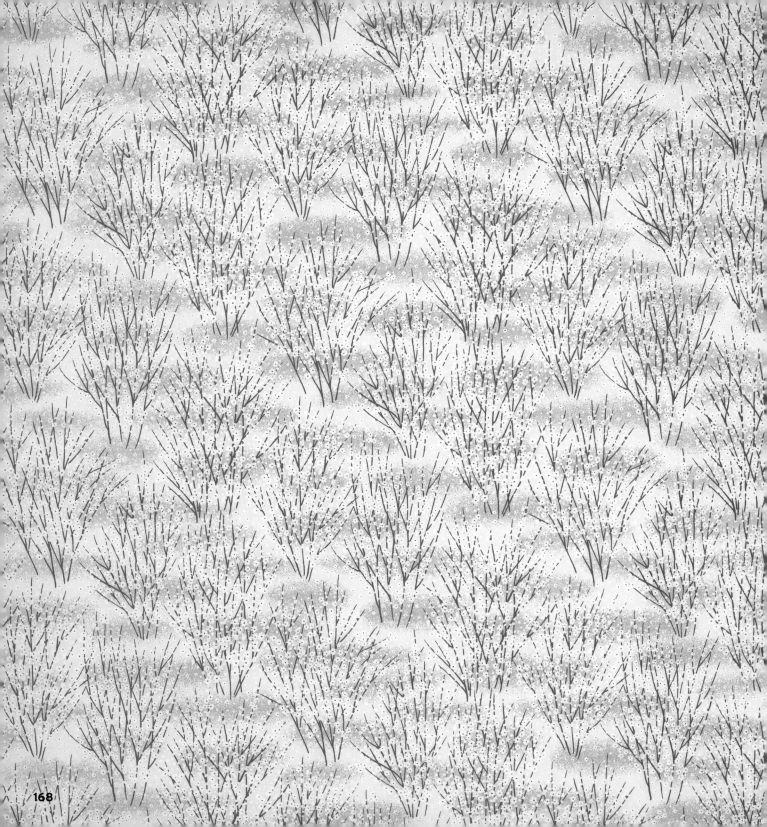

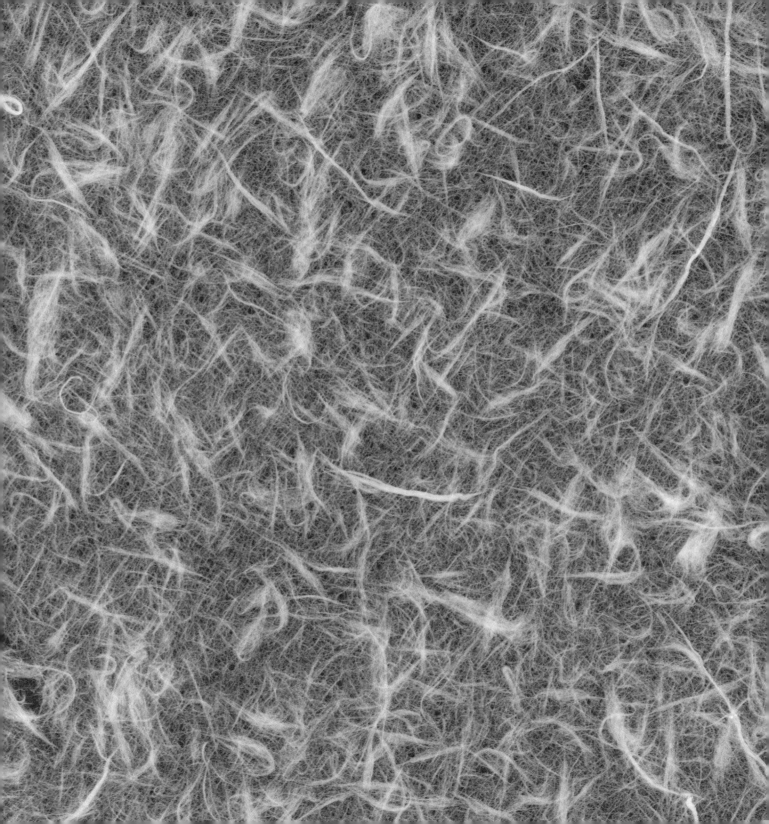

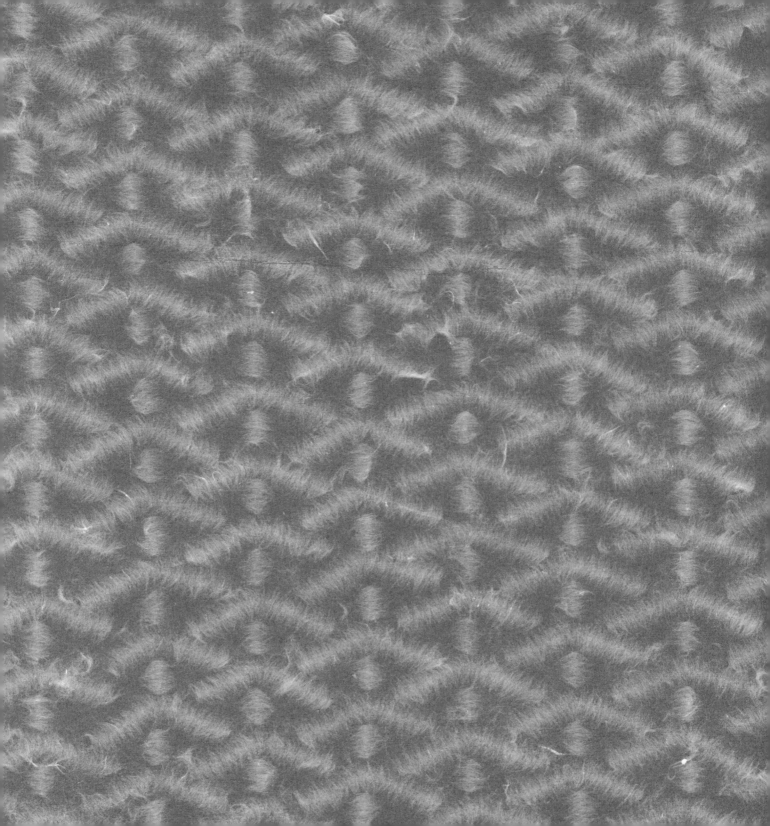